MICHELANGELO'S NOSE
A MYTH AND ITS MAKER

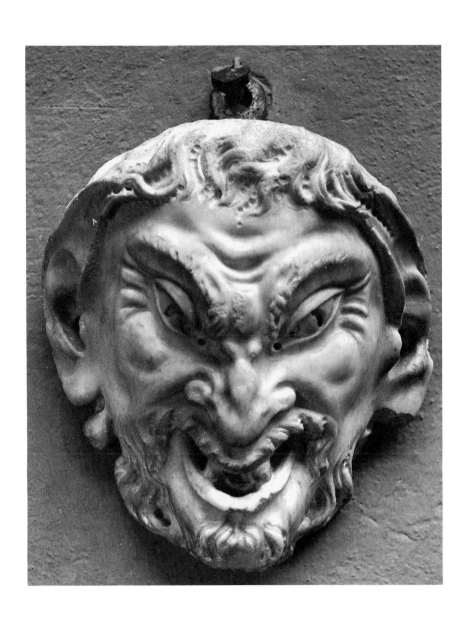

MICHELANGELO'S NOSE

A MYTH AND ITS MAKER

Paul Barolsky

THE PENNSYLVANIA STATE UNIVERSITY PRESS
University Park and London

ALSO BY PAUL BAROLSKY

Walter Pater's Renaissance
Daniele da Volterra: A Catalogue Raisonné
Infinite Jest: Wit and Humor in Italian Renaissance Art

Library of Congress Cataloging-in-Publication Data

Barolsky, Paul, 1941–
 Michelangelo's nose : a myth and its maker / Paul Barolsky.

 p. cm.
 Includes bibliographical references.
 ISBN 0-271-00695-1
 1. Michelangelo Buonarroti, 1475–1564—Criticism and
interpretation. 2. Michelangelo Buonarroti, 1475–1564—Psychology.
3. Arts, Renaissance—Italy. I. Title.
NX552.Z9M533 1990
700′.92—dc20 89–28363

It is the policy of The Pennsylvania State University Press to use acid-free
paper for the first printing of all clothbound books. Publications on
uncoated stock satisfy the minimum requirements of American National
Standard for Information Sciences—Permanence of Paper for Printed
Library Materials, ANSI Z39.48–1984.

FRONTISPIECE. *Faun*, said to be a copy after the lost sculpture by Michelangelo.
Bargello, Florence

For Ruth, Deborah, and Daniel again

Enough, enough, enough! Say no more! Lump the whole thing! say that the Creator made Italy from designs by Michael Angelo!

 —*Mark Twain*, The Innocents Abroad

And the nose is eternal . . .

 —*Wallace Stevens*, "The Man with the Blue Guitar"

LIST OF ILLUSTRATIONS

Photo Credits

Alinari/Art Resource, New York: frontispiece and Figs. 1–5, 7–13, and 17–19; Minneapolis Institute of Arts: Fig. 14; National Gallery of Art, Washington, D.C., Samuel H. Kress Collection: Figs. 6 and 20; Ralph Lieberman: Figs. 15 and 16.

PREFACE

In its sheer bulk, the literature on Michelangelo is michelangelesque. It bulges, like the muscles of his *Ignudi* and *Slaves*, from the over-crowded shelves of art libraries everywhere. What more is there to say about Michelangelo that has not been said already, that might justify adding to these already overstocked shelves? The answer to this question in a new book on Michelangelo is, predictably, "a great deal." This study is, I can and must proclaim without modesty, the first serious study of an essential part of Michelangelo's person—the first investigation of Michelangelo's nose.

Michelangelo's broken nose is legendary—legendary thanks to Michelangelo himself, who commented in some detail to his biographers on the painful circumstances of its violent deformation. Strangely enough, however, although this central episode in his biography has always been noted, its full significance has never been explored in any detail. To ponder this important historical incident, as I do in the first part of this book, is to reflect on how Michelangelo imagined himself. Not only is this study a meditation on how Michelangelo imagined his broken nose, giving it symbolic import, but it is, in a larger sense, a discourse on how Michelangelo imagined himself, indeed created himself.

It is well known that Michelangelo wrote a number of poems in which he spoke of himself as a sculpture, as a work of art. The full implications of this conceit have, curiously, never been explored. It is possible, I contend, to see Michelangelo, as he saw himself, as a work of art in his own right, to study the ways in which he created or

formed himself, especially during his last years, when he added the final touches to his self-portrait. As I will explain, such an approach is grounded in principles that Michelangelo inherited from the interrelated classical and biblical traditions central to the cultural milieu in which he was nurtured.

What sets this book apart from previous writing on Michelangelo is its focused attention on Michelangelo's self-creation, on the cunning and extreme artifice he employed in giving form to a complex image of himself. The story of Michelangelo's nose is part of the larger story of how Michelangelo assumed the masks of philosopher, saint, and prince, compounding them artistically into the colossal image of himself.

Michelangelo exploited the deformity of his nose, since it was necessarily part of the image of his ugliness. Such ugliness was appropriate to Michelangelo's idea of himself as a type of Socrates. The ancient philosopher was legendary for his ugliness, which stood in marked contrast to and hence pointed toward his inner virtue and wisdom. Michelangelo, as I will explain, created the fiction of himself as a socratic satyr or silene, ugly without, wise and virtuous within. In accord with a deep Christian tradition, Socrates' inner virtue was saintly, and Michelangelo, following suit, invested his own socratic icon with specific saintly meaning.

My principal texts in this investigation are the two biographies of Michelangelo written by his protégés Vasari and Condivi during the middle years of the sixteenth century, when Michelangelo was an old man. Condivi's biography is often correctly said to be in essence a form of "autobiography," dictated to Condivi by Michelangelo but recorded in a rather crude fashion by his humble disciple. Inadequate attention has been paid, however, to the artifice of this biography, which is informed by Michelangelo's sense of his own symbolic identity. Vasari's life of Michelangelo, in both versions, also contains a great deal of Michelangelo's autobiography. Condivi reported what Michelangelo told him; so did Vasari. Although it is often difficult, if not impossible, to ascertain what comes exactly from Michelangelo and what is the literary invention of Vasari, it is nevertheless my contention that in both Vasari's and Condivi's biographies we discover Michelangelo's autobiography. In other words, Michelangelo's autobiography exists, and it is the purpose of this essay to approach this autobiography within the galaxy of texts and images that surround Michelangelo.

Art historians are forever claiming to have rediscovered lost master-pieces by great artists, and in this spirit I claim therefore to have rediscovered Michelangelo's "autobiography," which for centuries has lain under the collective nose of all those who have contemplated his work and pondered the magnitude of his achievement. I am not speaking merely of the autobiographical impulses of his art, which have so often been discussed, but of the coherent autobiography, which can be extracted from a reading of his biographies in relation to his poetry. We can discern this autobiography in his biographies as he discerned the effigies of the *Slaves* in the unfinished blocks of Carrara marble. It is a highly developed, allegorical autobiography, rich in symbolic intentions, of which only aspects have previously been surmised.

It has often been said that Michelangelo portrayed himself in the subjects of his work or that he expressed himself through these subjects. He assumed the identities of the subject of the works he made both during the course of his life and retrospectively in his last years. Doing so, Michelangelo gave shape both to himself as a symbolic work of art and to his no less symbolic autobiography. No artist before Michelangelo thought so self-consciously about his own image as he did. No artist before him was so autobiographical in his art as he was—although the seeds for his creation of himself, of his own life, were sown by Dante. Like Dante, who wrote about himself in his *Vita Nuova* and *Comedy,* Michelangelo self-consciously formed himself in a still highly confessional mode. But, in molding himself, Michelangelo also gave form in many ways to the modern artist. When we speak today of Picasso as an "autobiographical" and "confessional" artist, we are talking about the type of artist essentially invented by Michelangelo in response to the example of Dante.

Whereas many studies have been written about the "influences" upon Michelangelo and his work, I will concentrate instead on how Michelangelo imitated his sources in his very person. I use the word "imitation" in the sense of becoming what one imitates, referring to the manner in which Michelangelo fashioned himself into a Socrates or Dante, to the way in which he gave shape to his autobiography by conceiving his life as an imitation of theirs. To pursue Michelangelo's "imitatio Dantis" is to do more than see him paraphrase a line of Dante's or illustrate an image of Dante's in one of his paintings; it is to recognize dantesque significance, previously ignored, in his very person. We will discover, to cite but a single case here, how Michelan-

gelo, imitating Dante in a deep sense, molded himself into a new Virgil. Although he saw himself as such, as did his friends, art historians have ignored this central part of his persona, even as they have ignored other aspects of his richly symbolic identity.

Michelangelo charged his own life and person not only with literary and religious significance but with political and military meaning as well. His creation of himself, I suggest, is closely related to Machiavelli's formation of a perfect prince. It is no accident that the legends of Machiavelli and Michelangelo are in certain essential ways so similar in character. It is often said that the legend of Michelangelo distorts the historical reality, that it is imposed on the truth. My purpose here is to show, on the contrary, that there is no separation between "myth" and "reality"—to show that Michelangelo created his own myth, which is central to his reality. Many of the fictions in the writings of his biographers and of those who wrote about him later are metaphorical exaggerations of the ways in which Michelangelo saw and thus formed himself. Michelangelo is, far more than has been recognized, responsible for his own myth.

If my subject is primarily Michelangelo, this essay is secondarily about his Boswell, Giorgio Vasari, whose *Lives* is one of the great works of Renaissance literature. Although recognized as a classic, Vasari's book is far richer than has been previously supposed, and I hope that what follows will help the reader to see that this is so. I also hope that what I have to say about Michelangelo's responses to Dante will be of interest to those who read and study Dante, since Michelangelo remains one of the poet's greatest and most creative interpreters.

I have written this book not merely for those who concern themselves with Renaissance art and literature, but for all those who have ever looked at or pondered Michelangelo's work and have contemplated the mysteries of his accomplishment. Although all the facts recorded here have already been established and much discussed, an investigation of these facts in relation to Michelangelo's grandiose self-creation sheds new light, I believe, on his imagination and fictive powers. Absorbing as Michelangelo has always been, he is even more fascinating than we have realized. The heart of this fascination lies in his powers of self-imagination—the central subject of this book. His imagination was so bold that not even his nose lay beyond its powers.

Rather than repeat here the same footnotes replicated over and over and over again in the vast modern scholarship on Michelangelo,

which would be otiose, I have provided the reader with a bibliographical essay and a selected bibliography of my essential sources, both primary and secondary. Virtually all the standard interpretations or facts considered below are systematically reviewed in the writings of Barocchi, De Tolnay, and Summers, to name just a few of Michelangelo's distinguished systematic scholars in recent years. I have not glutted the text with page references to Vasari and Condivi. Too often such quotations are read out of context. I hope instead to encourage those wishing to turn back to these important biographies to read them through in their entirety, reflecting on the patterns, symbolic and allegorical, that inform them—patterns that betray Michelangelo's own self-image.

This book is the distillation of more than twenty-five years of reflection and writing on Michelangelo. I began with a study of his influences on his disciple Daniele da Volterra, continued with an essay on Michelangelo's sense of humor (in the larger context of wit and humor in Renaissance art), and pursued Michelangelo even further in a recent investigation of Walter Pater, whose approach to Michelangelo is, in many ways, the *point d'appui* for this essay. Along the way, I had the good fortune to study with two distinguished scholars of Michelangelo, James Ackerman and Sydney Freedberg, and to work with Frederick Hartt and David Summers, who have contributed much to our understanding of Michelangelo. I have also profited from the photography and observations of Ralph Lieberman, especially during two stays in the last decade at that paradise where sense merges with spirit and they become one, perhaps the one place left on our planet where the massy earth and spherèd skies are not riven, known as I Tatti. My approach to Michelangelo is different from those of these distinguished scholars in many ways, but my own understanding would be rather different from what it is without their work. Scholars of Michelangelo will recognize what is new in the following pages, and they will equally recognize my profound indebtedness to those listed in the bibliography below. In addition, I have profited along the way from specific observations and suggestions of Bernadine Barnes, Jenny Clay, Larry Goedde, Bill Kent, Norman Land, Tom Platts-Mills, Tom Roche, Pat Rubin, Bill Wallace, and Paul Watson.

Finally and most emphatically, I should acknowledge my greatest debts—first, to David Summers, whose book on Michelangelo is a key foundation for my own essay, and second, to Cecil Lang, whose

countless suggestions concerning matters of both style and content inform the following pages. My wife, Ruth, and children, Deborah and Daniel, sustained me throughout the preparation of this book with their properly shandean spirit. It is only fitting therefore that I dedicate this nasal apostrophe to them.

MICHELANGELO'S NOSE

A MYTH AND ITS MAKER

Prelude: Pico, Prometheus, and Proteus

In his oration *On the Dignity of Man*, the neoplatonic theologian Pico della Mirandola spoke of man's capacity, through the agency of free will, to form himself into an angelic being. Writing in the 1480s, when Michelangelo was little more than ten years old, Pico, student to the physician Marsilio Ficino, wrote out what one might call a prescription for Michelangelo's future life. Pico spoke of man as the "plastes" and "fictor," the sculptor of the self, exalting his capacity to "form" or transform himself into a perfect being. The type of such metamorphosis, according to Pico, was Prometheus Plasticator, the Greek demigod who made man out of clay, into whom Athena breathed life. The image of Prometheus was, however, ambiguous. If he was an artist or inventor, he was also a thief, who stole fire from the gods—for which he was punished, some say throughout eternity, having his liver eaten out by an eagle. Man, Pico asserted, had the potential for good and evil.

For Michelangelo life would become a colossal, promethean struggle within himself, between the soul's reason of his higher nature (to speak in Pico's language) and the brutishness of his lower nature. The image of Michelangelo we have today is largely the result of the form Michelangelo gave to this conflict—this "psychomachia" or battle between the virtue and vice within his own soul. He gave form to this titanic struggle in his poetry, painting, sculpture, architecture, and in what I will speak of as his "autobiography." He molded himself, as we shall see, into a work of art.

When Pico alludes to Prometheus, he seems almost to have Proteus in mind as well. Pico speaks of man's transformation of himself, his sloughing off of his skin, as part of this metamorphosis. Forever trans-

forming himself—re-forming himself, one might say—Proteus, who takes on many identities, many faces, is also the type of humanity.

Michelangelo molded himself into a protean being of many forms. He made himself into a divinity, prophet, messiah, and saint; into a warrior and monarch; into a poet, philosopher, and theologian. He was "universal" in his art, as his biographer Vasari claimed, but he became universal in a deeper sense. He came to assume the identities, metaphorically, of God the Creator, Moses, David, Jesus, Saint Peter, Saint Paul, Saint Augustine, Saint Francis, and Savonarola; of Homer, Achilles, Phidias, Praxiteles, Apelles, Socrates, Plato, Aristotle, and Virgil; of Dante, Beatrice, Boccaccio, and Petrarch; of caesars, popes, and kings; and finally of the King of Kings, the wrathful God the Judge. Michelangelo molded, shaped, and polished these allegorical aspects of his persona, seeking to unify them within himself. The ideal of their unity within Michelangelo's being depended on the same doctrine of poetical theology employed by Pico in his oration. According to this doctrine, based on the principle of analogy, it was possible to reconcile philosophy and theology, the Hebrew Bible and the New Testament, the pagan and the biblical. Extending this principle through a series of further analogies, Michelangelo, similarly, linked art and politics, art and religion. Like Pico, he sought to make harmony out of potentially discordant elements—a form of "concordia discors." Michelangelo's synthetic creation of himself, his giving form to himself, indeed "symbolic form" as a metaphorical work of art—this self-creation is the subject of the following meditation.

It is as if Michelangelo gradually fashioned himself into the harmonious unity of all the saints, poets, philosophers, and lawgivers in the frescoes painted by his rival Raphael in the Stanza della Segnatura for their common patron, Pope Julius II. Like Pico in his oration, Raphael sees in his *Disputa, Parnassus, School of Athens,* and *Civil and Canon Law* the correspondences between poetry and philosophy, philosophy and law, law and theology, theology and poetry. When Raphael paints Dante, for example, he presents him as both theologian and poet, associating him as well with law and philosophy. We recall Boccaccio's assertion in his biography of Dante that Dante was poet, theologian, and philosopher. Assuming the identities of Raphael's heroes—of Dante, Socrates, David, and Saint Paul, for example—Michelangelo compounds their identities into the uni-

verse of his own being. In the language of traditional philosophy, he contains the universal category of humanity within his own self or individuality. Taking into himself various heroes, powerful, holy, and wise, becoming all of them in their own merged identity, Michelangelo molds himself into a colossus.

We call this giant "Michelangelo," who is a work of art, a fiction. This fiction cannot be seen, however, apart from the "real" Michelangelo because, as I have said, this fictitious "Michelangelo" is the creation of the "real" Michelangelo. The gigantic "Michelangelo" created over a lifetime by Michelangelo the artist does not exist as a single entity. The work of art "Michelangelo" is a metaphysical work in the sense that it exists beyond the physical boundaries of any single image or text. Like a painting or sculpture, it is apparently harmonious and unified. There are of course powerful tensions within "Michelangelo" (as there are in Michelangelo's *Slaves* or *Ignudi*)— conflicts between art and religion, between religion and political identity. Michelangelo compounds himself into "Michelangelo" out of various comparisons or "paragoni" between theology, poetry, philosophy, and law, but we should recall that the word "paragone" has at its root "agon," which means contest (as in "antagonism"). The fascination of "Michelangelo" lies in the conflict between Michelangelo's aspiration toward such concordance and the agonistic discordance of those elements of the self that are not always harmonized.

Molding himself into a work of art rich in symbolic meaning and colossal in proportions, Michelangelo exploited the most seemingly insignificant incidents from his life, the smallest details of his person. He scarcely looked beyond his own nose without finding material essential to the perfection of his self. In the same way that a Renaissance portrait painter would idealize his sitter by refining and reshaping the features of his or her face—reducing the flabbiness of the cheeks, smoothing the flesh, eliminating pox marks or moles, refashioning a bumpy nose into the very perfection of nasal form, Michelangelo artistically shaped or reshaped the details of his own anatomy in the service of his self-creation as ideal being. No less important than the lock of Berenice or the O or zero of Giotto, the nose of Michelangelo is a major aspect of his identity not to be overlooked by the serious scholar who would understand the artist in all his complexity, and it is, thus, to this very anatomical detail that we now turn our attention.

In Praise of Noses

Nasum virumque cano. I sing of Michelangelo's nose. Michelangelo's nose, like his very body, was not in fact of colossal scale, but, like the rest of him, it took on truly gigantic proportions in its significance. It became one of the world's greatest noses, a historical nose. How this happened is part of the story of how Michelangelo created himself and hence his own mythology. We cannot, however, fully appreciate the magnitude of Michelangelo's nose without first reflecting on its place in the history of the nose.

Despite academic resistance, the history of the nose, of its forms and meaning, urges itself as a field of legitimate investigation. Only through radical specialization, a minute examination of this part of the anatomy, small in size but universal in symbolic significance, will historical and art-historical scholarship raise itself from the abyss into which it has, with so much controversy and attending loss of direction, sunk in recent years.

It is indeed strange to contemplate the fact that, although historians especially, and not surprisingly, French historians, have written of late about the history of smell, little attention has been paid to the organ of that sense. Window to the world of scent, the nose also regulates the temperature of air flowing into our pulmonary system and, not least of all, filters out, however imperfectly, the dung of the treacherous dust mite. How strange not only that we have no history as such of this organ but that we have no extensive study of its larger role in our cultural life. These brief remarks, an encomium of sorts, are offered here as prolegomenon to the future study of the nose, both historical and art historical—the context for any subsequent and serious investigation of Michelangelo's nose.

When the history of the nose is written, it will begin with the classic snub nose of Socrates, that ancient nose memorialized most philosophically by Aristotle. It will examine such distinguished noses as those of Ovidius Naso and Judah Ha Nasi and include the great nose, a truly prodigious nose, of Michelangelo's mentor, the poet and classicist Angelo Poliziano, compared in the pseudo-aristotelian treatise of Gianbattista della Porta on physiognomy to the very horn of a rhinoceros. Fictitious noses will also be the subject of such a study: for example, the nose of Falstaff, "sharp as a pen" and thus related to the nose of Socrates in the upside-down world of Rabelais, who insisted in

comic inversion that Socrates' nose was not snub but "pointu," or pointed.

This future nasological investigation or, more strictly speaking, rhinological study will catalogue systematically and with considerable rigor the great noses known to us from painting: the grand aquiline apostrophe to the nose by Piero della Francesca, which is the proud focal point in his portrait of the Duke of Urbino, now in the Uffizi, or the nasal metaphors of Arcimboldo's various fantastical portraits, in which flowers, fruits, and seashells aspire to the condition of nasal perfection. Such a history will be informed by the full implications of Pascal's famous utterance: "If the nose of Cleopatra had been shorter, the whole face of the earth would have been changed."

In the modern period, Prignitz, Scroderus, and Paraeus, following Pascal, have made important contributions to our understanding of the nose, all of which should be remembered with gratitude. The culmination of this tradition is found in the classic *De Nasis* of Hafen Slawkenbergius, that great encyclopedic work tragically and mysteriously lost which can still be reconstructed, at least in part, thanks to the dedicated labors of Walter Shandy, whose library was a kind of Alexandrian center of nasal literature. In the nineteenth and twentieth centuries, just as art became increasingly autonomous, severed from the context in which it was made, so too the nose came to be independent of its physical environment. Witness the autonomous nose of Gogol, adapted by Shostakovich in his opera, and the strange nasal creature of Christian Morgenstern's Dada imagination, "das Nāsobem." In our own time an awareness of the significance of the nose is still found in the writing of the lepidopterist, nasologist, and novelist Vladimir Nabokov, whose brief treatise on the nose, though little read or cited by his admirers, is a classic of its kind.

"A great nose," Cyrano rightly observed, "indicates a great man," and, in order to study these great noses, we must define their basic types. The definition of such types is the subject of the science of nasology. Not surprisingly, the scientifically minded contemporary of Michelangelo, Leonardo da Vinci—the father of modern nasology as of much else—defined the essential types of nose in his notebooks. (I will not comment here on the strange absence of discussion of Leonardo's important nasological contribution in the recent Leonardo scholarship, especially that dedicated to his scientific investigations.) These types include the "gobbo," or humped nose, the "cavo," or

sunken nose, those "nasi cavi" so familiar to us all, and the proud, classic "aquilino," or aquiline nose.

There are of course subcategories of nasal classification. In a drawing of an old man by Leonardo now in Windsor Castle, the character of the subject's nose is ambiguous, for one cannot easily ascertain its type. It is somewhat like an aquiline nose, but it is not a true aquiline nose. Its downward slope suggests, however, the idiomatic definition of a related type, the "naso che piscia in bocca," the nose that pisses in the mouth. Perhaps the nose in Leonardo's drawing is a mixed form, a "naso misto"—between the "aquilino" and the "naso col rilievo," another type isolated by Leonardo.

The classification of noses should also be integrated with a study of linguistic usage. In our own language, as in other languages, the nose figures prominently, both in terms of intuition, judgment, and sagacity, as in "to have a nose for something," and, antithetically, in terms of being fooled or duped, as in "led by the nose." Not to be underestimated are the full implications of such idioms as to stick or poke one's nose into something, to have under one's nose, to look down one's nose, to rub someone's nose in something, to thumb one's nose at somebody, to hold one's nose, to pick one's nose, to blow one's nose, to have one's nose to the grindstone, to have one's nose out of joint, to nose around, to brown-nose, to be hard-nosed, to have a nose job, to nose out or win by a nose, to keep one's nose clean, to powder one's nose, to turn up one's nose, to count noses, to cut off one's nose to spite one's face, and to be as plain as the nose on one's face—to cite a few examples.

Not surprisingly, similar turns of phrase exist in Michelangelo's own language: "a lume di naso," "prendere per il naso," "naso in aria," "menare per il naso," "mettere il naso fuori," and "saltare la mosca al naso." The last idiom, which describes a fly jumping on the nose, is very nearly universal. We find it, as Nabokov regretfully observes, in too many bad jokes of nineteenth-century Russian literature; and long ago, in the *Lives*, Vasari claimed that Giotto painted a fly on the nose of a figure by his teacher, Cimabue—perhaps, as Vasari seems to suggest, in the sense of "prendere per il naso" or deceive, since, as Vasari adds, Cimabue tried to brush the fly away.

Despite Nabokov's brief treatise, Steve Martin's brilliant nasal tour de force in the film *Roxanne*, and the invention of the "nose job," there has been a general decline in our own time of interest in the

nose. As a result, the full iconography of the nose is often ignored. This iconography takes into account the deepest meaning of the nose—that implied by the idiom "a nose that pisses in the mouth," by the tragedy of Walter Shandy, who lamented the size of his son's nose, and, one might surmise, by the original meaning of "thumbing one's nose." This is the sense of Erasmus, who said that in domestic situations the nose, like the bellows, excites fire, and the sense of a follower of Erasmus, who said: "the size and jollity of every individual nose, and by which one ranks above another, and bears a higher price, is owing to the cartilaginous and muscular parts of it, into whose ducts and sinuses the blood and animal spirits are impelled and driven by the warmth and force of imagination."

The deep meaning of the nose is central to one of the classics of nasal literature, the now lamentably little read *Nasea* by the Italian humanist Annibale Caro, who is best known for his poetry and comedies and, by some, for his writing on art. Caro was a friend of Michelangelo and the father-in-law of Michelangelo's protégé and biographer Ascanio Condivi. Surveying the great noses in history, he brings us—finally!—closer to our subject when he writes in a letter related to the *Nasea* in praise of Michelangelo's rendering of the nose. "All the poets," says Caro, "sing of it, all the prose authors write of it, all who have told stories have discoursed on it. . . . it is not surprising that the sibyls made prophecies on it, that Apelles painted it, that Polyclitus carved it and that Michelangelo, both painting and carving it, rendered it immortal."

The Tragedy of Michelangelo's Nose

In a certain sense Michelangelo shaped his own nose, that is, the symbolism or symbolic form of his nose, by dwelling on it in conversation in such a way as to encourage his biographers to focus on its full import. Vasari refers no fewer than three times in fact to the key moment in Michelangelo's life, the moment when Torrigiani broke his nose—what we can, not inappropriately, refer to as the tragedy of Michelangelo's nose.

In his account of Torrigiani, Vasari constructs the biography of the artist around this central episode in Michelangelo's life. He tells us that Torrigiani, a sculptor-soldier, was choleric, fierce, hot-blooded, a kind of Florentine Hotspur. Proud and envious of Michelangelo, filled with hatred for this mighty rival, Torrigiani finally punched him in the nose, thus flattening it. This event occurred when both Torrigiani and Michelangelo were in the household of Lorenzo il Magnifico de' Medici, who was so indignant at the news of this atrocity that Torrigiani was forced to flee from Florence for fear of grave reprisal. Vasari dwells on Torrigiani's pride and temper, telling us that, finally, years later, when a patron in Spain refused to pay him enough for a work representing Saint Jerome in contemplation of the Crucifixion, Torrigiani flew into a rage and destroyed the work. For this crime he was thrown into prison, accused by the inquisitor of heresy, and condemned to death. So ended, most fittingly, the life of a man who personified those vices—envy, pride, and rage—that Dante had condemned so forcefully, the life of a man who, we might say, had persecuted the "divine" Michelangelo.

Vasari repeats this story of Michelangelo's nose in full in his biography of Michelangelo, alluding to it also in his summary description of the subject's physical appearance. He again emphasizes Torrigiani's envy of Michelangelo, now claiming that Torrigiani was banished from Florence for his crime. Not only is the story set in the context of Lorenzo's legendary gardens, a paradise of sorts, where young artists were nurtured, but Torrigiani's heinous deed actually occurred in the Brancacci Chapel, where, according to Vasari, Michelangelo and Torrigiani, among other artists, made drawings after Masaccio's frescoes. All of the major artists in Florence, Vasari said in his biography of Masaccio, made copies after Masaccio's work, which became the center of an imaginary academy of art, like the antiquities-filled garden of Lorenzo, which Vasari also imagined to be a kind of academy. These artistic centers were the very type of academy that Vasari established under the sponsorship of Duke Cosimo de' Medici, with Michelangelo as the figurehead in whom, one might say, all the academicians were united. For Vasari an academy was an institution that united artists in their love of art. This ideal of artistic fraternity or friendship throws into bitter relief the antithetical hatred and envy of Michelangelo's persecutor. When Vasari says that the blow Michelangelo received from Torrigiani in the Brancacci

Chapel marked him for life, he also gives us a sense of Michelangelo's own bitter memory.

Michelangelo's feelings about the episode were graphically presented in a few words, in another biography, that of his disciple Ascanio Condivi. After the publication of Vasari's *Lives* in 1550, Condivi published his own account in 1553, in order to correct some basic errors in Vasari's earlier biography of Michelangelo. As art historians have persuasively suggested, Condivi's crude and sometimes garbled biography is a sort of autobiography, which Condivi recorded, however imperfectly, from Michelangelo's dictation. Michelangelo told Condivi that Torrigiani was not only proud but also bestial. He also told Condivi that after his nose was flattened, he was carried home as if dead.

We might pause here long enough to observe that one can retell Michelangelo's tragic tale in the language of noses. Michelangelo looked down his nose at Torrigiani, that is, had his nose in the air, as the Italians say. Torrigiani told Cellini, who reports Torrigiani's accusation in his own autobiography, that he punched Michelangelo because he was provoked by Michelangelo's mockery. From what we know of Michelangelo's nasty sarcasm, Torrigiani's claim is not unlikely, if not probable, and it very likely "corrects" the myth-making accounts of Vasari and Condivi, which stem from Michelangelo himself. Michelangelo's provocative mockery caused a fly to jump on Torrigiani's nose, in the sense of the Italian idiom, which means to inflame with rage or, as we say, put his nose out of joint. Punching Michelangelo in the nose, Torrigiani left him with what the Italians call a "naso gelido," with the cold nose of a corpse, to which Michelangelo could have almost been alluding when he told Condivi that he was carried away after Torrigiani's blow, as if mortally wounded.

Condivi's and Vasari's references to Michelangelo's mortifying wound convey Michelangelo's feelings of humiliation at the hand of Torrigiani, and Annibale Caro addresses the deeper symbolic reason for this sense of humiliation in his *Nasea*. "The nose," Caro writes, "is the seat of majesty and honor in man; in consequence, the bigger one's nose, the greater one's honor. . . . to be without a nose is one of the greatest dishonors that can befall a man. Today Sicilians say that if one loses one's nose, one loses one's honor." Michelangelo did not lose his nose, but, having it flattened, he suffered a loss of honor. He thus suffered the fate of Walter Shandy's son.

In recent years Michelangelo has been the subject of much Freudian speculation, but, strangely enough, the episode of the nose and its deep implications have remained outside the compass of these investigations. Yet, as even Vladimir Nabokov conceded—and no friend was he of Freud and Freud's followers—the nose is a sign of virility. Let us consider: Michelangelo in adolescence had his nose flattened, broken by a male rival, and he burned with rage, the seat of his honor defiled. Imagine the full implications of this event—but no, we must bring down the curtain of discretion and leave discussion of Michelangelo's psychosexual humiliation to the Freudians, as a humble offering to their future endeavors. Before the curtain descends, however, we will vouchsafe them one further clue to the significance of Michelangelo's broken nose; this clue leads us to our next topic: Michelangelo's colossal statue of David.

David's Nose

At the time he carved the giant statue of David (Fig. 1), during the first years of the sixteenth century, Michelangelo wrote on a drawing, "David with his sling and I with my bow." The suggestion of this utterance is that of a simile, in which Michelangelo identified himself with his biblical subject. He was so successful in achieving this heroic identity to the extent that when we envision Michelangelo today, we think of him in terms of a giant, like his huge statue of David, rather than as the man of medium build described by his biographers.

The statue of David is the subject of a curious anecdote told by Vasari. According to this story, Piero Soderini, "gonfaloniere" or mayor of the Florentine Republic, which was symbolized by the powerful *David*, suggested to Michelangelo that the figure's nose was too large. Michelangelo then reascended the scaffolding, pretended to reduce the figure's nose, dropping marble dust slowly in order to give the impression that he was in fact working on the statue. Properly fooled, Soderini praised Michelangelo, saying that now he liked the statue better, that Michelangelo had given it life. Michelangelo, Vasari adds, then laughed to himself. The story is an obvious mockery of critics who think they know whereof they speak when in fact they are deficient in critical judgment.

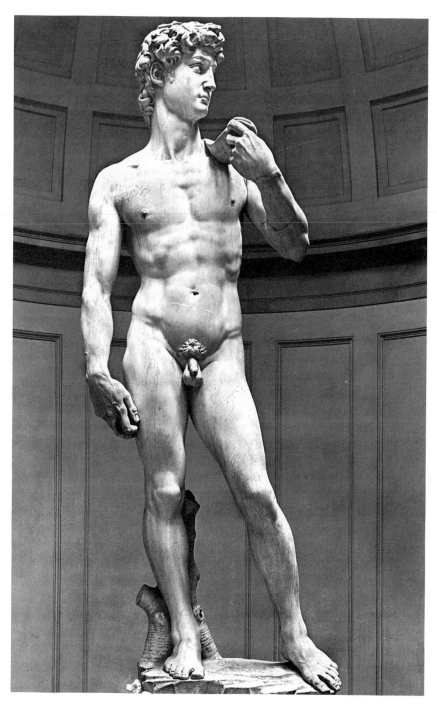

FIG. 1. Michelangelo, *David.* Accademia, Florence

Vasari's tale is highly conventional, reminiscent of a similar anecdote that Vasari presents about Donatello's *Saint Mark* (a statue particularly admired by Michelangelo), which was first criticized by his patrons, who later praised it after Donatello pretended to rework it. In the story of Michelangelo's *David*, the detail of the revised nose has rather more pointed connotations, once again suggesting the idiom "prendere per il naso," to take by the nose or to fool, since Michelangelo, pretending to work on David's nose, thus fooled Soderini, taking him by the nose. The subject of Vasari's story, finally, is Soderini's nose or, in a way, lack of nose. "To have a nose," in Italian "aver naso," means a kind of sagacity (which means keen-scented, from the Latin "sagax"), just as to do something "by the light of the nose," "a lume di naso," is to demonstrate judgment. Soderini, we might say, lacked the nose to judge David's or, ultimately, Michelangelo's nose.

David's nose has another resonance, which brings us to an implication of the statue discussed in the sixteenth century and known to modern scholars but not widely discussed by them—the statue's sexuality. Documents in the Florentine state archives suggest that a gold-leaf garland was commissioned to cover the figure's genitals, or what Michelangelo's rival Pietro Aretino specifically called "the indecency of the colossus." In a more positive way, Vasari points toward the statue's erotic zone when he praises the figure's "very divine flanks." The "fianchi," flanks or hips, enframe that region of the body which is the center of what Aretino refers to as the sculpture's "impudicità" or lewdness.

Given the very issue of the sculpture's decorum, it is particularly striking that when, in Vasari's anecdote, Michelangelo is urged to modify the *David*, it is precisely the nose that he is asked to diminish in size. Could it be, could it just be, that the story was invented not only as a commentary on the artist's superiority of judgment over that of the critic, but as a highly sublimed allusion to the problem of the sculpture's sexual content? Since the nose is, as Caro makes manifest in his learned treatise, a traditional sign of the virile member, the need to diminish the size of David's nose could be seen as a curious analogue of the issue of concealing that part of the body to which the nose alludes.

For some, of course, a nose is a nose is a nose, nothing more, nothing less, whereas for others, predisposed toward allegory, the nose points toward a meaning beyond itself. It will not be my pur-

pose, finally, to adjudicate this scholarly difference, but we might pause to imagine Walter Shandy, that latter-day disciple of Annibale Caro, reading Vasari's biography of Michelangelo without the advantages of either Freud or modern iconographical science: Walter Shandy pondering the nose of Michelangelo's *David*, as a knowing but sad smile plays for a fleeting moment over his sympathetic face.

The Socratic Michelangelo

Michelangelo's nose compels us to test the proposition of the redoubtable Prignitz, who claimed that "the excellency of the nose is in a direct arithmetical proportion to the excellency of the wearer's fancy"—that is, "the fancy begat the nose." In order to test this proposition, we must begin with a brief disquisition on how Michelangelo identified himself with the bearer of one of the "world-historical" noses, Socrates.

Art for Michelangelo was the embodiment of virtue and reason, the reflection of judgment, the distillation of wisdom. Such virtue, reason, judgment, and wisdom were personified for the platonizing Michelangelo by Socrates—the exemplary figure in whose image Michelangelo fashioned himself, encouraging his contemporaries to see and present him as a type of Socrates. Michelangelo told his biographer Condivi that he was like Plato in his pursuit of universal beauty. He also told Condivi that he was like the chaste, aged Socrates who resisted the charms of the beauteous Alcibiades—a particularly suggestive connection, given Michelangelo's ambiguous, sometimes slandered attractions, platonic he insisted, to such younger men as Cavalieri. Like Socrates, accused of impiety in old age, the aged Michelangelo was condemned for the indecency of one of his last paintings, the *Last Judgment*. Like the persecuted, martyred, and tragic philosopher, Michelangelo, as he saw himself, was similarly martyred by his critics, and he defined his own life in terms of tragedy.

Michelangelo's friends and biographers spoke in various ways of his socratic approach to things. He was concerned, Vasari said, with "being" or "truth," not with seeming or mere appearances. When he spoke, he spoke in two senses, thus ironically. When he made a joke, he did it seriously, "con serietà." Projecting a socratic persona, he encour-

aged those who wrote about him in old age to describe him as a wise
socratic type, in dialogues distinctly platonic in form—for example, the
dialogues of his friend the Florentine exile in Rome, Donato Giannotti,
in which Michelangelo is manifestly "savio," or sage. At the end of the
first of Giannotti's two dialogues, which were written in the 1540's,
when Michelangelo was about seventy years old, Michelangelo is espe-
cially like the aged Socrates of the *Phaedo*, discoursing on death, speak-
ing, himself socratically, about how death defines one's own singularity.
The contemplation of death being essential to self-knowledge, it is the
foundation of the socratic philosophy pursued by Michelangelo.

Michelangelo was, according to his biographers, humble; in this
respect he was like the modest Socrates, who professed his own igno-
rance. He associated with humble types—with Andrea Mini, Tolpo-
lino, Menighella, and Indaco, who can be likened to the cobblers,
joiners, and other artisans with whom Socrates associated. Like Socra-
tes, who wore the same clothes in summer and winter, Michelangelo
is said often not to have changed his clothes as a result of a kind of self-
forgetfulness, the reverse side of his extreme self-consciousness,
which we encounter in Socrates' own visionary experiences, as when
he rises out of himself. Michelangelo, as we have observed, aspired,
like Socrates, to universal beauty, but, in contrast to this aspiration to
beauty, Michelangelo, again like Socrates, was ugly in appearance—
or at least this is what he claimed in his poetry, perhaps in order to
embellish his socratic identity.

Michelangelo no doubt gladly learned that, according to Diogenes
Laertius, whose *Lives* of the philosophers were known in Florentine
neoplatonic circles, Socrates was said to be a sculptor, whose statue of
the Graces once adorned the Acropolis. Similarly, in accord with a
classical tradition, Socrates' father was thought to have been a stone-
cutter, and Michelangelo, perhaps seeking to develop his relations to
Socrates further, told Condivi that the wet nurse who suckled him (a
surrogate mother) was married to a stonecutter.

There are numerous other instances of Michelangelo being seen by
his contemporaries in relation to ancient philosophers, to Plato and
Aristotle. It is thus not surprising that years ago an art historian
proposed the hypothesis, now widely followed, that when Raphael
portrayed the philosopher usually identified as the pre-socratic Hera-
clitus in his assemblage of great philosophers known as the *School of
Athens*, he not only rendered Heraclitus in a michelangelesque style

but portrayed him in the very guise of Michelangelo. Perhaps the melancholic philosopher is indeed a portrait of the melancholic Michelangelo, but it is also possible that Heraclitus does not portray Michelangelo, that art historians subscribe to Michelangelo's own myth of his identity with the ancient philosophers, a myth of Michelangelo's own invention, a myth that, following Vasari and Condivi, we now read into Raphael's fresco.

Aesop's Crow

Already in his youth, Michelangelo had learned from the Florentine neoplatonists that death is the ultimate subject of philosophy, the central event being the liberation of the soul from the body, and Pico had led Michelangelo toward the example of Socrates at the point of death, contemplating the final significance of bodily mortality, the immortality of the soul. Now, in the 1540s, as Michelangelo meditated on his last end, he assumed, as we have observed, a properly socratic persona.

The sherlockian critic or historian will not ignore the smallest clue in his or her investigations of the past. Such a clue is found in the first of the two dialogues of Giannotti, when, after being praised by Antonio Petreo, Michelangelo says that unless Donato helps him, he will become Aesop's crow. Michelangelo had learned from Pico that philosophical truth is revealed in ancient fables, and he discovered such truth in the fable of the vain crow who, upon finding the feathers of a peacock, pretended, in his borrowed plumage, to be something other than what he was. Michelangelo modestly adds that if the legitimate owners of the virtues attributed to him by Antonio came to reclaim them, he would be left naked, subject to the mockery of others. He would be like the vain crow who was stripped of his finery by a flock of peacocks. If sadder, the crow became wiser as a result of this disrobing or plucking of feathers.

We will probably never know whether Giannotti's dialogues depend on what Michelangelo in fact said, but, even if Michelangelo's words are fictitious, they are, as the Italians say, well founded. They bring to mind Michelangelo's comment in his highly self-conscious poetry about man making "everyone else's image in his own likeness."

Similarly, in a remark attributed to him by Vasari, Michelangelo said there was a painter who borrowed so heavily from others in making a work that on the day of judgment, when bodies recover their members, there will be nothing left of the painter's work. He meant by this that there was nothing of the painter's self in the painting, warning artists, as Vasari adds, that painters should work by themselves. Invoking Aesop's crow, Giannotti's Michelangelo speaks of being "dressed" or "vestito" in the virtues of others, bringing to mind another remark quoted by Vasari. Seeing a friend of the church dressed in silks, Michelangelo mockingly tells him: "If you were as fine within as I see you to be without, it would be well with you."

Michelangelo's allusion to Aesop's crow also points ahead to the final passage in the dialogue. After Luigi Riccio tries to persuade him to dine with his friends, Michelangelo objects that, if he went with them, they would rob him of himself, that he would thus lose himself. By meditating on death in isolation Michelangelo can, he says, defend himself. He will not allow himself to dress in the virtues of others; nor will he give up parts of himself to others, for he must protect his integrity.

Although the wise, aged Michelangelo presented in a dialogue as parting from his friends evokes Socrates in a general way, the allusion to Aesop is a more pointed reference to the ancient philosopher. Mention of Aesop alludes to Plato's *Phaedo*, where Socrates, in prison a short time before his death, contemplates death and the immortality of the soul. Here Socrates speaks of a recurring dream bidding him to make music and, now, under sentence of death, he writes not only a hymn to Apollo but turns Aesop's fables into verse. It is fitting that Socrates should do so, since he was himself a fabulist, who had used fables—for example, the myth of Er—to reveal philosophical truth.

Michelangelo's reference to Aesop in Giannotti's dialogue is like that of Socrates. It is a rather precise way in which Giannotti links the poetical and philosophical artist with the ancient philosopher. When, after the allusion to Aesop, Giannotti himself says to Michelangelo that in their own day there is no greater poet than Michelangelo, he unites poetry with philosophy, since Socrates had used poetry to reveal philosophical truth. The ancients, according to Pico, covered the mysteries of philosophical doctrine with poetic garment, in the wrappings of fable; so too did the platonizing poet Michelangelo. Like Socrates, Michelangelo dug out the meaning of secret philosophy from the hiding places in fables. Turning to Aesop, he followed the

example of Socrates, practicing what Pico called "poetical theology." Aesop's crow evoked for the socratic Michelangelo Socrates' adage: "Know thyself." Socrates was apparently modest about his own limits as poet, saying he lacked invention. Michelangelo responded in a similarly humble manner to Giannotti's praise of him as a poet. Knowing full well, however, that he was a great poet, Michelangelo was no less socratically ironic than Socrates himself.

Vestments and Virtue

Although Socrates in the *Symposium* put on fine clothes to suit the occasion, he was remembered in antiquity by Diogenes Laertius, as by Aristophanes, for his humble dress, shoeless and without a proper coat. This lack of concern with his dress or vestments is the analogue of his physical deformity, another form of antithesis to his inner virtue.

Michelangelo's own concern with virtue over vestments—reflected in his rejection of the "dress" of praise from others or in his forgetting to change his clothes while working—belongs to this very tradition. Sometimes this socratic contrast is refashioned in Christian terms. Hence, when Michelangelo rejects the pope's idea of adorning figures in the Sistine ceiling with gold, he insists, upholding the Christian ideal of "povertas," that holy men long ago did not "wear" gold, because they despised riches.

Like Michelangelo, mocking the false appearances of fancy dress, Vasari ridicules the pompous finery of Sodoma and Alfonso Ferrarese. He also insists that humble dress is not to be equated with lack of virtue. When Vasari's friend Cristofano Gherardi is chastised by Duke Cosimo de' Medici for his careless dress, he rebukes the duke: "let your Excellency look at what I paint and not at my manner of dressing."

This anecdote has roots in those stories told in the fourteenth century by Boccaccio and Sacchetti, which were revived and revised by Vasari. In one such tale, the boccaccesque Buffalmacco was so indifferent to his dress that the nuns for whom he worked thought he was a "garzone" or helper, not the master, and they protested to the abbess. Buffalmacco then concocted a mannequin out of a water jug adorned with pontifical attire, which fooled the nuns, who now thought the master himself was at work. In the end, Buffalmacco had the last

laugh—of course—telling the nuns that "one must always judge the work not the artist's dress."

Such stories in Vasari and elsewhere in Tuscan "novelle" are related to Boccaccio's story about the unkempt Giotto, dressed in an old peasant cap. For Boccaccio, as we will see, the ugly, shabbily dressed Giotto was a socratic type, and he was no less so for Vasari and Michelangelo, who were forever making the Christianized socratic distinction between outer dress and inner virtue.

The Groves of Academe

As a boy Michelangelo not only learned about the philosophy of Plato and Socrates, but he participated in a truly neoplatonic world, re-created by his Medici patrons. We recall that at the time of the tragedy of his nose—circa 1490, when he was about fifteen years old—he was brought to the Medici household. Lorenzo de' Medici, who wished to bring honor to himself and to his city, formed what Vasari called a school of art, inviting Michelangelo, Torrigiani, and others to his gardens where they studied the antiquities gathered by their new patron. Lorenzo treated Michelangelo, the story goes, as one of his own sons, gave him a room, and brought him to table where he ate with Lorenzo's own children.

Lorenzo, we should recall, presided over a kind of modern platonic academy, in which Marsilio Ficino made translations of Plato and Plotinus, in which Pico della Mirandola, Cristoforo Landino, and Lorenzo himself celebrated the cult of Plato, whose bust was covered with laurel, whose birthday and death day were celebrated, whose *Symposium* was honored, when, after a banquet, it was delivered over for discussion. At Lorenzo's palace in the via Larga, or Broadway, as Henry James called it, Michelangelo, sitting at table with the Medici in a most convivial setting (as he sought to imagine in ideal-ized, platonizing memories recorded by his biographers), belonged to a world evocative of Plato's *Symposium*—that dialogue recalled by Michelangelo when he later told Condivi that he was like Plato himself in his quest for beauty.

So much has been made, and rightly so, of the way in which Vasari saw Lorenzo's school, real or fictitious, as the type of his own acad-

emy, that insufficient attention has been paid to the way in which Michelangelo himself saw this school—as the very academy of Plato reinvented by the Medici. The Medici gardens were the neoclassical or neoplatonic groves of academe where, surrounded by antiquities, poets, and philosophers, Michelangelo aspired toward the Beautiful defined by the neoplatonizing writers who now inspired him. With poetic license but without great historic distortion, we can imagine Michelangelo—as he later encouraged romantic historians to do through what he suggested to his biographers—seated at table between Ficino and Poliziano, with the music of Plato sounding in his ears, lost in contemplation. Michelangelo later told his biographers that the very first work he made in these Medicean groves of academe was a copy after an ancient, laughing old faun. An imitation of a laughing old faun? And to whom, dear reader, in this world permeated in memory and imagination by Plato's *Symposium*, might this faun most appropriately allude?

A Socratic Satyr

The story of this first work in the Medici gardens, of this laughing old faun, does not appear in the first edition of Vasari's *Lives*. Michelangelo mentioned it to Condivi, and Vasari adapted and revised Condivi's account in his subsequent, expanded biography of Michelangelo. Being somewhat dim of wit, Condivi did not fathom what the aged, bearded, and ironic Michelangelo intended when he said that his first sculpture was of a bearded, laughing old faun. Vasari fathomed it, however, emphasizing the ugliness of the faun's face, which, he said, was wrinkled, or "grinzo." Looking at a portrait engraving of Michelangelo from 1545, attributed to Giulio Bonasone, we see a bearded old man whose face is very wrinkled indeed. Vasari is even more pointed, making more explicit what Michelangelo had suggested to Condivi when he adds that the faun had a broken nose, was "guasta nel naso."

The ugly faun, broken-nosed and wrinkled in the face, brings us back to the *Symposium*, which Michelangelo evoked both in his remarks to Condivi, implying that he was like Socrates in his pursuit of beauty, and in his memories, recorded by Vasari, of a youth spent in

the *Symposium*-like setting of the Medici gardens. Identifying himself through his physical deformity with the very faun he claimed to have made, he was alluding to Alcibiades' portrayal in the *Symposium* of Socrates as a type of Marsyas, silene, or satyr. Silenes were statuettes, ugly and ridiculous on the outside, according to Plato's Alcibiades, but filled with images of the gods within. Michelangelo saw himself as ugly: "I know I am ugly" ("son di essere brutto"), he said in one of his poems. His broken nose thus contributed to a physical deformity, which made him like a socratic silene, since he was ugly on the outside and divine, or "divino," as his contemporaries so often said, within. Telling Condivi of the faun, he was re-creating the socratic silene in his own image, creating himself as socratic silene, in a work most appropriately made for a platonizing patron.

Developing an image of himself, a socratic persona or mask, if you will, Michelangelo recalled the teachings of Pico, who said, ironically, that the philosopher's style should be that of Alcibiades' Silenus, that is, socratic—not eloquent in speech itself, but only within, in the heart. The image of the silene thus embodies the very paradoxical character of Socrates and Michelangelo both. It is emblematic of the paradoxical socratic character of Michelangelo noted by his contemporaries, to which I have already referred. We can use the language of his friends and biographers in their dialogues and biographies of Michelangelo to describe the faun. The sylvan creature is both a "scherzo" (and here we should recall that Michelangelo's faun is a laughing faun) and is made in seriousness, "con serietà." Like Michelangelo's ironic speech, it has two senses that epitomize the platonic duality between appearance and reality or being, the very dualism that Michelangelo is himself forever dwelling upon in his poetry when he speaks of how he appears outside or "fuori" and what he would be within or "dentro." What we find within, in the very invention of the faun, is Michelangelo's creative genius or "ingenium," and his powerful imagination or "fantasia."

Michelangelo as Grotesque

Michelangelo's socratic faun of wrinkled skin and broken nose is a supreme manifestation of his concept of the grotesque. The term

"grotesque," derived from the Italian "grotta" or cave, came to designate those decorations found underground in the remains of Roman architecture, notably in Nero's Golden House. Like his teacher Ghirlandaio and his rival Raphael, Michelangelo turned to the example of these decorations, thinking of their strange mixtures of forms and combinations of animals and plants, worthy of praise because they depended on imagination. Although outwardly monstrous, they were inwardly exalted, like the socratic silene itself. The idea of the grotesque was central not only to Michelangelo's theory of art but also to his very identity—for Michelangelo begat and made himself into a grotesque!

To examine Michelangelo's transformation of himself into a grotesque is to identify a central nexus of psychology and philosophy woven throughout his work. Michelangelo's poetry is permeated by this grotesque self-image. In his famous poem in which he describes the torments of his work on the Sistine ceiling, he catalogues the deformities of his body as he works. His face covered with paint, his skin stretched, his head bent so far backward that it touches his neck, he grows the breast of a harpy. The poem wrings out, it expresses, the paradoxical contrast between his own suffering and deformity and the sheer exaltation and transcendence of his work, which he ironically calls "dead painting."

Such a grotesque image of himself recurs in even greater detail in a poem from his last years, in the "terza rima" stanzas written about the time that he described to Condivi the faun for Lorenzo de' Medici. Not only the form of the poetry but the dark world it evokes stems from Dante's *Inferno*. The catalogue of horrors and torments he describes—the stench from the dung of giants and from urine, the buzzing, noises, and intrusions of hornet, spider, and cricket— all make of the world of the poem he inhabits an inferno, in which he is locked, like a genie in a bottle, as he says, as if in a somber tomb. Imprisoned in his very body, all of his senses, not least that which he experiences through his legendary nose, contribute to his punishment. The poem is comic, a "scherzo" of grotesque images, but it is also earnest, a repository of the kind of despair and anguish we associate with his serious work. When he says that his soul is plucked and shaved of its feathers, he makes mockery of the platonizing aspiration of soaring heavenward found so often in his other poetical works. Like his faun, he is in this poem both old and ugly,

for, as he says, perfecting himself as a silene, his face "causes fright." He is, he also writes, broken, cracked, and split. When he alludes to his loose teeth, we recall that Lorenzo had with good humor objected to the faun Michelangelo originally had presented to him, since it had all its teeth, which was unexpected in an aged faun. Michelangelo, as he told Condivi, then knocked out one of these teeth, giving the faun an appearance more appropriate to its age and, we might say, making it more like the loose-toothed silenic self of Michelangelo's poetry.

This tendency toward the grotesque abounds as well in Michelangelo's visual work—for example, in the drawing, now in Windsor Castle, of a children's bacchanal made for Tommaso Cavalieri. An evocation of Dionysian sacrifice, Michelangelo's composition makes self-parodic reference to the Sistine ceiling frescoes, and in this respect is closely related to his self-mocking poetry. The dark, if not bitter, comedy of the drawing is seen in the activities of the putti— some drinking, one pissing, another wearing a comic mask. At the bottom of the drawing somnolent figures evoke a world of dream and hence of fantasy, a world in which Michelangelo transforms himself by reworking the heroic imagery of the ceiling into a dark, grotesque realm in which, allegorically, he is entombed. Rendered in what we might call a silenesque style, the drawing is a kind of riddle or "mystery" filled with allusive, evasive forms. Such an image, not inconceivably a highly personal, neoplatonic allegory on the senses, as it has been suggested, brings to mind Pietro Aretino's observation in Lodovico Dolce's *L'Aretino* that Michelangelo was like the great philosophers who hide the greatest mysteries of philosophy under the veil of poetry. Surely a "poesia," the *Children's Bacchanal* is at bottom a socratic work.

A more overtly comic example of michelangelesque grotesque comes down to us in a story told by Vasari about a painting made by Michelangelo's somewhat simple but devoted and sympathetic protégé Giuliano Bugiardini. According to the tale, Bugiardini painted a Pietà, illustrating a figure of Night on the tabernacle of the panel, appropriate to this dark and tragic event. He employed Michelangelo's *Night* from the Medici Chapel as his model, but since this statue had only one attribute, an owl, he added a lantern, bats, pillows, nightcaps, and a candlestick—to make his point—in a veritable brueghelian, rabelaisian, or dare one say, michelangelesque cata-

logue. Michelangelo, when he saw this parody of his *Night*, nearly unhinged his jaw from laughter, or so the story goes.

This grotesque is a fantasy, the fantasy of dream imagery, suggested by the sleeping *Night*. It is as if Bugiardini pictured *Night*'s dream. Did the slightly obtuse Bugiardini really make such a painting? Or did the cunning Vasari make up this story, just as he pretended that Leonardo confected a *Medusa* out of lizards, serpents, and such? Or did Michelangelo, who assumed the identity of his own *Night* in his poetry, make up this little tale and tell it to Vasari? We can not answer these questions here, but if it is a fiction, as we might suspect, we can say that in some sense Bugiardini's painting is derived from Michelangelo's poetry, in which Michelangelo associates sleep and fantasy, fantasy and the grotesque—the grotesque into which he transformed himself. Bugiardini's parody of Michelangelo's *Night* is indeed close to the strange grotesque world of the self in Michelangelo's poetry, especially the stanzas in which at night a spider weaves a web in one of Michelangelo's ears, while a cricket buzzes in his other. One way or another the sly Michelangelo impends over "Bugiardini's *Night*."

A Socratic Portrait of Michelangelo

There is another good story about Bugiardini in Vasari closely related to the episode of the *Night*. Once upon a time, when Bugiardini painted Michelangelo's portrait, Michelangelo exclaimed, "what have you done, you've painted my eye up in my temple." Bugiardini in turn protested to Michelangelo that the painting was perfectly fine, that the defect was that of his face. Recognizing Bugiardini's lack of artistic judgment, Michelangelo sneeringly and ironically agreed with him, finally, although when he spoke of the "defect of nature," he meant the defect of Bugiardini's art—a point lost on the simple portraitist. Whether the story, which plays on Michelangelo's physical deformity, is ultimately of his own invention or was made up by Vasari, what is important in it is the play between truth and appearance.

The tale of the portrait echoes a platonizing remark of Michelangelo's recorded elsewhere in Vasari's biography of Bugiardini. Michel-

angelo said, according to Vasari, that Bugiardini was blessed because he was contented with what he knew, whereas of himself quite the opposite was true. Socrates' ironic profession of his own ignorance has rarely been more eloquently evoked.

Boccaccio's Socratic Artist

Vasari's suggestions of Michelangelo's socratic identity are part of a broader socratic typology of the artist in the *Lives*—a typology that has its surface roots in Boccaccio. Consider Vasari's portrayal of Brunelleschi, who, in his "terribilità," is a fifteenth-century Michelangelo. Like Michelangelo, Brunelleschi is persecuted and mocked by his rivals. This mockery recalls the martyrdom of Socrates, and Vasari makes this association explicit by telling us that Brunelleschi knew himself, that he said that one must know one's self—echoing the oracular wisdom of the ancient philosopher. In appearance, Brunelleschi, who was witty and ironic, was himself a socratic silene, for beneath his ugliness lay the virtue of his genius. In this respect, Vasari says, he was like Forese da Rabatta and Giotto. (The reference here is to the fifth "novella" from the sixth day of the *Decameron*.)

Both Forese and Giotto are men of virtue who are outwardly ugly. Forese's face is flat and pushed in like that of a dog, reminding us of Socrates' famous snub nose. Like Socrates, both Forese and Giotto, men of "ingegno," are witty and ironic. When he is mocked by Forese for his disheveled appearance after they are both caught in a rainstorm, Giotto says to his friend, a distinguished jurist, in similar disarray, "Who looking upon you would think you even knew your ABCs." Boccaccio's story is closely related to the legend of Giotto current in the fourteenth century, according to which Giotto produced ugly children in contrast to the beautiful figures he painted. In a variation on a theme, Giotto is socratically silenic, because the ugly children he produces correspond to his own ugliness, just as the beautiful figures he paints reflect his own inner virtue.

Michelangelo and Vasari both inherited this concept of the artist as socratic type. Michelangelo played with the idea in a story he told Vasari about his meeting with the son of the Bolognese painter Francesco Francia. Michelangelo, who held the Bolognesi in contempt,

calling them "solennissimi goffi," most solemn clods, told Francia's son, in insulting words of apparent praise, that his father made "living figures more beautiful than those he painted." The obvious humor of this remark is unexceptional, but its ironic wit escapes notice. Michelangelo is alluding to the classical idea, ultimately neoplatonic in origin, according to which the ugly artist produces ugly children but beautiful figures. In the fourteenth century Giotto, we saw, was the subject of this story, which, merging into legend, is alluded to by Leonardo in his notebooks—in the very period of Michelangelo's encounter with Francia's son. The wit in Michelangelo's quip resides in his inversion of the idea of the ugly artist who socratically produces beautiful figures, since Francia, according to Michelangelo, proceeds unplatonically, producing works less beautiful than his progeny. To Michelangelo Francia is the antithesis or antitype of the ideal socratic artist, who is ugly like Brunelleschi, like Giotto, like Socrates himself.

Perhaps Michelangelo did make this remark to Francia early in the sixteenth century, not long after he left the Medici gardens, or perhaps he later pretended to have said it. In either case, the anecdote of Francia's son has its analogue in a poem by Michelangelo, in which the poet says that the contrast between his own ugly face and the mirror image of his painting makes the painting even more beautiful than it would have seemed. Many of the stories told by Michelangelo and retold by Vasari (even stories invented by Vasari himself) are poetical elaborations of conceits and themes in Michelangelo's poetry. Though in prose, these fictions are themselves "poesie." They are the fruit of Michelangelo's ambition to create himself.

Lorenzo's Satyrs

Although the idea of the artist as socratic silene had an extensive history behind it—dating back to Boccaccio in the modern period and ultimately to Macrobius in antiquity—the importance of the socratic satyr took on new, reinvigorated meaning in the neoplatonic circle of the Medici, in which Michelangelo was nurtured. As a youth, Michelangelo entered the gardens of Lorenzo de' Medici, where he made the statue of the faun. Here, according to Vasari, just inside the door to the gardens in the via de' Ginori, an ancient white marble statue of

Marsyas, restored by Donatello, was put in place by Cosimo de' Medici. Lorenzo, who acquired an even more beautiful Marsyas in red marble, had his statue restored by Verrocchio and placed inside the door as a companion piece to Cosimo's Marsyas. These two satyrs, thought to be the two statues of Marsyas now in the corridor of the Uffizi, are charged with meaning, since Socrates was compared to Marsyas by Plato, whose works were translated and studied under the auspices of Medici patronage. They are also the type of the faun made by Michelangelo for Lorenzo, since Michelangelo made his satyr's head after an ancient sculpture in the Medici gardens.

Suggesting that the two statues of Marsyas were placed just inside the door at the entrance to the gardens, Vasari was likely exploiting the platonic meaning of Marsyas. Both of the Medici statues were sculptures of the satyr tied to the trunk of a tree before being flayed by Apollo. They thus alluded to the musical contest between the god and the satyr. Upon his victory the triumphant god flayed his competitor, entering into his flesh. This myth stands behind the socratic meaning of Marsyas, who although ugly on the outside was divine within. It is hard not to believe that in the platonizing ambience of the Medici household, this connotation of the statues was not appreciated and thus exploited, and surely Vasari had it in mind when he mentioned these works in his biographies of Donatello and Verrocchio. At the very entrance to the Medici gardens, to the neoplatonic groves of academe, these satyrs about to be flayed referred to the divine realm within. This dualism between the inside and outside of the satyrs would have become, either in fact or in Vasari's poetical imagination, an architectural metaphor for the entrance from without into the sacred precincts of the Medici gardens.

Lorenzo as Silene

The pastoral paradise of Lorenzo's gardens alluded to a realm of nymphs and satyrs in the greenland of his poetry, where the myth of Pan and Syrinx was re-created. This myth is evoked in Luca Signorelli's *Kingdom of Pan*, generally thought to have been painted for Lorenzo. Suggestive of the sylvan world of satyrs and woodland deities found in Lorenzo's own poetry, this pictorial "poesia" portrays figures who hold

pipes—the musical instruments fashioned from the very reeds into which Pan's beloved was metamorphosized. Signorelli's painting both nostalgically evokes this lost love and celebrates the origins of music or "poesia," a poetry now nostalgically re-created by Lorenzo himself. The painting of Pan also inspired the young Michelangelo a short time after his stay in the Medici gardens, for he recalled a suave nude musician at the right of Signorelli's picture when he re-created Bacchus in his sculpture of the god of wine.

"Dear Pan, thou and all the gods of this place, oh make me to become beautiful within"—thus Socrates in the *Phaedrus*. Socrates' prayer could just as well have been that of Lorenzo. Lorenzo not only identified with Pan, but he was himself like the socratic satyr or silene Marsyas, who presided over his gardens. His biographer Niccolò Valori says that although his face was dignified, it was deficient in beauty. Lorenzo in fact had a defective nose, a depressed nose, or "naso depresso," through which he could not smell. Despite this physical defect, his face inspired reverence and thus revealed his inner dignity. Given Lorenzo's superintendency over a kind of modern platonic academy, it is hard not to imagine that his biographer, contrasting his physical deformity and dignity, was transforming him into a modern socratic silene or satyr. Lorenzo wrote silenic poetry, for example, a poem in "terza rima" called "Il Simposio" or "The Big Drinkers"—both a parody of Dante, like Michelangelo's later "terza rima" stanzas, and a mockery of Plato's *Symposium*, as his title suggests. In this coarse-grained work, Lorenzo, who elsewhere wrote idealizing neoplatonic poetry, wrote in what Pico spoke of as the style of Alcibiades' silene. Lorenzo's poetry, like his own physical aspect or person, could be socratic.

Vasari made Lorenzo's identification with the socratic satyr explicit in his posthumous portrait of Lorenzo, now in the Uffizi (Fig. 2). In Vasari's portrait, Lorenzo commands our respect, although he is notably ugly and has a "depressed " nose—the kind of nose that Leonardo typed as "cavo" or hollowed out, what we colloquially call a ski-slope nose, like that proudly worn and exploited in our own era by Bob Hope. Behind Lorenzo and to the right of Vasari's portrait is a pitcher, which contains the inscription "VIRTUTUM OMNIUM VAS," the vessel of all virtues. The word "VAS" both plays on Vasari's name and artistic virtue and conspicuously refers to Lorenzo as the vessel of all virtues. He is like those statuettes, the "sileni" described by Plato,

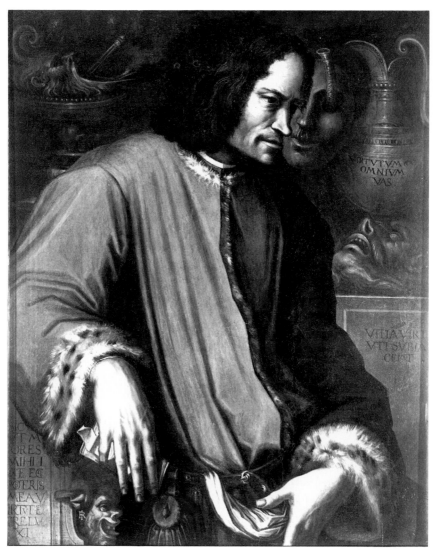

FIG. 2. Giorgio Vasari, *Portrait of Lorenzo de' Medici*. Uffizi, Florence

ugly on the outside but divine within. Vasari alludes to Plato's "sileni," surrounding Lorenzo's face with a series of such silenic grotesques: behind Lorenzo's shoulder an open-mouthed face forms a monstrous lamp; below Lorenzo's hand appears the grotesque "Bugia" or False-hood, biting its tongue; to Lorenzo's right a reclining mask, "Vitio" or Vice, appears with hideous teeth and foreshortened, dilated nostrils; and on the wall above, a mask hangs with a hornlike object passing through one of its eyes. All of these deformed "sileni" enframing the sitter make comment on the ugliness of a man who is nevertheless filled with virtue, who is a socratic "vessel of all virtues."

The Faun as Fiction

When Michelangelo looked back over half a century to his youthful days in Lorenzo's arcadia, in his neoplatonic academy, it was as if he saw in those early days a kind of "golden age," like that idealized in Signorelli's *Kingdom of Pan*. Speaking from this perspective, Vasari in fact calls the period of Lorenzo a "golden age." It is as if Michelan-gelo's biography embraced all of history, as if those early days of the faun, old and antique, were a kind of antiquity in Michelangelo's own lifetime.

The faun that Michelangelo said he made for Lorenzo is a fiction. The analogue of a sculpture, it is an icon of Lorenzo and Michelangelo both, a nostalgic image of Michelangelo's neoplatonic origins. The faun is the emblem of their silenic identity. Its broken nose refers both to that of Michelangelo and that of Lorenzo, metaphorically broken. As his patron, Lorenzo was a substitute father to Michelan-gelo, who remembered his place in Lorenzo's family with romanticiz-ing affection. As the ugly Giotto produced ugly progeny, so Lorenzo, himself physically defective, had an ugly son in Michelangelo. He was Lorenzo's creature or "creato," in a certain sense Lorenzo's creation.

Growing old, Michelangelo finally grew into the image of himself that he embodied in the faun, imbuing his past life or youth with saturations of subsequent experience, saturating the historical past with his own present identity. Some will perhaps regret the idea of thus eliminating the faun from the catalogue raisonné of Michelan-gelo's works—especially those scholars who recently organized an

exhibition in Florence, in which they tried to reconstruct the original appearance of the "lost" faun. What we gain, however, in recognizing that the faun is a fiction, is insight into how Michelangelo, telling Condivi about the faun, participated in the tradition of Boccaccio as a storyteller and thus shaped his own legend. We also learn something about the ingenuity of his Boswell, Vasari, who embellished this myth-making fiction.

The Old Man as Child

The image of the faun depends on Michelangelo's perspective, his thoughts in old age about his youth. He ironically told his biographers that his youthful works, made when he was a "fanciullo" or boy, were better than those he now made in old age, when a "vecchio." He remarked that he now could be accused of being a "vecchio rimbambito," an old man who had regressed into a second childhood.

Such ideas are implicit in the story of the faun. As a youth making the head of an old satyr, Michelangelo is not just a child prodigy, like Giotto before him, but, in accord with a deep literary tradition, a "puer senex," a youthful artist with the wisdom of a mature or old artist. This image is ironic, however, since in fact the faun is an invention of old age, when Michelangelo still had youthful powers of invention, making him, if anything, a "senex iuvenis" in the positive sense antithetical to "vecchio rimbambito." In old age when he invented the faun, Michelangelo aspired to spiritual regeneration or rebirth. Creating the fiction of the boy who made the faun, he in a sense re-created himself. This re-creation, as we will presently see, is not without inner spiritual meaning.

Michelangelo as Marsyas

Michelangelo's image of himself as faun is resonant with allusions in his poetry to his ugliness and hairy pelt. In a poetical analogy, Michelangelo speaks of the "scorza" or skin of the marble he seeks to penetrate in the creation of a sculpture, the completion of which stands metaphorically for his own self-perfection. The penetration of this

skin—this "scorzare" or flaying of the skin—recalls the flaying of Marsyas, a subject he found prominently associated with poetic inspiration at the beginning of Dante's *Paradiso*. In a Christianized neoplatonic conceit, Dante associates Apollo's entering into Marsyas with poetic inspiration, an inspiration now emphatically Christian in character. For Michelangelo, his penetration of the marble depends on his own ugly, cracked, wrinkled, Marsyas-like skin being penetrated by the inspiring beloved, who will bring him closer to perfection and thus to God.

Years ago an art historian suggested that in the flayed skin of Saint Bartholomew of the *Last Judgment* (Fig. 3) Michelangelo portrayed himself. This image, it has been further suggested, is informed by Dante's allegory of Marsyas. In this context, Pietro Aretino's letter to Vittoria Colonna on the *Last Judgment* is invoked. Princes would rather see "Marsyas without skin," Aretino claims, than the sight of the flayed apostle. Art historians now write as a matter of course of the flayed skin of Saint Bartholomew as an allegorical, Marsyas-like self-portrait of Michelangelo, as his prayer for redemption. Through death, according to this interpretation, the outwardness of Michelangelo, his ugliness would be thrown off, and his inward spiritual self resurrected, pure and perfected. This interpretation has taken hold in large measure because of the power of Michelangelo's highly personal poetry, in which his outward sinfulness and ugliness are so pronounced. We, in a sense, read the poetry into the image, just as Michelangelo probably read Dante's Marsyas into Saint Bartholomew. Even if we cannot say categorically that the pelt held up by Saint Bartholomew is indeed Michelangelo's self-portrait, we can see how Michelangelo's image of his own skin, peeled away as part of his quest for perfection, has shaped the imagination of his interpreters or latter-day followers. This dantesque, Marsyas-like self-image and its power to enthrall is part of the context in which we must approach Michelangelo's fiction of the faun—the emblematic image of himself as socratic Marsyas.

The Self as Work of Art

Creating the faun, Michelangelo conceived of himself as a work of art. This way of speaking brings to mind the words of Nietzsche, who, like

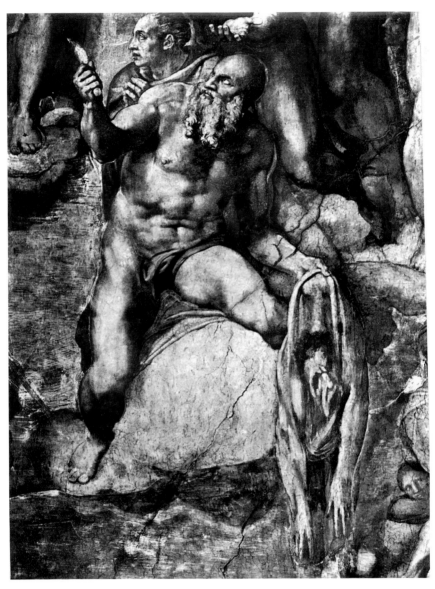

FIG. 3. Michelangelo, *Last Judgment* (detail of Saint Bartholomew), Sistine Chapel. Vatican Palace, Rome

Michelangelo, meditated throughout his life on Socrates: "We derive such dignity as we have from our status as works of art." Nietzsche echoed Hegel, who said in his lectures on aesthetics (and here I am using the translation of Hegel by Walter Pater, another well-known "aesthete" so called): the Greeks are "ideal artists of themselves, cast each in one flawless mould, works of art which stand before us as immortal presentments of the gods."

This manner of speaking in Hegel, Nietzsche, and Pater is not mere aestheticism, for it makes use of the same deep metaphor that Michelangelo inherited from Plato, linking the perfected self with a harmonious work of art. In the *Republic* Socrates compared the process of perfecting the self with the carving or molding of a statue, and this metaphor was later assimilated by the neoplatonist Plotinus, who made it into an inner paradigm. Withdraw within yourself, Plotinus said, and if you do not find yourself beautiful, act as a maker of a statue. Cut away, he tells us, what is excessive and never cease chiseling your statue until you see the perfect goodness.

Plotinus's neoplatonic ideas were absorbed into the early Christian theology of Gregory of Nyssa, who compared the progress of man's soul to the making of a statue. Gregory likened the process of purifying oneself to that of carving and polishing a statue until one achieved similitude with God. Not only Pico della Mirandola's metaphor of man as the sculptor of the self but, more to the point, Michelangelo's poems likening his quest for spiritual perfection with the carving of statues stand in this neoplatonic tradition, to which Hegel, Nietzsche, and Pater later belong. Our perspective on Michelangelo carving himself into a sculpture is thus no mere reflex of nineteenth-century aestheticism, is not misread through the nineteenth century, for the very metaphor of the perfected self as an idealized sculpture is rooted in a classical idea. In fact, writing of the Greeks as ideal artists of themselves, Hegel and Pater wrote as belated followers of Plato, Plotinus, Pico, and Michelangelo.

It should be clear from the single example of Michelangelo's faun and its context that the myth of Michelangelo is not just something that happened, that Michelangelo both created this myth out of himself and out of his sense of his place in history, that he superintended the development of this legend. Inventing the story of the faun, Michelangelo produced in old age, in a supreme fiction, the youthful image of himself, creating the image of himself as an old man—as an

ugly satyr or socratic type. In other words, as if contemplating himself in a fantastical mirror or on the magic screen of his inner imagination, he reconstituted himself as a youth, creating himself prophetically as he would become in old age. He did this by copying or imitating an ancient sculpture of a bearded old faun, which is an analogue of the ancient philosopher he became, an analogue of those statuettes of "sileni" to which Socrates was compared. The aged Michelangelo made himself as much a part of antiquity, as he revived and surpassed this antiquity.

However much we praise Michelangelo, if we underestimate the high degree of socratic self-consciousness in the faun, we underestimate him as an artist, thinker, and poet. Not seeing the faun for what it really is, accepting it at face value, we miss the form and design of Michelangelo's ironic, socratic art. The faun is not a sculpture as such, but the idea of a sculpture, in platonic terms, a truly paradigmatic idea. It is created in a fable or story that is itself very nearly a platonic parable, pointing toward the apprehension of the ideal Michelangelo, who made himself into the subject of his own platonic mystery—in an allegory that both shrouds and ultimately reveals his poetic invention.

Michelangelo's Supreme Scherzo

The faun or satyr, which alludes to that martyred Marsyas, Socrates, evokes the dark world of suffering and pain of Dionysian sacrifice and tragedy emblematic of Michelangelo's own suffering and "tragedy." But the faun, like the utterances of Socrates and Michelangelo both, is ironic—echoing the laughter of the faun and thus of its maker. The mask of the faun that Michelangelo assumes at the end of his life embodies the words of Socrates at the end of the *Symposium*, that dialogue central to Michelangelo's autobiography and being.

The genius of comedy, Socrates said there, was the same as the genius of tragedy, and the true artist in tragedy was also an artist in comedy. Over and over in his last years Michelangelo spoke in the philosophical aphorisms of bitter jests in his poetry about his suffering and pain, about his martyrdom and imminent death, and to this list of "scherzi" or jests, we must add the aged, laughing faun. Perhaps the

greatest "scherzo" in the entire history of art, this jest, in all its associations, is at once tragic and comic, playful and profound.

Just as Michelangelo carved his giant statue of David out of a damaged block of marble, as it was said, he carved the gigantic image of himself, or the idea of himself, out of his damaged anatomy. He did this by adapting his humbled, deformed nasal cartilage to the grotesque image of his physical ugliness and hence socratic virtue. Contemplating this ugly satyr and all that it intends, this socratic faun with a broken nose that endures in imagination, although it never existed at all in stone, we can only exclaim in the language of Michelangelo's friend Annibale Caro, "O Gran Naso!"—"O Great Nose!"

Montaigne Meets Michelangelo

The story of how Michelangelo created himself as a socratic faun, of how he exploited his deformed nose as part of that ugly but virtuous image, does not end here. On the contrary, it suggests a far more complex idea of how Michelangelo formed himself than we have previously supposed. It further suggests profound historical relations between Michelangelo and other socratic or silenic writers of his age.

Not long after Michelangelo created or re-created himself as socratic satyr, Montaigne presented a portrait of himself, invested with the spirit of Socrates. The ancient philosopher is ever present in the *Essays,* which are a form of inner, imaginary platonic dialogue between Montaigne and himself. Following the example of Socrates, Montaigne seeks to write of his very essence. For Montaigne, Socrates "alone chewed to the core of that precept of his god, 'Know thyself.' "

In the spirit of Socrates, Montaigne compares his writings to the grotesques of a painter. His writings are "grotesques and monstrous bodies," he says, "pieced together of diverse members, without definite shape." They are like the lovely woman who tapers off into a fish in Horace. Like Michelangelo, who reinterpreted the horatian grotesque as a celebration of fantasy, Montaigne, who said that he was "consubstantial" with his writing, thus sees his very self as grotesque. Those passages in which Montaigne investigates the frailties of his body, his own foibles, habits, and appetites, are inspirited by the kind

of socratic self-consciousness that we find in Michelangelo's monstrous portrayal of his own deformed, grotesque self.

In 1580—approximately a decade after the early essays and more than a decade after Michelangelo's death—Montaigne traveled to Italy, where he encountered the ghost of Michelangelo. Visiting the Medici gardens at Pratolino, outside Florence, he beheld the giant michelangelesque statue of the Apennines, "Appennino" by Giovanni da Bologna. This monster is filled with "ingenium" or artistic "virtù"— exhibited in the fantastical waterworks and grotesques within. Influenced by Michelangelo, it is an extension of the michelangelesque grotesque. Its ancestors are those giants imagined in his poetry, letters, and conversations with his biographers: the snowman made for Piero de' Medici; the mountain at Carrara, which Michelangelo dreamed of transforming into a giant; the mock giant he proposed to erect behind the Medici palace; the poetical giant of hairy pelt—not to mention the giants who left dung at Michelangelo's doorsteps. Beholding Giovanni da Bologna's michelangelesque colossus, Montaigne thus experienced the imagination of Michelangelo. Delighting in this realm of fantasy, he shared in Michelangelo's own pleasure in the strange, the bizarre, and the grotesque.

Rabelais's Giants and Erasmus's Folly

Contemplating the michelangelesque monster at Pratolino, Montaigne would surely have recalled the giants of Rabelais, as indeed he had them in mind when he wrote his *Essays*. When he compared his essays and thus himself to the grotesques of painters, he echoed the prologue to *Gargantua*, where Rabelais linked his work to the paintings on the outside of the shops of apothecaries: "gay, comical figures as harpies, satyrs, bridled geese, horned hares, saddled ducks, flying goats, stags in harness, and other devices of that sort, light-heartedly invented for the purpose of mirth." If these fantasies recall the marginal drolleries of Northern illuminated manuscripts, they are also evocative of classical grotesques, resembling those strange inventions at the heart of Michelangelo's concept of fantasy.

Rabelais compares these grotesques to Silenus himself, not only pointing toward Montaigne's silenic identity, to the grotesques of his essays, but reminding us of Michelangelo's portrayal of himself as a laughing old faun. Rabelais contrasts the appearance of Socrates, foolish and ugly, bovine of expression, with the divine wisdom within. Beneath the grotesque surface of his book, he says, is a similar socratic virtue and wisdom, and the reader is not to be fooled by mere appearance. In words nearly identical to those employed by Michelangelo, Rabelais warns his readers that "the habit does not make the monk."

The socratic persona that Rabelais assumes depends, as it has often been remarked, on the image of Folly in Erasmus's *Praise of Folly*. Erasmus's ironical, highly paradoxical work celebrates Alcibiades' Socrates—ugly without, beautiful within, foolish on the surface, wise inside, indeed divine. Composed in 1509, Erasmus's mock-encomium dates from the very period of the Sistine ceiling, when Michelangelo was mocking his own serious efforts at monumental painting. Erasmus's neoplatonic Folly was nurtured by the writings of Ficino and the Florentine neoplatonists, who similarly inspired Michelangelo. The laughing socratic faun of Michelangelo is thus a first cousin of all those Northern European silenuses of the sixteenth century. To put it differently, Erasmus's Folly, Rabelais's Gargantua, and Montaigne's Grotesque Self, all of these socratic personae, descend from the same stock as the laughing old faun born in the neoplatonic gardens of the Medici.

A New Saint Paul

Michelangelo's conception of himself as socratic silene is strikingly like the spiritual ideal of Erasmus's *Praise of Folly*, because, like Erasmus, he associates the socratic type with Saint Paul. Erasmus compares the saint's folly in Christ with the saintly philosopher's professed ignorance, elaborating on this similitude in his *Adages*, where he dwells evangelically on the fact that Jesus and the apostles, in their simple, outward appearance, are the type of the ugly socratic silene. For Erasmus, as for early Christian writers, Socrates was a saint, like Jesus in his humble demeanor, paradoxically related to Christ in his inward spirituality.

Michelangelo not only created a socratic image of himself, transforming himself into Socrates, he also formed himself as Saint Paul, becoming a new Saint Paul. Doing so, he made of himself a kind of compound being—a pauline Socrates, a socratic Saint Paul. The pauline impulse is articulated in Michelangelo's poetry, especially his last poems, written in old age, when the poet's spiritual aspirations became increasingly fervent. Like Socrates, who speaks of the dualism between appearance and inner being, Paul speaks of the disparity between the "outward" man of the flesh and the "inward" man of the spirit. Echoing both, in a language at once pauline and platonic, Michelangelo dwells on his soul buried in the prison of his body.

FIG. 4. Michelangelo, *Conversion of Saint Paul*, Cappella Paolina. Vatican Palace, Rome

Striving for "rebirth" and spiritual perfection, Michelangelo seeks, in Saint Paul's language, to become a new man, reborn.

As he grows old and dwells on his old age or "vecchiezza," Michelangelo writes in the manner of Paul in the Epistles, "putting off" the "old man" and the "body of sin," "putting on" the new. Like Paul, Michelangelo focuses on the sins of his mortal body, judging himself harshly in pauline terms to be "dead," captive to the law of sin. The words of Paul in Romans become those of the aged tormented artist: "Oh, wretched man that I am! Who shall deliver me from the body of this death?" He cries out in anguish, "My soul uncertain and disquieted finds in itself no cause but some great sin," as he contemplates his two deaths, the death of his body and the judgment of God.

Michelangelo gave nearly tangible, visible form to such sentiments when he depicted the *Conversion of Saint Paul* for Pope Paul III in the Cappella Paolina in the 1540s (Fig. 4). The fresco has generally and justly been said to be expressive of Michelangelo's own turning toward God in these very years—a conversion, fervently rendered in his prayerful poetry. Whereas Saint Paul is traditionally rendered as youthful at the moment of conversion, Michelangelo depicts him as a bearded old man. Even if the image is not an explicit self-portrait, the departure from convention here is indicative of Michelangelo's identification in old age with the saint. The association is, however, even deeper, for it is evocative in the spiritual sense of Saint Paul's preaching on the death of the old man as the prelude to rebirth. In the image of Saint Paul in old age, in which Michelangelo participates, imitating it in the deepest sense, Michelangelo illustrates Paul's putting off the old man, being reborn in the light of Christ. Making the saint's metaphor literal, Michelangelo makes Saint Paul's conversion his own.

Michelangelo as Saint Paul

Michelangelo's friends adorned his identification with Saint Paul nicely. In his dialogues on art Francisco de Hollanda places the discussion of art after frate Ambrogio's sermons on Saint Paul's Epistles. Michelangelo's pious friend Vittoria Colonna remarks teasingly on Michelangelo's discussions of art in relation to the frate's preachings on the spirit, mocking Hollanda, who would prefer to hear Michelan-

gelo rather than such religious preachings. Hollanda protests that when one hears the Epistles of Saint Paul, he prefers to listen to frate Ambrogio; but, even so, the parallel between the frate's sermons and Michelangelo's discourses has been established. The relation is not fortuitous or inappropriate, since it is based on the fact that for Michelangelo art is a spiritual exercise. As Michelangelo says, it is necessary for an artist to live a virtuous life, and more than this, to be a saint, in order for his spirit to be inspired by the Holy Spirit. "Nothing is higher, more religious than painting," he insists, for, as he avows, it "stimulates devotion." "Good painting," he adds, "is nothing else than a copy of the perfection of God."

Vasari develops Michelangelo's spiritual identity further in his biography of Brunelleschi, who, as we saw, is a type of Michelangelo. Foretelling the advent of Michelangelo, the fifteenth-century architect is not only likened to Socrates in his quest for self-knowledge, but his knowledge of theology is so profound, according to Vasari, that he was called "a new Saint Paul." Precisely this compounding of Saint Paul and Socrates in Brunelleschi stands for Michelangelo himself.

Saint Paul had preached that the foolishness of God is wiser than man. When Vasari says that the socratic Brunelleschi was called fool, or "pazzo," that he was persecuted by his rivals before he completed his dome for the cathedral of Florence, he alludes to Socrates' persecution by the Athenians and to Paul's sense of Christ's martyrdom. As Savonarola had preached to the Florentines, Socrates was a Christlike "fool" whose martyrdom by the Athenians foretold that of Jesus, the "folly of the Cross." Brunelleschi's persecution, like that of Socrates, thus foretold the martyrdom of Michelangelo. One of the major themes of Vasari's biography of Michelangelo is that of his persecution by his vicious rivals, especially during his old age when he worked on the dome of Saint Peter's. He was like the socratic and Christlike Brunelleschi, laboring on the dome of the cathedral of Florence, which came to be the type of the heavenly dome envisioned by Michelangelo.

When Michelangelo sent a deeply religious sonnet to Vasari in 1554, he wrote in the accompanying letter that Vasari would call him both "old" and a "fool," "pazzo," for writing such sonnets. Michelangelo surely used the word "pazzo" in the spiritual sense of pauline folly, since the poetry he was writing was deeply spiritual, indeed pauline in its themes. Michelangelo told Condivi, we recall, that he had heard Savonarola's sermons and later read them. He would likely

have been familiar with the identification of Socrates as a type of Christ, defined by Savonarola as foolish in the language of Saint Paul. When Vasari quotes Michelangelo's letter to him in his revised biography, he conflates this letter with another from Michelangelo of the following year, in which Michelangelo alludes to his rivals at Saint Peter's. Vasari then comments on Michelangelo's persecution by his malign rivals. The artist, "old" and "foolish" in his spiritual work, both his poetry and his architecture, is persecuted like Brunelleschi, who is a Christlike Socrates and new Saint Paul.

Vasari embellishes this pauline image of Michelangelo further by using a favorite word of Paul's to describe Michelangelo. The old artist, he says, is notable for his sobriety or "sobrietà." Vasari echoes Paul's repeated stress on this virtue in his preaching: for example, "the aged man [should] be sober-minded, grave, temperate" (Titus 2:2); the ideal bishop "must be blameless, . . . vigilant, sober-minded" (1 Timothy 3:2). Such sobriety is the quintessence of the new Saint Paul.

Moses as Saint Paul

Saint Paul, we shall see presently, also informs Vasari's exegesis of Michelangelo's *Moses* (Fig. 5). Calling the *Moses* "a most terrible prince," Vasari implies the identity of Michelangelo and Moses, since he elsewhere emphasizes that Michelangelo was both princely and "terrible," that is, he inspired terror. When Vasari says that the face of the *Moses* is "so splendid and luminous" that a veil is needed to cover it in order to protect the beholder from its overwhelming light, he refers, as it has been said, to Exodus 34, where Moses comes down from Mount Sinai, his face shining so brightly that the children of Israel are afraid to come near him. The veil needed to protect the beholder of Michelangelo's statue is like the veil that Moses wears when he speaks to Aaron and the children of Israel.

In the Hebrew Bible Moses is the king of the Jews, and although Vasari recognizes this princely image, he develops an allegory in which Michelangelo's *Moses* becomes a saint. Indeed, he speaks of the *Moses* as having "the air of a saint," of his "very saintly face." Such saintliness is made manifest in the perfection of his body. The "perfection" of Moses' body, Vasari says, gives us an idea how the body will

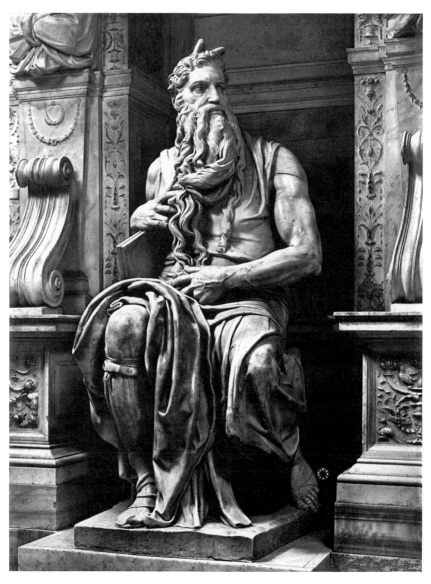

FIG. 5. Michelangelo, *Moses*. San Pietro in Vincoli, Rome

appear after resurrection. The blessed, who are perfect, shall see the face of God, it is said in Revelation, and these words recall those of Saint Paul in 2 Corinthians 3:18: "we [are] all, with unveiled face beholding as in a mirror the glory of the Lord." Now the veil of Exodus, which covered Moses, is "done away with in Christ." Given that Moses is seen by Vasari in the allegorical terms of the New Testament, it is inconceivable that when he speaks of the veil needed to cover the *Moses* that he does not have in mind Paul's rewriting of Exodus as the unveiling of Jesus. This connection is especially likely, since the *Moses*, as he himself observes, was originally paired with a statue of Saint Paul on the tomb of Pope Julius II. The relation of the two statues would have suggested to Vasari the spiritual progress from law to grace and thus to the resurrection of the perfect body: an appropriate subject for a funerary monument.

Vasari's reading of Exodus through Saint Paul is made explicit in his final words on the statue. The Jews, he says, came every Saturday "to visit and adore" the *Moses*, "not as a human presence but as a divinity." This anecdote is usually either ignored or dismissed, but it is clearly an embellishment of Vasari's vision of Moses through Saint Paul. Whereas the Jews did not worship graven images, as Vasari himself remarked elsewhere, they came to behold, and more than behold, indeed adore, the *Moses*, on the Sabbath at that, when they should have been in the synagogue. Through the power of the statue, they turned away from their laws, from the commandments brought to them by Moses himself, and turned toward Christ. By worshipping the *Moses*, the Jews were no longer blinded, for the veil "was done away with" in Christ. Michelangelo had in a sense converted them, and the saintly statue from his divine hands foretold their perfection through Christ.

Although Vasari wrote about a statue conceived in the first years of the century, he was writing from the perspective of Michelangelo in the 1540s in particular, and of his last years in general. When the tomb of Julius was finally erected, at the very time Vasari was writing, the *Moses* became its principal figure, indeed dominating the work. Whatever its original meaning within the context of the patron's tomb, it was now given new significance within the context of its creator's biography. In Vasari's allegory, the statue was read through the spiritual concerns of Michelangelo's last years. As a figure of conversion, interpreted through Saint Paul, the statue came to epito-

mize Michelangelo's own spirituality. It was thus linked to Michelangelo's own fresco of the conversion of Saint Paul, painted at the very time when the *Moses* was put in place on the tomb. The conversion of the Jews by the pauline Moses was seen as parallel to Paul's own conversion and efforts to convert the Hebrews. In Vasari's allegory, the *Moses* stood for both Michelangelo himself and also for his pauline efforts to convert nonbelievers to the faith.

Michelangelo as Pauline Pilgrim

Michelangelo's pauline identity is reflected in one of his most interesting, late works, a medal conceived approximately four years before his death. Mentioned by Vasari, this work, which exists in various versions, has therefore always been known and discussed, usually in passing, but it tells us a great deal about Michelangelo's image of himself. It epitomizes and reinforces our sense of the way in which Michelangelo shaped his own image during his last years. In this respect, the medal is also related to the invention of the faun, which personifies Michelangelo's symbolic identity.

Sometime around 1560 Michelangelo asked his friend Leone Leoni to strike a medal, which was delivered to him about a year or so later, in March 1561. Since it has generally been assumed that Michelangelo was responsible for the invention of the medal, it is rather surprising that the object has never been studied in great depth. We can only assume that this is so because it is not of his own hand. The medal, nevertheless, reveals much about Michelangelo.

On the face of the medal is Michelangelo's portrait in profile (Fig. 20), which I will discuss below. On the reverse side there appears an image of an aged, bearded pilgrim with a dog (Fig. 6). It has sometimes been said that this figure is a portrait of Michelangelo, and it is likened to other images in his art presumed to be his self-portrait, including figures in his *Crucifixion of Saint Peter* in the Cappella Paolina, where he also painted the *Conversion of Saint Paul*. The image may not be a literal portrait of the artist, but, appearing on his own medal, the aged, bearded pilgrim certainly stands for Michelangelo himself, for the artist who saw himself, in his letters and poems of the period, as at the end of his own earthly pilgrimage.

The image of the pilgrim that Michelangelo assumes here is rich in implication. It leads us back to one of the fundamental sources of Michelangelo's self-imagination, the Bible. Walking is central to the spiritual journey of the Bible—from Genesis ("walk before me and be perfect") to Revelation ("walk in the light"). The image of walking is similarly important in Psalms and in the utterances of the prophets, but, perhaps most of all, it is crucial to Saint Paul, who is in Michelangelo's mind and heart in these final years. Paul's words in the

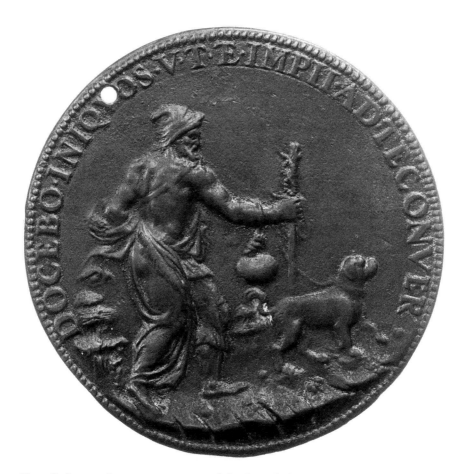

FIG. 6. Leone Leoni, Portrait medal of Michelangelo (reverse). National Gallery of Art, Washington, D.C.

Epistles—"walk in steps of that faith," "walk in newness of life," "walk not after the flesh, but after the Spirit"—are those of Michelangelo, who walks in faith, seeking to liberate his spirit from his mortal flesh, to be reborn.

The exegesis of the pilgrim can be made even more specific thanks to Vasari, who tells us that the old man is blind. Knowing this, we recall specifically 2 Corinthians 5:7, where Paul says in words now given visible form by Michelangelo that "we walk by faith, not by sight." Not only does the blindness of the pilgrim allude to Paul's words, "we walk . . . not by sight," but the dog before him, a conventional symbol of faith, evokes the words of Paul, "we walk by faith." Saint Paul's words point back to the crucial episode in his own spiritual pilgrimage, for they autobiographically refer to the moment of his conversion: "there shined round about him a light from heaven" and "he saw no man." Alluding to the moment when Paul was blinded, filled with spirit, converted to the faith, Paul's words in Corinthians also suggest Michelangelo's own identification with this conversion. These implications of the pilgrim on the medal are utterly consistent with Michelangelo's preoccupation with the Epistles during his last years, when he dwelt on the possibility of rebirth, when he contemplated and depicted the conversion of Saint Paul as if it were his own.

Saint Paul and David

At first it may seem odd for an artist to portray himself as blind, since his art depends on vision. But, we should recall, in this period of old age, Michelangelo turned against the idolatry of his earlier art. "I made art my idol," he laments, filled with a deep sense of sinfulness. Turning increasingly inward, toward the insight of faith, Michelangelo followed the example of Saint Paul, who said (1 Corinthians 8:4) "an idol is nothing in the world." Like Saint Paul, he imitated the David of the Psalms, who rejected the idols of silver and gold of the heathens, the idols that, although they have feet, "walk not."

It would be a mistake to limit the association of the pilgrim upon Michelangelo's medal merely to Saint Paul, for the pilgrim also evokes David, Job, and the prophets (to whom Michelangelo would also have compared himself)—all walking in the valley of the shadow

of death, walking still in darkness but wisely to be delivered, walking humbly and in the fear of God toward perfection. Of all Paul's antecedents David is most essential to his vision of spiritual pilgrimage: David, who, in the Psalms, walks in the midst of trouble, who walks toward the house of God, David who would walk before God.

The Psalms are indeed fundamental to Saint Paul's vision, and any concordance to the Bible will show how Paul assimilates David's words to his own. Just as Michelangelo fashions himself as a new Saint Paul, following Paul, he molds himself into a new David. We recall that already at the time he made the giant statue of David, he identified himself with David, writing on a drawing: "David with his sling and I with my bow." Still retaining this davidic identity, Michelangelo grew from youthful hero in arms into the aged psalmist, confronting his own mortality and sinfulness. On more than one occasion scholars have associated his late, penitential poetry with the Psalms. When Michelangelo writes, "loaded down with my years and filled with sin, bad habits having roots in me," he becomes the David of the penitential Psalm 51, who "was shaped in iniquity and sin." When his own life is over, his biography already written, he finds the aged David contemplating his years "as a tale that is told." No less important, he discovers in David the great biblical poet, whose devotional poetry is the model for his own. That Michelangelo had David in mind during these last years is seen in his portrait medal, for around the blind pilgrim he had inscribed the following words from Psalm 51, "docebo iniquos vias tuas et impii ad te convertentur": "Then will I teach transgressors thy ways, and sinners shall be converted unto thee." These words of David, now Michelangelo's own, make manifest not only his identity with David but his quest, like Saint Paul's, to teach sinners God's ways and convert them to him. It is in the context of this ambition of Michelangelo's that we recall Vasari's allegory of Michelangelo's pauline *Moses*, which had the power to convert the Jews, who worshiped the Hebrew king, himself converted into Christian saint. David's words on Michelangelo's medal also acquire significance in relation to all those critics, including Pietro Aretino, who condemned him for the violations of religious decorum in his *Last Judgment*. It is now he, Michelangelo, his medal proclaims, who is teaching sinners the ways of God.

Reading the words from Psalm 51 upon the medal, we must read the entire psalm as if it were now a poem by Michelangelo. Such a

reading is warranted, not only because the lines on the medal imply the entire psalm, but because Michelangelo sometimes appropriated David's language to his own psalmodic poetry. The "Miserere mei Deus" at the beginning of the psalm—"Have mercy upon me O God"—becomes the "Miserere di me" of his poem "L'alma inquieta." The sin or "peccatus" and the iniquity or "iniquitate" of David are now the sins and iniquities with which Michelangelo feels himself loaded down or "caricati." In his poetry Michelangelo strove to be "purged" of his sins, echoing David, who implores his Lord to "wash him," to purge him of sin. When David prays to God that he might "renew a right spirit" within him, these words are those of Michelangelo, who, throughout his penitential poetry, prays to God for spiritual rebirth, "rinascere" or "riformare."

The combination of pauline pilgrim and David's words on Michelangelo's portrait medal reminds us that, just as David's words were assimilated to Paul's sermons, Michelangelo reads the Psalms through Saint Paul. Hence David's cry for renewal, like his renunciations of idolatry, are read by Michelangelo as they were by Saint Paul in the Epistles. Aspiring to renewal with David, Michelangelo seeks to change his life ("cangiare la vita") with Paul, who says: "we shall all be changed." Struggling against sin, Michelangelo aspires to the spirit of which Paul preaches, inspirited himself, by David. Like Paul and David both, he hopes to reach "the Spirit of the Lord," where "there is liberty." With David and Paul, with whom he achieves similitude—assimilating himself to them in his portrait medal and poetry—Michelangelo struggles toward spiritual renewal and perfection.

Saint Paul as Architect

When Michelangelo designed his own medal, he had been architect at Saint Peter's for well over a decade. The psalm he chose for the medal would have had special meaning to him as a commentary on his very activity as architect, since David says in it, "Do good in thy good pleasure unto Zion; build thou the walls of Jerusalem." As Pietro Aretino observed in his commentary on Psalms of 1536—in accord with the conventions of theology—Jerusalem was the type of "our mother church," and Michelangelo inherited this idea, for, according

to tradition, the Rome or church of the popes was identified as the New Jerusalem. Completing the dome of the church begun by Bramante for Pope Julius II, Michelangelo was continuing David's work, building the New Jerusalem (Fig. 7). When he designed his own medal, he would surely have had in mind the medal struck nearly sixty years earlier for Pope Julius, which depicted the pope on one side and the new church designed by Bramante on the other. Bringing the church to completion, Michelangelo achieved a status worthy of his former patron and of his former rival, whose design for the dome he modified into his own glorious conception.

We know from Michelangelo's letters that his work at Saint Peter's was the central preoccupation of his last years—the final stage of his earthly pilgrimage. He repeatedly said to Vasari, who used these letters prominently in the revised biography of Michelangelo, that to leave his work at Saint Peter's would be a great "sin." Michelangelo had to struggle against his rivals of the San Gallo "sect," as if these vicious detractors belonged to a heretical group. Michelangelo's rivals, who persecuted him, conceived a church—he said with characteristic mocking humor and bitterness—which would be so dark that it would allow for counterfeiting, the rape of nuns, and the hiding of criminals within. The darkness and sheer vice of their design stood against the luminosity and enlightenment of his own project.

In the 1550s, during this very period, Michelangelo made a series of drawings that show Christ driving the moneylenders from the temple. It has generally and convincingly been suggested that this design had decided autobiographical meaning for Michelangelo—as if he took on Christ's identity, himself driving out those who would despoil the church. Indeed, Michelangelo spoke of his rivals as "ghiotti," gluttonous. They were the greedy criminals and counterfeiters whom he drove from the temple of Saint Peter's. Paul's words again became Michelangelo's: "If any man defile the temple of God, him shall God destroy; for the temple of God is holy, which temple ye are" (1 Corinthians 3:17).

Vasari adorned Michelangelo's self-portrait as papal architect at Saint Peter's, pretending that Michelangelo worked for nearly twenty years without pay "for the love of God." Michelangelo's architecture, a work of love, indeed of charity, was a deeply religious exercise, for, as Paul says in 1 Corinthians 8:1, "Knowledge puffeth up, but love edifieth." To build, "aedificare," is for Paul a deeply spiritual exercise

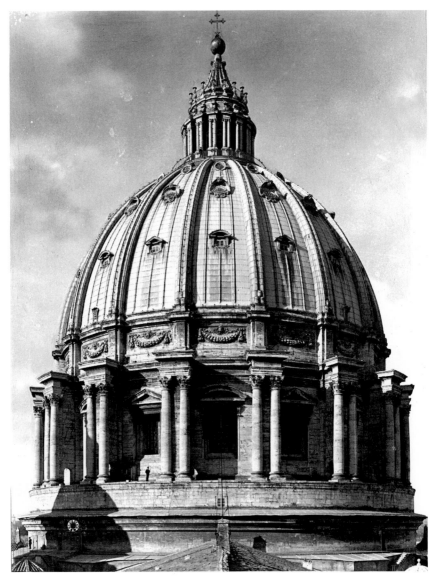

FIG. 7. Michelangelo, Dome of Saint Peter's. Vatican, Rome

born of love and, as Vasari suggests, quoting extensively from Michelangelo's letters, Michelangelo saw his own building of the New Jerusalem, his completion of David's work, as such a work of love, of the love of God. These words from Paul on building as a spiritual edification come from the section of 1 Corinthians 8 where he denounces idolatry—the very text important to Michelangelo in this period, when he repudiated the idolatry of his own previous art. Now it was his "spiritual sonnets," as Vasari called them, and the "edification" of Saint Peter's that were the epicenter of his spiritual exercises.

Although Michelangelo's dome is based immediately upon Bramante's, it depends ultimately on Brunelleschi's dome for the cathedral of Florence. As the "new Saint Paul," Brunelleschi, we saw, was the type of Michelangelo. The comparison of both architects to Saint Paul was especially appropriate, since they built great domes, which rose up to heaven, recalling that Saint Paul rose into the "third heaven." Saint Paul was himself, as he said in 1 Corinthians 3:10, "a wise master builder" who "laid the foundations, and another buildeth on it." But "the ultimate foundation," he adds, is Jesus Christ and, just as he follows Christ in his spiritual edification, as he says in his Epistles, so do both the pauline Brunelleschi and the pauline Michelangelo in Vasari's gospel. Brunelleschi as the type of Michelangelo and Michelangelo himself, both types of Saint Paul, are thus portrayed in Vasari's *Lives* after 1 Corinthians 3:10: "According to the grace of God which is given unto me, as a wise master builder, I have laid the foundations, and another buildeth on it." Brunelleschi, the "new Saint Paul," built upon the foundations laid by Saint Paul, and Michelangelo, the newest Saint Paul, built upon the foundations laid by Brunelleschi.

Just a few lines below, in the same epistle, Paul says: "If any man defile the temple of God, him shall God destroy." These words, which we have associated with Michelangelo's drawings of Christ driving away the moneylenders from the temple, are applicable to Brunelleschi, who drove away his vicious rivals who sought to unseat him at the cathedral of Florence, in a manner foretelling Michelangelo's triumph over the despoilers of Saint Peter's. In the same epistle, Paul turns from architecture to his theme of the folly of Christ: "If any man among you seemeth to be wise in this age, let him become a fool, that he may be wise." This foolishness of Paul, based on self-knowledge (which Michelangelo and Vasari relate to that of Socrates) is that of

Brunelleschi, who was called a "fool" by the Florentines, and that of Michelangelo, who appropriately calls himself a "fool" for writing a spiritual sonnet in old age. Becoming a fool in Christ, Michelangelo becomes wise. In his own mind he is like Saint Paul, who edifies through love. Adapting biblical typology, Vasari thus adorns Michelangelo's pauline image of himself. Fiercely protecting the temple of the church, through charity, he assumes the identity of Saint Paul, defending the ultimate foundations of the church, which, as Paul says, is Jesus Christ. Like Saint Paul, foolish in Christ, Michelangelo is the "wise master builder."

David's Headstone

Keeping in mind the interrelations of Saint Paul and David implied by Michelangelo's medal, his twin identities as a new David and a new Saint Paul, we find that Vasari exploited other spiritual metaphors from the Psalms and Epistles to enrich Michelangelo's symbolic identity. When Paul says in 1 Corinthians 6:15, "Know ye not your bodies are the members of Christ," he is referring to the church, united in Jesus. The members ("membra") come together in the "caput," who is Christ, as we see in Ephesians 4:15–16, where Paul develops his architectural metaphor, saying that Christ is the "head . . . from whom the whole body fitly joined together and compacted by that which every joint supplieth, according to the effectual working in the measure of every part, maketh increase of the body unto the edifying of itself in love."

Vasari had such pauline images in mind in his discussion of Masaccio, who foretells the coming of Michelangelo. All of the important artists in Florence came together in the Brancacci Chapel to study the exemplary frescoes of Masaccio, most prominently Michelangelo, just as all of the principal artists in Florence would unite later to study Michelangelo's cartoon for the *Battle of Cascina*. (It was here, in the Brancacci Chapel, we recall, that Michelangelo was brutally assaulted and had his nose broken by Torrigiani.) Speaking in the language of Saint Paul, Vasari says that where all "heads" or "capi" are, here will come together all the followers ("membra"). Coming together, they are the "whole body fitly joined together" in the Christ-

like Masaccio. For Vasari the unity of artists in the Brancacci Chapel foretold the ultimate coming together of all artists in his Academy of Design, united in Michelangelo, whom Vasari called "capo" of the academy. The Academy of Design and all such groups of artists foreshadowing the academy are a body "edifying of itself in love," since Vasari sees the academy as a churchlike institution in the mutual love and fraternity of its members.

The idea of Christ as the headstone of the church in Saint Paul is rooted in the language of the Psalms. Speaking of the gate of righteousness in Psalm 118, David says that "the stone which the builders refused is become the head of the corner." This passage, repeated by Isaiah and again by Matthew, Mark, and Peter, is an important context in which Paul speaks in 1 Corinthians 3 of the faithful as "God's building." Christ, says Paul, is the head of the body, and this head is the "caput" of which David first spoke.

Again Vasari makes capital of the Bible, assisting Michelangelo in the creation of his biblical identity. Speaking of the colossal *David* made for the Piazza della Signoria, he tells us that the statue was made from a stone that was left "in abandono." The stone, a marble of nine "braccia" in measurement, was to have been carved into a giant by Simone da Fiesole, but he had botched the work in such a manner that the "operai" of the cathedral had no intention of having it finished; they effectively abandoned the project and the marble. Not only is the statement true, calling attention to Michelangelo's skill in making a masterpiece from flawed materials, but it also alludes to the refused stone, who is Christ. Undoubtedly, Vasari had the refused stone in mind here, because its ultimate source is David, the very subject of Michelangelo's work. He plays on the fact that the stone from which Michelangelo carved the *David* was refused in order to develop a christological allegory: Michelangelo's work is a refused stone, becoming the head, in the sense, as Vasari says, that the statue surpassed all sculptures, ancient and modern.

David is the seed of Jesus, and Vasari exploits this typology in his description of the statue. When he says that the stone from which Michelangelo carved the David was damaged, he uses the word "storpiato" or "crippled" three times. This manner of speaking suggests Christ's healing of the crippled: "And the blind and the lame came to him in the temple, and he healed them." Vasari reinforces Michelangelo's identity with Jesus even further when he says that

"certainly it was a miracle that Michelangelo resuscitated one who was dead." He is speaking of the damaged stone brought back to life by Michelangelo, suggesting the miracles of Christ, who resurrected the dead. Out of Michelangelo's identity with David, seed of Jesus, and out of the davidic refused stone, which became the head of Christ, Vasari fashions an image of Michelangelo as himself a type of Christ— an image that conforms to Michelangelo's own "imitatio Christi."

Michelangelo's Sanctity

In his imitation of Christ Michelangelo follows the example of the saints. Stressing both his persecution and martyrdom, however rhetorically, in his letters and poetry, he makes this saintly identity evident. When he describes himself in one of his poems as "between virtue and vice," he is like those holy personages who, feeling the depths of their sinfulness, aspire through penance to the purity of a godlike saintliness. It is as if Michelangelo were the very Saint Anthony tormented by devils, whom he drew as a youth. Vasari amplifies Michelangelo's theme in his *Lives*, for if the book is a series of biographies rooted in the classical example of Diogenes Laertius and Plutarch, it is also, as often observed, modeled on the lives of the saints. Over and over in the pages of Vasari's hagiographical work, from the life of Giotto to that of Michelangelo, artists are depicted in their poverty, humility, patience, and other virtues as like Saint Francis and the saintly figures whom they themselves illustrated in their art.

At the beginning of his revised biography of Michelangelo, Vasari speaks of Michelangelo's "saintliness" or "santità," suggestively mentioning that he was born near the spot where Saint Francis received the stigmata. Throughout the biography he uses a spiritual language to describe Michelangelo's works as "divine" and "perfect," as "miracles." At the conclusion of the biography, Vasari summarizes Michelangelo's virtues, implying the deep connection between the perfection of his works and his spiritual purity. Whereas Michelangelo himself dwells on his own sinfulness, Vasari stresses his virtues, which are contrasted with the pride, envy, or greed of his rivals, Torrigiani, Perugino, Bandinelli, San Gallo, Della Porta, Ligorio, and Baccio

d'Agnolo. He tells us that Michelangelo reads scriptures and the sermons of Savonarola—linking him to those other artists (Lorenzo di Credi, il Cronaca, Botticelli, and Fra Bartolommeo) all under Savonarola's spell. Michelangelo, Vasari says, lives as a "poor man," although he is rich. His life is one of moderation, for he is "parchissimo." He partakes of a little bread and wine (almost sacramentally, we might add), and he is free of lascivious or impure thoughts. In the spirit of Saint Paul he is, as we saw, both sober-minded and vigilant. He is, as Vasari says, an "old saint."

Vasari resorts to hagiographical fiction in his description of Michelangelo's death. When his body is brought back to Florence for burial, it is carried, Vasari pretends, "secretly," as if it had been stolen from Rome. Suggesting a theft of the body, Vasari thus associates Michelangelo with those saints similarly restored to the cities where they had previously lived and preached, with Saint Mark, for example, whose body was stolen from Alexandria and carried back to Venice for burial. Vasari implies a similar "translatio sancti," the carrying or "translatio" of Saint Michelangelo back to Florence.

Vasari adorns this image, claiming that when the Florentines went to Santa Croce to see the body of Michelangelo, they thought his body would be putrefied and decayed after being in a casket for twenty-five days, only to discover that his bodily parts were whole and that he was without bad odor. It seemed, furthermore, that Michelangelo reposed in a sweet and very quiet sleep. There was something more than human about this miraculously preserved body. It was as if in his serenity and perfection Michelangelo, achieving utter beatitude, embodied the perfect saint.

Art-Historical Hagiography

There are countless cases of exemplary, saintly, or pious artists in the catechism of Vasari's book—for example, Giottino, who lived in poverty, not caring to acquire riches, or "ricchezze." Vasari says that he painted his great *Deposition* "with love," stressing the bitter "sorrow" of those who lament the death of Jesus, who died for "our sins." Both Giottino's poverty and piety make of him a trecento Michelangelo, his austere *Deposition* being an ancestor of Michelangelo's *Pietàs*.

Sometimes Vasari preaches on the hagiography of the art itself. He tells us in some detail the story of Marino Barattiere, painted in Arezzo by Barna da Siena. After yielding to avarice, to the devil himself, Marino is extremely penitent and, liberated from sin, he returns to God. Here too the saint is exemplary, suggestive of Michelangelo's own preoccupation with avarice, with his own penance and turning toward God or, as Vasari says, "ritirando verso Dio."

Presenting Michelangelo at the end of the history of Italian art, Vasari places him in relation to a number of previous artists similarly holy in their ways, who imitated the earlier saints. Throughout the *Lives* Vasari develops a typology of the artist as saint. We find such holy artists in both the fourteenth and fifteenth centuries. The first example to come to mind is of course Fra Giovanni da Fiesole; so holy was he that he came to be named Angelico. As an angelic being he foretold the sixteenth-century archangel, Michelangelo.

The piety and religious devotion of Fra Angelico are legendary, thanks to Vasari, so well known that we need only briefly review his saintly ways. Fra Angelico's "very saintly life" is virtually the subject of a sermon delivered by Vasari on the love of the poor and fear of God. Vasari catalogues the angelic friar's humility, charity, sobriety, sincerity, devotion, simplicity, poverty, and indifference to wealth. He was an artist, Vasari says, dedicated solely to "the things of Christ." According to some, Angelico never touched a brush without offering a prayer to God; he never painted a Crucifixion without bathing his cheeks in tears of pity. Living in a saintly manner, "santamente," Fra Angelico was, Vasari insists, truly "angelico." His works seem to have been painted not by a man but by an angel, to have been made in paradise.

Although Vasari's portrayal of Fra Angelico is grounded in the facts of the painter's life, it is based, nevertheless, primarily on the sheer effect of the painter's work, which is deeply devotional. Vasari resorts to fiction, however, when he suggests that Pietro Cavallini was just such a saintly type in an earlier period, for Vasari knows almost nothing about this artist. He essentially invents Cavallini in his account of an artist who epitomizes the angelic type to which Angelico and Michelangelo belong. Imagining that Cavallini was a follower of Giotto, Vasari presents him as a good Christian, very devout, a friend of the poor—in short, as a fourteenth-century Fra Angelico. But he clearly has Michelangelo in mind when he imagines Cavallini, indeed the

aged Michelangelo, and says that in old age Cavallini led such an exemplary life that he was nearly thought to be a saint. Whereas many artists before Michelangelo were devout, Michelangelo was the first artist to develop fully and self-consciously the image of himself as saint. In old age, he perfected this image of himself in his poetry and letters, as we have observed, speaking of his persecution and martyrdom. And responding to this self-portrait, Vasari ornamented it by outlining its historical context.

Michelangelo as saint is typologically present especially in the lives of those three great Florentines of the quattrocento, Masaccio, Brunelleschi, and Donatello, all friends, from whom he learned so much. Vasari discusses Michelangelo's study of their works, his opinions concerning their art, and the relation of his work to theirs. Like Masaccio, whose frescoes he studied, Michelangelo rendered "cose essenziali," essences; like Donatello, who, Vasari says, is a fifteenth-century Buonarroti, Michelangelo is an artist of great judgment or "giudizio" and "terribilità"; and like Brunelleschi, he is an artist of audacity, who takes on great projects. These and other links between Michelangelo and his fifteenth-century forbears also depend on their shared spirituality. Brunelleschi, who gave to the poor, living "cristianamente," was, we recall, "a new Saint Paul." Like Brunelleschi, his friends Donatello and Masaccio both lived modestly and were charitable. When, in the first edition of the *Lives*, Vasari speaks of the loving charity or "caritativa amorevolezza" between Donatello and Brunelleschi, who were like brothers or "fratelli," he suggests the idea of artists as "frati," united almost ecclesiastically in their love and charity.

Nowhere is this loving generosity more apparent than in Vasari's description of Donatello's old age—an old age or "vecchiezza" that suggests Donatello's association with Michelangelo. Shortly before his death, Donatello's relatives came to him, hoping to inherit a farm that he owned at Prato. Nearly in the language of a biblical parable, Donatello addressed them, saying: "I cannot satisfy you my relatives, because I wish (and so it seems reasonable) to leave it [the farm] to the peasant who has always worked it with great labor, whereas you expect to have it, thinking that just because of this visit I will leave it to you." Vasari adds that these relatives lacked love, noting that the peasant, who had worked the land, had greater need. His story is almost a variation on the parable of the householder. The relatives in

the story are like the vicious farmers who would receive the fruits from the labors of the servants, to whom Donatello's peasant is implicitly compared. Vasari seems also to be saying in the language of the Gospels that they will be rewarded who are not avaricious but who, through their labor, bring forth good fruits.

Consider, too, Vasari's related portrait of Masaccio. Similar to Brunelleschi and Donatello in his indifference to dress and appearances, Masaccio made loans without bothering to collect ("riscuotere") his debts. Vasari uses this term pointedly again when he describes Masaccio's *Tribute Money*, where the tax collector takes pleasure in his task of collecting ("riscuotere") payment. The contrast between Masaccio and the tax collector is that between Virtue and Vice. Vasari underscores Masaccio's loving character and simple ways by pretending that the painter portrayed himself as one of the humble, simply dressed apostles in the *Tribute Money*. In this respect, he was like his saintly, loving, and humble friends Donatello and Brunelleschi, themselves apostolic, themselves the type of Michelangelo.

The Gift of Gifts

All of Vasari's saintly artists antecedent to Michelangelo are loving in the root sense of "caritas." They express their Christian love through giving. The supreme example of such charity is the gift of grace, which comes from God. In the language of Michelangelo's poem "Non è più bassa," this grace is a celestial gift or "celeste dono," the gift of gifts, "dono de' doni." Michelangelo is using here the language of the Bible, of the Gospels, and especially of Acts and of the Epistles of Paul—"donum Spiritus sancti," "donum Dei," "donum gratiae Dei," and "donum coeleste." When Vasari speaks of artists as "doni" or gifts from heaven, he suggests in the same language that their coming into the world depends on the grace of God, which is of course the source of Michelangelo's advent.

During his last years, Michelangelo was tormented by guilt, by the sense of his sinfulness. Not only did he repudiate the idolatry of his earlier art and his earlier amorous poetry, he also worried about the possible sinfulness of his wealth. To read his letters, especially those

to his nephew Leonardo, is to discover a man who was extremely exacting and scrupulous in his financial dealings. There were contemporaries of Michelangelo who thought that he was more than merely financially responsible, for, as Vasari says, "there are some who have accused him of avarice." He insisted to Condivi, however, that he was, on the contrary, both austere in his manner of living and very generous—points elaborated by Vasari in his apologia. Echoing Michelangelo's own sense of his Christian charity, Vasari presents a list of the gifts he made to others. This list is to gift-giving what Homer's catalogue is to ships. Michelangelo gave drawings "worth a lot" of money to Tommaso Cavalieri, Bindo Altoviti, and Sebastiano del Piombo; he gave drawings and the cartoon for his *Leda* to Antonio Mini; to Gherardo Perini he gave his models in wax and clay, along with three drawings of "divine heads"; to Bartolomeo Bettini he gave the cartoon for his *Venus and Cupid;* to the Marchese del Vasto he gave the cartoon for his *Noli me tangere;* he gave his two *Slaves* to Roberto Strozzi; and to Francesco Bandini he gave a *Pietà.* Throughout all this Vasari repeats "donò" and "donato," as part of his celebration of Michelangelo's giving nature.

Vasari adds that Michelangelo could have made thousands of "scudi" from these works. How could anybody, he asks, accuse him of avarice? He also observes that Michelangelo gave money to his servant Urbino, making him "very rich," and that he provided many women with dowries. In short, Vasari portrays Michelangelo, as no doubt Michelangelo saw himself and wanted to be seen, as the paradigm of munificence and charity. Michelangelo may have been parsimonious in his handling of finances. But how dare anybody accuse him of avarice? Moreover, as Michelangelo said defensively to Condivi, "Ascanio, although I am rich, I have always lived as a poor man." Michelangelo was an entrepreneur, accumulating capital, owning considerable property, but he wanted to be known for his simple saintly ways, for living as a poor man and being charitable, in conformity with Christian ideals. When Vasari portrayed Brunelleschi giving to the poor, Masaccio not collecting his debts, and Donatello leaving a basket in his shop from which his helpers could take money whenever they needed it, he was celebrating this saintly ideal of the artist—the saintly artist of a loving, giving nature, free of avarice, of which Michelangelo was the supreme type.

Donatello's Gift

Donatello's name alone seemed heaven-sent for Vasari. Opportunity lay in his way and he found it; and the artist was, as Vasari says, a type of Donatus Buonarrotum. The "spirit" of Donatello worked in Michelangelo. Michelangelo, imitating the gift of God, was charitable and giving, as Vasari claimed, and we would expect Donatello to be so as well, since both were united in spirit. Indeed, Donatello was charitable, as we have already observed, leaving money in his shop for his students to take whenever they had need, without asking for it.

Like Michelangelo, Donatello gave away works of art. He gave to the Martelli, Vasari tells us, a statue of David, and to the Florentines in Venice he gave the *Saint John the Baptist* made for the church of the Frari. Using the words "donate," "donare," and "donò" to describe Donatello's giving, Vasari is clearly playing on his name, Donato. In this respect, he follows the example of Boccaccio in his biography of Dante. No doubt remembering Dante's assertion in the *Vita Nuova* that names are the consequences of things—"nomina sunt consequentia rerum"—Boccaccio had suggested that Dante's name was derived from the verb "dare," to give. Following suit, relating Donatello's name to "donare," to give, Vasari is doing more than merely indulging in wordplay, however, for the artist, loving and therefore charitable, imitates the example of God's grace.

Vasari makes this link between Donatello's name and God's grace clear at the beginning of his biography of Donatello, when he describes the artist's *Annunciation*—a work that "gave him his name." He means something quite precise by this last phrase, since the word "dono" or gift is central to the subject of the artist's sculpture. Mary exhibits the humility and gratitude, Vasari asserts, of one who has received an unexpected gift ("dono"), especially since the gift ("dono") is great. This gift is the gift of God, the gift of grace. When Vasari says the work exhibits a beautiful grace, "bellissima grazia," he further implies the association between gift and grace, referring to the "donum gratiae." Being the personification of charity, as his name purports, Donatello anticipated Michelangelo. Using the verb "donare" over and over in his list of Michelangelo's gifts, Vasari recalls the example of Donatello, just as Michelangelo, writing of the gift of grace, the "dono de' doni," hopes that his own charity will be worthy of this "celestial gift."

Michelangelo and Vasari in Dialogue

Let us pause to reconsider Vasari's role in Michelangelo's creation of himself. When he wrote the first biography of his hero, Vasari articulated and ornamented many of Michelangelo's own ideas about himself. When Michelangelo then dictated his life to Condivi a few years later, he not only corrected Vasari's "errors," but he further embellished, indeed magnified, the rhetoric of Vasari's account of himself. Vasari then assimilated Michelangelo's elaborations into his revised biography, ornamenting them even more. We might speak of Michelangelo's creation of himself as the result of his dialogues with Vasari. We might also want to say not only that Vasari's biographies of Michelangelo thus contain Michelangelo's "autobiography"—that they articulate what Michelangelo thought about himself—but that Vasari's own rhetoric kindled Michelangelo's imagination even further, both in his "autobiography" dictated to Condivi and in his other works of his last fourteen years. He knew that his poetry, his medal, his dome for Saint Peter's had all taken a place in a monumental history now provided by Vasari, a history culminating in himself. Surely it was impossible for Michelangelo to imagine himself, to think about his last works, to speak, to act outside of the grandiose historical framework Vasari had established for him.

It is as if, while sitting for his portrait by Vasari, Michelangelo had an influence on the very way in which Vasari painted it. After Vasari painted his portrait, Michelangelo, moved beyond his wont and appreciative, but not wholly gratified and scenting other possibilities, then sat for a second portrait by Condivi. He now exerted an even greater control over the way he should be depicted, telling the artist exactly how to paint, stroke by stroke—as if he himself were the painter. Finally, when Vasari painted Michelangelo's portrait a second time, posthumously, he used as a model his own first version as well as Condivi's portrait, made under Michelangelo's more immediate supervision. All three of these portraits are informed in varying degrees by Michelangelo's idea of how his portrait should appear, but Michelangelo's idea of this portrait, this self-portrait in his mind,

was no doubt transmogrified by his experience of Vasari's initial portrait.

It would be too easy to dismiss Vasari as merely a disciple celebrating his master, since it is likely that his imaginative conception of Michelangelo influenced the way in which Michelangelo imagined himself. The relationship between the two is probably far more complex than we can ever know. Sometimes Vasari's writing about Michelangelo has been casually compared to Boswell's writing about Dr. Johnson—a highly suggestive comparison, since Vasari's *Lives* was well known in Dr. Johnson's circle. The relations between Boswell and Johnson, their complex interrelations in the shaping of Boswell's *Life of Samuel Johnson*, the ways in which Boswell even influenced Johnson in the latter's way of presenting himself, may have their parallel in the interrelations of Vasari and Michelangelo. As Michelangelo initially shaped the manner in which Vasari wrote about him, Vasari's formulations may well have determined the ways in which Michelangelo conceived of himself.

The dialogue between Vasari and Michelangelo is carried out after Vasari's first biography and even after the revisions in Condivi's biography. Writing to Michelangelo on 20 August 1554, Vasari praises him for being free of avarice, echoing Michelangelo's proud claim that at Saint Peter's he worked not for money but for the love of God. Vasari then says in a highly conventional language, as biblical as it is political, that if Michelangelo will return to Florence he will be journeying ("camminando") along the "path of virtue," to "paradise," living in the "grace" of the prince, Cosimo—that is to say, living in the grace of God. This is at once the language of Michelangelo's own spiritual poetry of these years, a response to Michelangelo's image of himself as pilgrim journeying toward paradise, and also the language of Vasari's first edition of the *Lives*, in which artists are presented as pilgrims journeying toward perfection. Revising his biography of Michelangelo, including in the revised version quotations from Michelangelo's letters and poetry, Vasari develops the theological allegory more sharply in accord with the spiritual allegory of Michelangelo's last letters and poems, in which the saintly artist, seeking to overcome sin, aspires to the perfection of paradise. When Michelangelo later used a pilgrim to stand for himself on his medal, he employed a religious image born of his own poetry but made more nearly universal in Vasari's spiritual history of art.

Biblical Allegory in Vasari's *Lives*

In Vasari's spiritual history, artists are often saintly, as we have observed, and, like those of the saints themselves, their lives are grounded in the New Testament. Their biographies are further linked in the biblical allegory of the history of art as a spiritual journey toward perfection, of which Michelangelo is the pinnacle. Throughout the *Lives* Vasari speaks of the "camminare" or journey of art toward truth and perfection. Artists are spirits, "spiriti," pilgrims or "peregrine spirits," who, through their "virtù," ascend higher and higher to the summit of perfection, "somma perfezzione." Journeying away from darkness and vice toward light, they follow the path of God, continuously purifying art of grossness in the special sense of spiritual purgation. The history of art is progressive, a "progresso," as Vasari calls it, meaning spiritual progress. It is for Vasari, as for Michelangelo, a spiritual exercise.

Already in the "proemio" to the *Lives* Vasari employs this spiritual language, speaking of the "miracles" or art. He uses this term here and elsewhere not only as Pliny had used it in antiquity but with religious meaning, as when he speaks of the stone from which Michelangelo made the *David*, miraculously brought back to life. When Vasari says of the arts that they are reborn, "resorte," in Tuscany, he uses the words "rinascita" and "rinovare" both in the classical sense of "renovatio" and in the biblical sense of spiritual regeneration. For Vasari in his *Lives*, as for Michelangelo in his poetry, art is not only a formative process but the means to spiritual "reformation" or rebirth as defined by Saint Paul. Vasari thus emphasizes Giotto's paintings of Saint Francis, describing in detail the saint's virtues, which are those of saintly artists. As Saint Francis reformed religion, Giotto, Vasari suggests, reformed art. The epitome of the history of spiritual and artistic reform, which began with Saint Francis and Giotto, is Michelangelo, who brings this history of art as spiritual reform to a close, who personifies the Catholic Reform. When Michelangelo told Condivi to say that he was modest, and patient, that he lived like a poor man, he stressed his own saintly virtues. These are indeed the virtues of Saint Francis described by Vasari in his life of Giotto, and Vasari suggestively elaborates upon this association in his revised biography of Michelangelo, observing that Michelangelo was born near the location where Saint Francis received in a vision the wounds of Jesus.

Vasari outlines this theological allegory to good effect in the first biography of the *Lives*, that of Cimabue. After "the infinite flood of evils," "l'infinito diluvio de' mali," he begins, Cimabue brought the first lights, "primi lumi," to painting. Vasari borrows a suggestion from the *De origine civitatis Florentinae* of Filippo Villani, who said of Cimabue that his name was "Johannes," that he opened the new road of painting, "in novis via." Playing on Cimabue's name, John, Villani thus bound the artistic revival of art to spiritual revival. According to Saint John, author of the Gospel, John the Baptist bore witness to the coming of Jesus. According to Villani, Cimabue, whose name was also John, bore witness to the advent of Giotto. Vasari elaborates on Villani, speaking of the "first lights" of Cimabue coming after the darkness or "tenebre" of painting, thus alluding directly to the Gospel of Saint John, for the Baptist was not the Light "but was sent to bear witness of that Light." Cimabue plays John to the Christlike Giotto (who, in his association with Saint Francis, "secundus Christus," is a spiritual reformer), but, ultimately, Cimabue foretells the coming of the true Light, who is Michelangelo. When Vasari later says that Michelangelo's Sistine ceiling frescoes are the lantern or "lucerna" of art, he uses the language of Apocalypse—bringing this spiritual history that began with the Gospels to a close, for Jesus was the Lamp of the heavenly Jerusalem.

Cimabue, Vasari reaffirms, "began to give light and open the way to the invention" of art and was followed by Giotto, who, helped by heaven and by nature, went even higher and opened the door of truth, "la porta della verità," to those who eventually brought painting to the "perfection" of the present day. Vasari uses art itself to develop this allegory. He says that Simone Martini, to whom he attributes Andrea da Firenze's *Triumph of the Church* in the Spanish Chapel of Santa Maria Novella, portrayed Cimabue and painted himself in the fresco. This work, which Vasari calls the "story of faith," shows the Church in the form of the cathedral of Florence, with Arnolfo's design for the dome, which was later emulated by Brunelleschi, just as Brunelleschi's dome was later emulated at Saint Peter's by Bramante and Michelangelo. The fresco is an allegory of the journey of the soul heavenward, culminating beyond the heavenly dome in paradise itself, at the gates of which Peter receives the blessed souls. In Vasari's biblical language, the fresco is a parallel journey upward toward re-

newal and perfection, to the gate of truth. Placing Cimabue in this fresco after describing it, Vasari equates the history of art that Cimabue initiates with the spiritual history it illustrates, "la storia della fede," "the story of faith," as he calls it.

Simone Martini, the author of this fresco, according to Vasari, was a friend of Taddeo Gaddi. Free of "envy," they loved each other fraternally, "fraternamente," as did Donatello and Brunelleschi later and, as Vasari hoped, artists would in his own day, when there was still too much envy. The friendship of Taddeo and Simone is like that between Taddeo's father, Gaddo Gaddi, and Cimabue, between Gaddo and Andrea Tafi. In friendship, "amicizia," and charity, "carità," these gentle spirits, "spiriti gentili," stood against envy and evil, against those who diabolically sought to defraud others. Pretending that loving and fraternal artists are portrayed in the "story of faith," standing directly next to the allegorical Church, Vasari suggests a close relation between the ideal unity of artists and that of members of the commune and of the Church, united in love, hence in Christ. Through such love artists will achieve, Vasari preaches, both spiritual and artistic renewal. The completion of this history occurs in the revised biography of Michelangelo, the exemplar of spiritual love who drives the vicious from Saint Peter's. Completing the heavenly dome for the love of God, Michelangelo brings final perfection to the history of art, opening the door of very truth.

The Rebirth of Nicodemus

Vasari's history of art, we have now seen, is biblical. His uses of the word "rebirth" and the related words "resuscitate" and "renew" are closely tied to Michelangelo's own use of the word "rinascere" in his poetry, where, following Saint Paul and David, he prays for renewal or rebirth, hence spiritual perfection. Vasari creates a historical structure for this historical quest in his *Lives*, making Michelangelo the epitome of such perfection, and Michelangelo articulates this aspiration in his art. Nowhere is it more emphatically evident than in his *Pietà* in Florence (Fig. 8), probably conceived for his tomb.

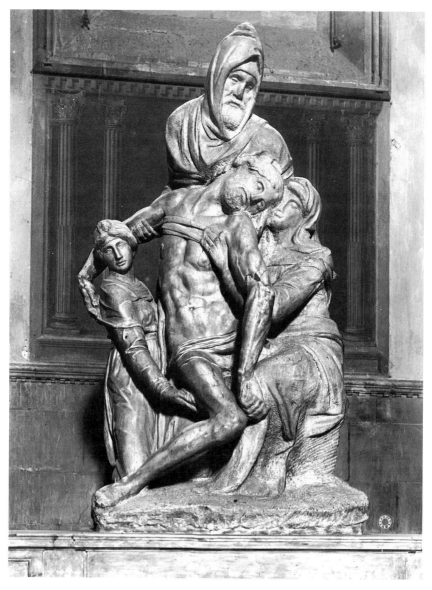

Fig. 8. Michelangelo, *Pietà*. Museo dell'Opera del Duomo, Florence

The haunting figure standing above and behind Christ, hovering as if he supported him, has been plausibly associated with Joseph of Arimathea, who gave his own tomb to Jesus, as Michelangelo did symbolically. Vasari says in a letter, however, that this figure portrays Michelangelo in the guise of Nicodemus—an identification especially apposite since, according to a tradition alluded to by Vasari elsewhere, Nicodemus was a sculptor who carved the *Crucifixion* known as the "Santa Croce." Some have supposed further, and again not unreasonably, that Michelangelo had both Joseph and Nicodemus in mind when he portrayed himself in the *Pietà*. He portrayed himself as a loving sculptor, expressing the spirituality and devotion of his art.

Michelangelo's identification with Nicodemus is especially relevant to his general concern with spiritual renewal. Portraying himself as Nicodemus, Michelangelo surely had in mind the dialogue between Nicodemus and Christ in John 3:1–7. When Jesus says to Nicodemus, "except a man be born again, he cannot see the kingdom of God," Nicodemus asks, "how can a man be born when he is old?"—to which Jesus answers: "Marvel not that I said unto thee, Ye must be born again." Filled, like the aged Nicodemus, with doubts about his own rebirth, Michelangelo carves his prayer to God, asking that he be born again. Nicodemus's words become his own. He also prays with Paul that "the inward man" be "renewed," with David, whose penitential psalms are filled with hope that a "right spirit" will be renewed within him. This is his fervent hope in his nicodemian old age when he writes penitential poetry, when he directs the building of the dome of Saint Peter's upward toward God.

Divine Personae

If the spiritual pilgrimage of Michelangelo's biography concludes with his ascent heavenward at Saint Peter's, it begins with God sending him (should we say Him?) into the world. In the first sentence of his biography of Michelangelo—arguably the greatest sentence in the entire *Lives*, a majestic period of twenty-two lines in the Milanesi edition, Vasari magisterially describes Michelangelo's advent: while artists worked according to the light of Giotto and his followers, laboring in darkness far from the truth the most benign rector of heaven,

turning with clemency toward the world, seeking to liberate them from their errors, decided to send into the world a spirit—"mandare in terra uno spirito"—universal in his judgment, a judgment informing the three arts of painting, sculpture, and architecture that he practiced. (This is a radically reduced paraphrase of Vasari's untranslatable sentence.)

The historical panorama that Vasari presents, which features God in heaven sending Michelangelo into the world, is truly michelangelesque. It is seemingly inspired by the Sistine ceiling frescoes, as if Vasari were, in his imaginative pictorial prose, describing a tenth scene of the ceiling, that of God creating Michelangelo, just as Michelangelo had pictured him creating the heavens and the earth, creating Adam and Eve. Vasari's language is unmistakably theological. Laboring in error, from "errare," to wander, artists had wandered from the true path, the "via domini" or way of God, and were now working in darkness. Sending to earth a spirit, the rector of heaven dispatched one whose right judgment, "retto giudizio," is related to his own judgment, as the very association of "retto" (right) with "Rettore" (rector) suggests. Uniting in himself ("per se solo") the three arts, Michelangelo personified a divine unity, like that of the Trinity. Sent by God to purge art made by spirits, to purify spirit, to expunge error from the world of art, Michelangelo is indeed a kind of messiah.

In the pages of Vasari, Michelangelo takes on various "divine" identities. When Vasari says that Michelangelo's Adam appears to have been made by the Creator himself rather than by the brush and design of a man, he associates Michelangelo with God the Creator. Vasari's repeated references to Michelangelo's "divine hands" are charged with reference to the divine creative hands of God that he pictured in the Sistine ceiling. When Vasari describes the "terribilità" of Michelangelo's *Last Judgment*, as well as its "grazia," or grace, he endows Michelangelo again with the power of God on the "day of wrath," both his terrifying condemnation of sin and his mercy. As the "victor" of art, he is like Christ the Victor. Creating in his fresco "the perfect and very most proportionate composition of the human body," Michelangelo creates the visual analogue of the perfected bodies of the blessed on the Day of Judgment itself—prefigured by the *Moses* as Vasari had said.

Incarnational Mysteries

Like Christ, Michelangelo is for Vasari both human and divine. Michelangelo's representations of Christ, by analogy, are imitations of what is human and divine in Jesus. They are imitations in both the artistic and spiritual senses of the word "imitare." Such imitation is appreciated by Vasari in his description of Michelangelo's first *Pietà* (Fig. 9). Vasari graphically describes the naturalism of the Christ, the human anatomy of his body worked down to its very "veins" and "pulse beats." He adds, however, stressing the beauty of the members of the body, that, "divinely" made, the figure is more than human, for "it is a miracle that a stone without any form at all has been reduced to a perfection which nature could form only with difficulty in the flesh." Thus Michelangelo does to the stone what God did to the flesh when he created Jesus. Saying that the statue is "mirabile," Vasari speaks in the language of the Bible: the *Pietà* is "mirabile in oculis nostris," a marvel to our eyes. It is a re-creation of the perfect body of Christ, a miracle.

It is not uncharacteristic of Vasari to associate the formative powers of art with incarnational theology. In his description of a fresco of the Nativity by Sodoma, he says that the artist painted the Christ foreshortened ("in iscorto") and "with great relief, which meant to show that the Word was made flesh"—"il Verbo è fatto carne." Foreshortening and relief create the illusion of the actual three-dimensional bodily presence, the analogue in art of the Logos or Spirit becoming flesh.

Such incarnational significance informs one of the most famous stories in all the pages of the *Lives*, the beloved tale of Brunelleschi's *Crucifixion*. Not found in the earlier sources, this anecdote is surely of Vasari's own invention. It was obviously important to its author, for he told it twice, in the biographies of both Brunelleschi and Donatello. Often quoted in anthologies of Italian literature, it is presented as a sample of Vasari as "prosatore minore," writing in the tradition of Boccaccio. Beneath the boccaccesque surface of the story, however, lies a deep spiritual allegory.

According to the story, Donatello makes a *Crucifixion* that his "great friend" Brunelleschi criticizes because the figure of Christ looks like a peasant, or "contadino." Indignant, Donatello replies in defiance,

"take a piece of wood and make one yourself." Brunelleschi, without telling anyone, does so. He then invites Donatello to lunch. When he enters Filippo's house, Donatello is carrying the things bought for their meal in the nearby market. Suddenly he sees the *Crucifixion*. Shocked by what he sees, in amazement he drops the eggs he is holding. Brunelleschi laughs and teases Donatello, who concedes that "it is your work to make Christs, mine to render peasants."

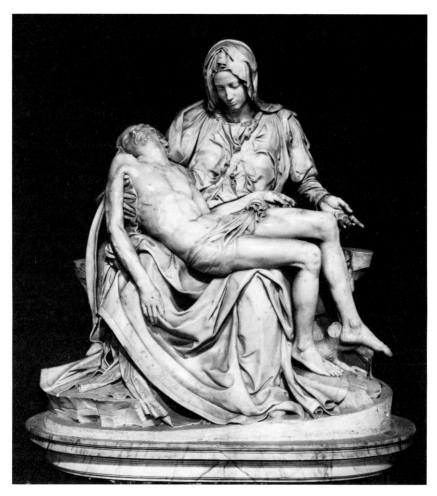

FIG. 9. Michelangelo, *Pietà*. Saint Peter's, Rome

The story comments on the loving friendship between the two artists, despite their competition. It alludes to Donatello's "giudizio" or good judgment, since he recognizes the superiority of Brunelleschi's work. The crude realism of Donatello's Christ also suggests Donatello's very person. Uninterested in fine things, he is himself coarse-grained like his own peasantlike Christ, like his powerfully raw *Zuccone*. But the story cuts deeper. Donatello's figure has failed, Brunelleschi says, because, similar to a peasant, "it is not similar to Jesus Christ, who was very delicate, being in all parts the most perfect man ever born." Brunelleschi's Christ, however, achieved "somma perfezzione," the summit of perfection. Vasari's description of Brunelleschi's work is, in short, charged with theological meaning.

We have had occasion to suggest that when Vasari uses the word "perfection," referring either to the completion of the history of art in Michelangelo or to Michelangelo's divine rendering of the perfection of Christ, he uses the term with its explicit biblical meaning. Describing the need to portray Christ as "perfect," Vasari speaks in the language of Saint Paul in Hebrews 5:9: "And being made perfect, he became the author of eternal salvation unto all them that obey him." Elsewhere Vasari suggests that the perfection of Christ's form in art reflects this spiritual perfection—for example, the Christ of Ghiberti's *Resurrection of Christ* in the north door of the baptistry, "glorified in the perfection of his beautiful members," or the Christ of Raphael's *Transfiguration*, who "shows the essence and deity of all three Persons tightly unified in the perfection" of art. In the life of Angelico, Vasari speaks similarly of "the most perfect and most beautiful God the Creator from Whom every perfection and beauty is born." As the perfection of God the Creator informs Christ, it informs also the most perfect images of God.

Brunelleschi and Donatello made images of two extremely different kinds of Christ. Donatello's very human, indeed peasant Christ conforms to a tradition of realistic evangelism found later in Caravaggio's interpretation of the Gospels. Brunelleschi's type of Christ, however, we would call more ideal in the language of modern aesthetics. In the biblical language employed by Vasari, Brunelleschi's Christ is the embodiment of spiritual perfection. This outward physical perfection mirrors such inward perfection. Brunelleschi's work exemplifies Vasari's Catholic Reform sense of religious decorum. A figure of Christ must appear not only human but also divine. In its "delicatezza,"

Brunelleschi's Christ is like the figure of Christ in Michelangelo's *Pietà*. Both perfect in form, they personify spiritual perfection. Brunelleschi, in Vasari's story, is the type of Michelangelo, not only rendering the divinity of Christ but, through this rendering of perfection, exhibiting the perfection of his own creative powers. More than just a delightful anecdote, the story of Brunelleschi's *Crucifixion* is a commentary on the artist's divine powers in portraying the mystery of Jesus as God incarnate. Brunelleschi foreshadows Michelangelo, from whom "every perfection and beauty is born."

Apocalypse

Michelangelo the Creator is also a type of God the Judge, who renders the ultimate judgment of art. From the beginning of the *Lives* Vasari stresses Michelangelo's role as judge, quoting his various "giudizi" or judgments from life to life, suggesting that Michelangelo is "universal" in his judgment. Given that Vasari associates the terror of Michelangelo's art with that created by God on the day of judgment, connecting the artist with God, the association between "universale" and "giudizio" in Michelangelo with the "Giudizio Universale" or *Last Judgment*, even if not stated explicitly, is not to be overlooked. For just as Michelangelo's right or "retto" judgment derives from that of the "Rettore" or rector of heaven, so are his universality and judgment associated with the "universal judgment" of God. The Judge is a Creator, for he re-creates the blessed in their perfected bodies. Michelangelo does the same thing in his depiction of the resurrection of perfected flesh, creating, as Vasari insists, the "perfect" composition of the human body.

Although there are several climactic or nearly climactic moments in Vasari's biography of Michelangelo, in both versions, the description of the Sistine ceiling frescoes and that later of the *Last Judgment* also painted in the chapel are key moments in Michelangelo's story. Vasari describes both in highly theological and especially apocalyptic terms. Not only does his allusion to the Sistine frescoes as a "lantern" of art evoke the Lamp of the heavenly city of God, but so too does his reference to this work as the "fount of so much light," "fonte di tanta chiarezza," which brings to mind the "fountain of the water of life" in

Revelation. He makes this theme of revelation explicit, saying that such light lifts the darkness from the eyes ("le tenebrose luci dagli occhi") of artists, enabling them to distinguish the true from the false, which had previously enshadowed the intellect. When he says that the artists of this "happy age" are "blessed," he speaks of those who, having been in a sense saved by the messiah of art, are prepared to enter into its very paradise. His panegyric on the Sistine frescoes builds to a prayer: "thank heaven," he says, for what Michelangelo has done and "strive to imitate him" in all things—by which he means both artistically and spiritually, since the two kinds of imitation are the same.

Such rhetoric is repeated in Vasari's description of the *Last Judgment* (Fig. 10), which completes the decoration of the chapel, as it concludes the biblical history begun with the scene of creation illustrated there. In the briefer, more tightly structured first version of the *Lives*, Michelangelo's biography is the final life included, the *Last Judgment* being the final work of both his biography and the entire history of art. When Vasari says toward the end of the biography and of the *Lives* that Michelangelo has "rent the veil of all difficulty in the art of painting"—"squarciato il velo delle dificultà"—he describes the final revelation of art, which has been preceded by the revelations of his *Moses* and Sistine ceiling frescoes. Vasari refers here to the rending of the veil in the temple, when it "was torn in two . . . and the earth did quake. . . . and the graves were opened; and many bodies of the saints that slept were raised, and came out of the graves after his resurrection, and went into the holy city, and appeared unto many" (Matthew 27:51–53). Pretending that the fresco was first unveiled on Christmas day, 1541 (it was in fact uncovered on 31 October), Vasari associates its "epiphany" and Christ's final advent with Christ's nativity, bringing together the very alpha and omega of his life.

Describing the *Last Judgment*, Vasari says once again that Michelangelo, or, more specifically, his painting, was sent by God, adding that it was "infused with grace." He thus unites the grace of art with the grace of God, the gift of gifts. Building on his description of the Sistine ceiling frescoes, he describes the "felicità" of those who have seen this revelation of art, especially Michelangelo's patron, Pope Paul III, who is especially blessed, "beatissimo." Vasari's description stands in the tradition, stemming from Revelation, of Augustine de-

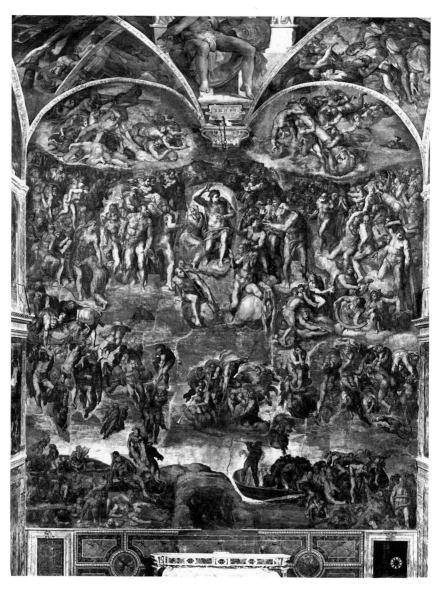

FIG. 10. Michelangelo, *Last Judgment*, Sistine Chapel. Vatican Palace, Rome

scribing "the great felicity" of those beholding the heavenly city, of Dante celebrating the similar "joy" and "happiness" of the blessed in paradise, and it brings to mind Vasari's own description of the blessed in Renaissance paintings—in celestial joy as they enter into paradise. Thus apocalyptically ends the life of Michelangelo and the entire history of art united in him.

Church Militant and Catholic Reform

Vasari says that originally Michelangelo planned a fresco for the wall opposite the *Last Judgment*, depicting Lucifer driven out of heaven, in hell with all the angels who sinned. He makes reference to the triumph of Saint Michael, an appropriate subject in relation to the Last Judgment, since in Revelation 12:7–9 John describes the victory of Michael over Satan: "And there was war in heaven," and Michael and his angels drove out "the Devil and Satan, who deceiveth the whole world; he was cast out into the earth, and his angels were cast out with him."

Michelangelo had undoubtedly already learned from the hebraists in the platonic circles of Medici Florence that his name Michael meant "Who is like unto the Lord." There is a deep tradition in Florence, as we have already observed, of finding significance in names. In the *Lives*, Vasari plays on the significance of the names of artists; for example, Perino del Vaga's work is praised for its "vaghezza" or loveliness, and Pellegrino da Modena is endowed with a "spirito . . . peregrino." Here we might recall that Vasari had played on his own name in his portrait of Lorenzo de' Medici, in which the "vaso" or vase comments on Vasari's virtues (as well as his subject's). In like fashion Michelangelo played on his own name and identity with Saint Michael in a poem from 1555, "Al zucchero." Generally thought to be an acknowledgment of gifts received from Vasari, Michelangelo writes: "Sugar thou givest, candles, a mule to ride, and add'st thereto a flask of ruddy wine: gifts which do so outman all needs of mine, that with Saint Michael, I the wealth divide."

It seems almost impossible that when Michelangelo conceived the

Last Judgment and the *Triumph of Saint Michael over the Devil* he did not think of his own identity with the triumphant archangel. Vasari's comparison of Michelangelo to God in his "terribilità" and grace, in his universality and judgment, is rooted in Michelangelo's conviction that as Michelangelo, he was, as his name meant, like unto God. In a preliminary study for the *Last Judgment*, Michelangelo placed a figure of the militant Michael, sword in hand, at the very center of the composition, directly below the Judge, deliberately aligned with the very deity with whom he was associated through his name. The representation of Saint Michael in the *Last Judgment* is not only iconographically appropriate, as we have observed, but it is also a signature of the godlike angelic artist.

As a militant "arcangelo," Michael was an important symbol of the militant church during the years of the Catholic Reform. Pope Paul III, patron of Michelangelo's *Last Judgment*, commissioned from Perino del Vaga during the 1540s a magnificent *Triumph of Saint Michael*, executed by his assistant Pellegrino Tibaldi in the Castel Sant'Angelo, the very fortress of the Vatican over which Michael presided, defending the Church. Tibaldi's fresco was painted in the manner of Michelangelo, depending on an earlier design by Raphael, itself already influenced by Michelangelo's grandiose style. One cannot but wonder whether contemporaries recognized the apposite michelangelesque manner of these Saint Michaels, inspired by Michelangelo. In addition, Michelangelo's protégé, Daniele da Volterra, was commissioned to make a statue of Saint Michael for the Castel Sant'Angelo to go with other figures in an appropriate triumphal arch. Saint Michael's triumph was that of the church triumphant.

Michelangelo assumed the identity of the militant angel defending the church when he drove off his vicious rivals at Saint Peter's, who sought diabolically to defraud the church, leaving it in darkness. He lived up to his name. Names were indeed the consequences of things. Michelangelo's michelangelesque identity was also consistent with his pauline person. Saint Paul, whom Vasari describes as fierce and indomitable, preached to the faithful to put on the "armor of faith." Putting on this armor, Michelangelo authenticated his own identity as Saint Michael. In triumph over the "superbia" or pride of his adversaries, the sect of San Gallo at Saint Peter's, he enacted the role of Saint Michael in Revelation vanquishing Satan. He became one of the greatest saints of the Catholic Reform.

The Example of Dante

Michelangelo's spiritual persona derives not only from the Bible but also from the example of Dante. It is to Dante, finally and inevitably, that we must turn in order to penetrate that most profound source of Michelangelo's self-conception. Michelangelo told Condivi that already when he was in Bologna as a young man he was familiar with Dante, for he read Dante, along with Petrarch and Boccaccio, to Gianfrancesco Aldovrandi. This claim, which Vasari adapted to his revised biography of Michelangelo, does not seem unreasonable, since the Tuscan poets were no less important than Plato in the highly literary circles of the Medici, which Michelangelo had left only a short time before. Michelangelo also told Condivi not only that he was like the philosophers Socrates and Plato and that he wrote poetry, but that he was a theologian or "teologo." Making this claim, Michelangelo surely had in mind what Boccaccio said in his biography of Dante, that Dante was poet, philosopher, and theologian. Painter, sculptor, and architect, Michelangelo was, like Dante, truly universal, for, as he insisted, he was similarly a poet, philosopher, and theologian.

Although Michelangelo claims to have known Dante's work as a young man, it was only in old age that, assisted by his admirers, he fully achieved and consolidated the image of himself as a new Dante. The bulk of his poetry, which is conspicuously in the tradition of Dante, dates from after 1530, when he was well over fifty years old, and much of his finest, most dantesque work dates from the 1540s and 1550s, when his poetry was compared to Dante's by his contemporaries. In his poetry of the 1540s to Vittoria Colonna, Michelangelo played Dante to Vittoria's Beatrice, and his last poems, of the following decade, which dwell on the end of his earthly pilgrimage, are shaped not only by the Bible but by the spiritual journey of Dante's *Comedy.*

It was sometime toward 1540 that Michelangelo took a decisive step in his art, adding to his *Last Judgment* the passage from Dante of Charon's bark, not included in the original design, and it was in the 1540s that, as he told Condivi, he based the figure of "vita attiva" in the tomb of Pope Julius on Matilda in *Purgatorio.* In the same decade, we recall, Michelangelo appeared as a Dantista, as an expert on Dante's *Comedy,* in the dialogues of his friend Donato Giannotti, and,

a short time later, Vasari focused on Michelangelo's use of Dante in the invention of the *Last Judgment*. It was in this same period, in the 1540s, that, aspiring to be a new Dante, Michelangelo wrote two poems about Dante. These two poems were, as we shall see, as much about Michelangelo himself as about Dante.

Where do we first encounter Dante in Michelangelo's work? Quite possibly in his first *Pietà*. Already in the first edition of the *Lives*, Vasari quotes a poem by Giovan Battista Strozzi, written about the copy of Michelangelo's statue by Nanni Bigio, which was placed in Santo Spirito in Florence in 1549. Calling Mary bride of Christ, daughter, and mother—"unica sposa sua figliuola e madre"—Strozzi echoes Saint Bernard's prayer to the Virgin at the end of *Paradiso*, where Mary is called the daugher of her son—"figlia del tuo figlio."

This very idea is found just a few years earlier in the Saint Barnabas altarpiece, painted by Michelangelo's friend Botticelli. Here the artist, illustrator of the *Comedy*, inscribed Dante's words about Mary on a step of her throne. If Dante was on Michelangelo's mind when he carved the *Pietà*, it would help explain the mystery of her appearance, for although she is protective and maternal, she is also astonishingly youthful in appearance, indeed childlike, hence "madre" and "figlia." If Michelangelo was referring to Dante's Mary, he would have been recalling Bernard's words, "in te misericordia, in te pietate"—in you is mercy, in you pity. Michelangelo would have been carving his prayer to Mary, to use Dante's language, in the form of "visible speech."

It may be, however, that the dantesque implication of the *Pietà* is not part of Michelangelo's original meaning, that Strozzi (with Vasari, who quotes him) gives the statue a dantesque significance not consciously intended by Michelangelo. It may be that because Michelangelo had established himself by the 1540s as a great dantesque artist and poet, Strozzi and Vasari invested the *Pietà* with an appropriate significance not part of Michelangelo's meaning. The question must remain an open one. In either case, whether Michelangelo was thinking of Dante when he carved the *Pietà*, or whether the sheer force of Michelangelo's dantesque personality made Strozzi think of Dante when he responded to the statue, the *Pietà* becomes an expression of Dante's vision. Either way, Dante's vision becomes Michelangelo's own.

Dante the Sculptor

As Michelangelo was a sculptor, so too was Dante, who worked the language of stone, the ideals of which Michelangelo would later quarry in both his art and writing. Nowhere did Dante work this hard stone or "pietra dura" with greater effect than in the "rime petrose" of his *Rime*. Here Dante says that, with the image of his beloved "petra" in mind, his own mind is now of stone. Speaking of his own death, he says he will become a man of stone, "uomo di marmo," his heart will also be of stone, "core un marmo"—as if he had beheld Medusa and been petrified. Over and over in these "rime," Dante, describing his beloved, repeats the word "petra." Hard as stone, she dresses in precious stone as well. She is harsh in her actions, and Dante wishes to be "aspro" or appropriately harsh in his very speech.

Although art historians have paid almost no attention to the "rime petrose," scholars of Michelangelo's poetry have recognized their importance for Michelangelo's poetic diction and style. We should add, however, that, more than mere "influence," Dante's stony rhymes helped Michelangelo to carve his very self. Dante the poet-sculptor furnished Michelangelo with the sculptural language to articulate and express in words the sheer difficulty of making sculpture, the harshness of this exercise, the hardness of the stone. Dante provided Michelangelo with the means of becoming himself a sculpture, even if like his own works he was "non finito," not yet perfected. Speaking of himself as a sculpture, Michelangelo thus played out the implications of Dante's invention. When Giovanni di Carlo Strozzi wrote a poem in praise of Michelangelo's *Night*, carved by "an angel," as he remarked, Michelangelo replied with his own poem. He wrote it, Vasari said, in the person of *Night*. Saying that he was glad to be asleep and to be of stone, "essere di sasso," the times being what they were, Michelangelo became or rather made himself into his own dantesque sculpture.

Michelangelo makes hard stone, marble, the very stuff of his origins. He tells his biographers of those occasions when he retired into the mountains of Carrara, as if he were disappearing into the stone from which he originated. When he tells Condivi that his wetnurse was married to a stonecutter, when he tells Vasari that he took in the hammers and chisels of sculpture at her breast—emphasizing the fact that he was raised in a place "abundant in stone, full of caves of

'macigno' "—he elaborates this nearly mythic sense of his origins in stone. Such anecdotes, themselves poems in a way, could not have been written without the language of the great sculptor Dante. When Michelangelo carves from hard stone, renders lithic beings in paint, or re-creates the "donna petra" in his marmoreal drawings of "divine teste," he follows the example of Dante—who revealed to Michelangelo an ideal of petrified beauty. Carving himself, finally, into sculpture, Michelangelo imitated Dante in the deepest sense, because he assimilated himself, in the root sense, to Dante, becoming a "man of marble." In his own words, he was now made of "pietra viva," of living stone. This is the larger dantesque context in which Michelangelo imagined himself as the Pan-like faun or socratic Marsyas that he carved for Lorenzo de' Medici—the context in which he came to be seen by others as, in a way, his own *David* or *Moses*—as if he were the sculptor of himself.

Dante's Eyes

It is through his eyes, Michelangelo writes over and over again, that he receives from the eyes of his beloved the light and splendor of her grace, which promises to transport him out of darkness. Michelangelo's poetry, like his visual art, is about seeing, what he calls the "visive virtue" and, in this respect, it is born of Dante's visionary writing. "Guardare," to look, and, above all, "vedere," to see, are central verbs in the world of Dante's luminous and splendid "images" or forms. Like Dante, Michelangelo aspires to "lo perfetto veder," perfect vision.

There are moments when Dante becomes, as we have observed, a sculptor in words, becoming a painter as well. In *Purgatorio* X he re-creates three gigantic relief sculptures exemplifying humility. To use his own language, he does this by employing "visible speech." He sustains this reference to art in the next canto where he makes his famous reference to Cimabue and Giotto. This allusion is developed further in the following canto by his description of figured pavements of the proud brought low. "Vedea . . . Vedea . . . Vedea," he repeats, making the reader see also, as he does throughout the poem, images to which his words give shape.

In the canto preceding these three, Canto IX, Dante describes at the gate to purgatory his visionary dream of the eagle with golden feathers, suspended in the sky. This "vision . . . nearly divine" is that of the heavenly eagle of divine justice who carried Ganymede "up to the supreme conclave" of heaven. Ravished himself by this vision, Dante imagines that he is scorched by a terrible flash of lightning before awakening. It has been reasonably suggested that when Michelangelo made a drawing of the Rape of Ganymede for Tommaso Cavalieri his image reflected the kind of neoplatonizing allegory found in Landino's commentary on Dante's eagle as "la divina charità." It is even more likely that the very "vision" of Michelangelo's drawing is informed by the visionary "terribilità" of Dante's "visione . . . quasi divina"—that Michelangelo tried to make visible the speech of Dante.

Already in the Sistine ceiling frescoes Michelangelo had re-created a vision from Dante in his depiction of the execution of Haman. Art historians have often observed that whereas Haman is executed by hanging in the book of Esther, Dante envisions him crucified in *Purgatorio* XVII and that, seeking to make visible Dante's vision, Michelangelo depicts Haman upon a cross: "Then rained down within the high fantasy one crucified, scornful and fierce in his look, and he was dying so." In this image of the truly terrible Haman, one of the most complex and exalted in the entire ceiling, Michelangelo demonstrates his own exalted imagination, suggesting that he is a new Dante. Whereas Dante had imagined visions in words, Michelangelo translates such visionary experience into directly visible form.

Given this dantesque reference, it is hard to imagine that painting the Sistine ceiling—a decoration of such unprecedented magnitude, a work of complex allegorical form, making a synthesis of the Hebraic and Hellenic traditions—Michelangelo did not have in mind the analogous scope and complexity of Dante's *Comedy*. The allegorical journey of Dante's *Comedy* was placed in the year 1300, and Michelangelo's "Comedy" was painted two hundred years later—just after 1500, the very midpoint of the millennium. Dante the pilgrim was thirty-five years old in the *Comedy*, and Michelangelo was approaching the same age as he began his Christian epic. This association surely did not escape Michelangelo's attention as he sought to create his own dantesque monument, for he thought of himself as the hero of his poetical life or autobiography, imitating Dante, who saw himself as

the hero of his autobiographical poem. Aspiring to Dante's "high fantasy," Michelangelo rose above the allegory of words, beyond similes and metaphors, into the realm of vision itself. Gazing upward at his Sistine frescoes, we behold a terrible, visionary art that is enlarged by Dante, for what Michelangelo renders visible he envisions through Dante's eyes.

The "Divine Comedy" of Michelangelo's *Last Judgment*

When Michelangelo painted the *Last Judgment* in the Sistine Chapel, years after his execution of the ceiling frescoes, he asserted even more boldly his dantesque ambitions. Describing the fresco in some detail, Vasari shows how Michelangelo illustrated Dante, but his account is by no means complete. We might pause to consider some of the details from Dante that Michelangelo illustrated, as well as Vasari's rhetorical embellishments of Michelangelo's dantesque ambitions.

Michelangelo's depiction of Charon (Fig. 11) at the lower right of the fresco is, as Vasari indicates, from the third canto of the *Inferno* by his "most familiar" Dante: "The demon Charon, with eyes of burning coal, beckons to them the sinners and gathers them all in, smiting with the oar any that linger ('si adagia')." In Michelangelo's image the movement of the sinners is indeed slow and grave in the form of a pictorial "adagio," as if he were trying to convey the slow motion of their delay. Spilling out of the bark, Michelangelo's figures are, as Dante says, "like the autumn leaves falling," "come d'autunno si levan le foglie." When Michelangelo paints the eyes of Charon as gigantic orbs, he probably has in mind Dante's description of Charon's eyes as "wheels" of flame, for in their very circularity they are wheel-like. At the extreme lower right of the fresco toward which Charon's sinners descend, we see merely the suggestion of infernal flames, cut off by the fresco's border. This is the blaze of red fire—"balenò una luce vermiglia"—that Dante describes in the final "terza rima" of the canto.

Dante alludes throughout his poem to moments past and to come, weaving his work into a whole and, Michelangelo, in the same man-

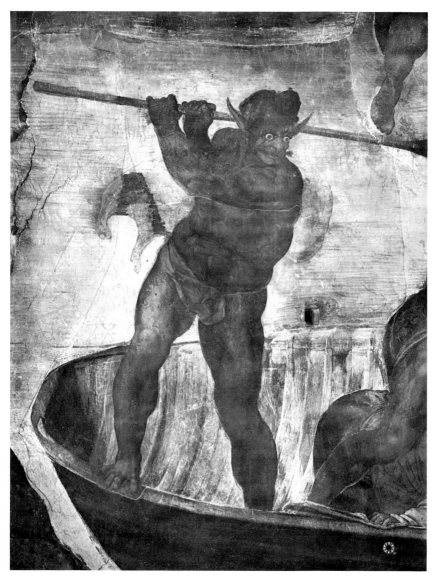

FIG. 11. Michelangelo, *Last Judgment* (detail of Charon), Sistine Chapel. Vatican Palace, Rome

ner, conflates different passages in Dante. He brings Cantos III and V together by depicting Minos directly next to Charon's bark. This huge nude figure, "horrible and snarling," as Dante says, and encircled by a serpent, is Dante's judge of the underworld. When Dante describes Charon with eyes like "wheels of flame," he refers, in purposeful inversion, to Revelation 10:12, where the Christ of the Second Coming has "eyes . . . like flames." Charon becomes the very antitype of Christ. So too is Minos, the judge of the underworld, who thus stands in opposition to Christ the Judge.

The figure of Minos, according to a fiction adapted by Vasari in his revised biography of Michelangelo, was a portrayal of Biagio da Cesena. The papal master of ceremonies had criticized Michelangelo's fresco, saying its nude figures were more appropriate for baths or taverns. The story makes Michelangelo appear to be like Dante, who had set an example for the painter by similarly placing contemporaries in hell for their sins. The anecdote plays on the fact that Biagio has been an unjust judge and, for his injustice, he is not merely placed in hell but made to be the very judge of hell himself. This implicit humor reminds us of the kind of humor found in Dante, especially in his description of infernal demons.

Elsewhere in his description of the fresco Vasari seeks to convey the effect of Michelangelo's fresco by quoting Dante's words in *Purgatorio* XII: "The dead seemed dead, the living seemed alive." This is an especially appropriate canto from which to quote here, since in it, we recall, Dante becomes a painter in words, describing the figured pavement of the proud brought low—a theme also appropriate to Michelangelo's very subject. Dante tried to make the reader see ("Vedea . . . Vedea . . . Vedea"), and Michelangelo similarly makes us see the proud sinners who are now humbled. Dante asked in this canto, "What master of brush or chisel could have portrayed the shape and outlines there, which would have filled with wonder a discerning mind?" The answer to Dante's question, Vasari suggests, is simple: Michelangelo.

When Dante describes hell, he does so in relation to paradise, foretelling *Paradiso*. Those driven down by Charon, "who die in the wrath of God," are punished through divine justice, "la divina giustizia." No less does Michelangelo's fresco necessarily make such a connection between heaven and hell. By quoting from *Purgatorio* Vasari further implies Michelangelo's uses of the middle section of the

Comedy. He thus completes Michelangelo's allusions to all three parts of Dante's work, implying that in creating his grandiose apocalyptic image Michelangelo had created a work comparable in sheer scope to Dante's entire poem.

Dante and Saint Peter

There is one other detail in Michelangelo's *Last Judgment* that seemingly makes visible the speech of Dante's poem. This is the depiction of Saint Peter, who appears to Christ's left (Fig. 12). This truly fierce nude figure steps forward, extending the keys of the church back toward Christ, who had given them to him—as if to imply the very relation of Christ's judgment to the church itself. In *Paradiso* XXVII Saint Peter sharply denounces the church: "He that usurps on earth my place, my place, my place, which in the sight of the Son of God is empty, has made of my tomb a sewer of blood and filth." Peter's words are Dante's own words of denunciation of the pope, for previously in the *Comedy* he had already attacked the corruption of Pope Boniface. In an early sonnet, Michelangelo, perhaps with Dante's Saint Peter in mind, had similarly written a denunciation of the church: "They make a sword or helmet from a chalice, and sell the blood of Christ here by the load, and cross and thorn become a shield, a blade, and even Christ is being stripped of patience." In the face of Saint Peter in the *Last Judgment* we behold just such an accusation. Extending the keys of the church up to Christ, he could almost be saying, in the words of Dante's Saint Peter, "It is not our meaning . . . that the keys which were committed to me should become the device on a standard for warfare on the baptized."

Michelangelo makes Dante's Peter his own in the *Crucifixion of Saint Peter* in the Cappella Paolina (Fig. 13)—a work directly across from the *Conversion of Saint Paul*, discussed above (Fig. 4). The fierce scowling Peter turns and looks directly, indeed accusingly, at the beholder. The words of Dante's Peter could be his own: "The Bride of Christ was not nurtured with my blood for gain of gold." As Peter spoke accusingly, Dante saw all of heaven suffused "with the color that paints the morning and evening clouds that face the sun," the color of shame. Michelangelo or Michelangelo's Peter, or even

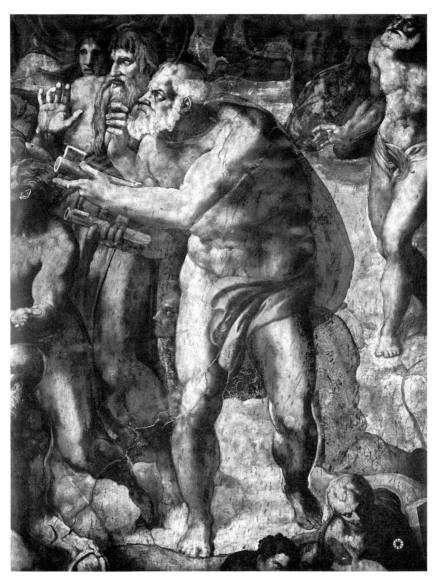

FIG. 12. Michelangelo, *Last Judgment* (detail of Saint Peter), Sistine Chapel. Vatican Palace, Rome

Michelangelo becoming Saint Peter, seeks to create such shame through the direct accusing look of the martyred saint—as if those who beheld his martyrdom made his tomb a sewer of blood and filth, as if they were indeed sinners.

Saint Peter's cause of spiritual reformation and edification became Michelangelo's at the very moment that he was painting the Cappella Paolina, for it was at this time that he was made the chief architect at the very church of Saint Peter. He wrote to Vasari several years later, when Vasari sought to induce him to return to Florence in order to work for Duke Cosimo de' Medici, saying that he could not depart from Rome because leaving behind "the great ruin of the building of

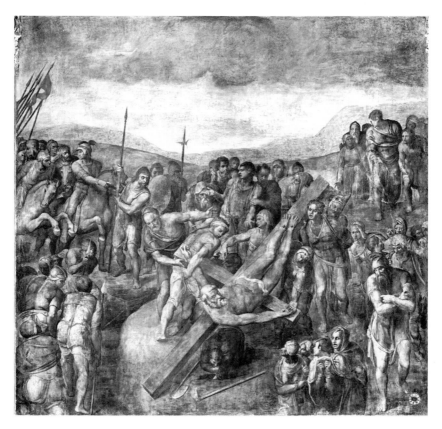

FIG. 13. Michelangelo, *Crucifixion of Saint Peter*, Cappella Paolina. Vatican Palace, Rome

Saint Peter's" would be "a great shame and a very great sin." It was his duty to defend the church from the "gluttons" who wanted him to leave his post as architect, who sought indeed to drive him away. Becoming the architect of Saint Peter's, Michelangelo assumed the role of Dante's Saint Peter, protecting the church against vice. When Vasari quotes Michelangelo's denunciation of those who persecute him and, hence, the church, Vasari makes Michelangelo's virtually petrine persona an integral part of his highly spiritualized biography. Ending the history of art with Michelangelo's defense of Saint Peter's, Vasari is like Dante presenting Saint Peter's defense of his church at the end of the *Comedy*.

Art and Purgatory

Vasari's explicit references to the *Divine Comedy* in his description of Michelangelo's *Last Judgment* are both suggestive of Michelangelo's further meditations on Dante and indicative of Dante's place in Vasari's overall history. Vasari's *Lives* is not only a biblical allegory of the spiritual pilgrimage of art but a dantesque allegory as well. Like Dante's poem, this history begins "in medias res," when painting had fallen into darkness. When Vasari says in the life of Cimabue that painting was lost rather than bewildered ("più tosto perduta che smarrita"), he writes in the language of Dante lost in the wood at the beginning of the poem: the straight way was lost ("smarrito"). Dante's journey is a "cammino," and so too is the pilgrimage of art such a "camminare" in Vasari's dantesque words.

When in this "cammino" or journey of the artist-pilgrim, the peregrine spirit, toward artistic and spiritual perfection, we encounter such vicious artists as Andrea del Castagno, we meet sinners fashioned from the arch-sinners of Dante's *Inferno*. Diabolical and wicked, bestial and covetous, Castagno personifies hatred, fraud, and violence when he betrays and murders his friend Domenico Veneziano, according to a fiction exploited by Vasari. For his rage Castagno should be seen in the upper reaches of hell with Filippo Argenti; for his violence he belongs with those in the river of blood, presided over by centaurs (indeed Castagno is bestial); and for his fraudulence, he deserves to be with the "traditori" in the ninth circle, in the very pit of

hell. Vasari portrays Castagno cradling the innocent Veneziano dying in his arms, shortly after he has mortally wounded his "friend." When Veneziano expires, we are made to feel the same kind of horror we experience when reading about the sweetness of Ugolino's innocent sons. Vasari's monstrous inversion of the *Pietà* is indeed worthy of and created out of the horrors of Dante's hell. "Diabolical" and a "traitor," Castagno deserves a place, Vasari intends, in proximity to both Judas and Satan himself.

Loving and kind, in opposition to his murderer, Castagno, Domenico Veneziano is the personification of sweetness and "gentilezza." He belongs with Cavallino, with Fra Angelico, with all those exemplary, saintly spirits who, throughout the *Lives*, foretell the advent of Michelangelo and who are worthy of paradise. We can almost imagine these artist-saints gathered in paradise, reunited and joining Francis and Dominic and the saints and angels in the Rose—all there to greet the final dantesque pilgrim of art: Michelangelo.

Vasari's history is mapped out between the sins of hell and the spiritual perfection of heaven—"between," as Michelangelo says of himself, "virtue and vice." It is essentially the story of the "purgation" of art—a theme Vasari establishes at the very beginning of the *Lives* on the basis of *Purgatorio*. Here in the lives of Cimabue and Giotto, Vasari refers to the passage in *Purgatorio* XI, where Cimabue's pride is condemned, when his art is surpassed by Giotto's. For Vasari, as for Dante, the sin of pride, what Vasari calls "vanagloria," must be purged. Already in the "proemio" of the *Lives* and shortly thereafter in the life of Gaddo Gaddi, Vasari speaks of the "purgation" of art. Art in Tuscany and, in particular, in Florence, he says, is purged as a result of the subtlety of the air, "la sottilità dell'aria." Painters are spirits, indeed subtle spirits or "spiriti sottili," whose work is "assottigliata"—subtilitiated, in the archaic English, which meant to sublime or refine in the sense of purification. Purified, the arts were thus purged: "si purgarono." They were made pure. It is through love and charity, through friendship and fraternity—in opposition to envy—that artists were united, working in friendly competition to perfect their art, to purify it and themselves of vice.

Vasari describes this purification of art as a taking away, "levare via" of the grossness or "grossezza" of art until, finally purged, it reaches the highest summit, "la somma perfezzione," as he says in a language reminiscent of Dante. When Vasari uses the phrase "levare via," he

employs the same term used by Michelangelo in his poetry to describe the subtraction of physical matter in the making of a sculpture, which was a spiritual metaphor for the perfecting of the self. In Vasari's history of art, as in Michelangelo's poetry, to which it is indissolubly united in both poetic diction and theology, the ideas of spiritual rebirth and perfection are linked with the notion of purgation, and these concepts are tied to the Bible through Dante: the very type of the artist as spiritual pilgrim. Loving, humble, and charitable, Michelangelo, the new Dante, is the personification of the artist-pilgrim purified and perfected, worthy of journeying step by step, "di grado in grado," into paradise.

Giotto and Dante

At the beginning of the pilgrimage of art Giotto "opens the way" to perfection. A type of Socrates, foretelling the coming of Michelangelo, he is no less a type of Dante. Indeed, building on Dante's discussion of Giotto in *Purgatorio* XI and the attending legend of their friendship, Vasari creates an elaborate portrait of a dantesque Giotto, who foreshadows Michelangelo.

Giotto is "amicissimo," a very great friend of Dante, and their lives are interwoven. When Giotto traveled to Ravenna, where he worked, Dante was "in exile there" and, as Vasari says, in 1322, the year of the poet's death, the painter worked in Lucca. Giotto's frescoes in the Palazzo del Podestà included a portrait of the artist's "very great friend" Dante, who, Vasari adds with a rhetorical flourish, "was no less famous a poet than Giotto." The artist also portrayed in these frescoes, according to Vasari, Brunetto Latini, who foretold Dante's future greatness in *Purgatorio* XV, and Corso Donati, whose story is touched on in Canto XXIV.

Vasari also adapts the language of Dante to describe Giotto's work, or rather, the response to it. Speaking of a panel of the death of the Virgin, which Vasari says was praised by Michelangelo, he tells us that it was stolen from the church Ognissanti. It was taken "for the love of art" since, "as our poet" says, it was "spietato"—that is, not esteemed. Vasari's use of the term "spietato" here, as the reader well versed in Dante recognizes, is the paradox of *Paradiso* IV: "Alcmaeon, urged by

his father, slew his own mother and, not to fail in piety, turned pitiless ('spietato')." By analogy, just as Alcmaeon commits murder out of love, so, Vasari is saying, does the thief of Giotto's painting commit his theft out of love or piety.

Vasari's references to Dante are sometimes rather witty, inspired by affinities of circumstance between Giotto's work and the *Comedy*. When Vasari mentions that Giotto painted a portrait of Farinata degli Uberti, the famous defender of Florence, in his frescoes in Pisa, we do not necessarily think of Dante at all, since Farinata was praised in the writings of many Florentines. The key to Vasari's allusion to Dante lies, however, in his statement that Giotto's frescoes were painted in a cemetery, which was filled with "ancient sepulchers." Vasari is playing here on the fact that the heretic Farinata of *Inferno* X rises up grandly from a flaming sepulcher. The world in which Giotto works is transmogrified in Vasari's and the reader's imagination into the world of Dante's imagination.

Vasari deepens the poetical relations between Giotto and Dante when he suggests that the painter's frescoes in both Naples and Assisi were inspired by Dante's "discourses," to which he listened while working. When Vasari says that Giotto's fresco of the Apocalypse is based on an "invention" of Dante, he is drawing a direct parallel to Michelangelo's dantesque, apocalyptic *Last Judgment*. As a painter intimately tied to Dante, who illustrates Dante, who is a Dantista, Giotto, in Vasari's typology, is Michelangelo "avanti la lettera."

Dantesque Images in Vasari

Vasari is forever pretending that the frescoes of the Florentine paint-ers are filled with portraits of famous citizens, sometimes pretending that these citizens were patrons of works made long ago. This pious fraud enables him to pass off his history of Florence as the history of Dante's Florence, of Dante's fame and importance in art. Telling us that a *Crucifix* painted by Margaritone was made for Farinata degli Uberti, he keys this reference to that in the work of Giotto, where the allusion to Dante's Farinata is inescapable. When he describes the frescoes by Lorenzo di Bicci in San Egidio at the hospital of Santa Maria Nuova, he says that the hospital was founded by Folco Porti-

nari, the father, as he well knows his readers will recall, of Dante's beloved Beatrice.

Throughout the *Lives* Vasari presents a veritable catalogue of artists who illustrate Dante. Orcagna painted an *Inferno* in Santa Maria Novella, all the circles and other details of which depend, Vasari says, on Dante—of whom the painter was "studiosissimo," a great student. He also painted an *Inferno* near the Ponte Vecchio following, according to Vasari, the description of Dante.

Vasari's very descriptions of Orcagna's works are dantesque. In his *Last Judgment* in Santa Croce, Orcagna is said to have placed his enemies in hell, his friends in paradise—approximating Dante's practice or presenting his own contemporaries in the *Comedy.* Orcagna's depiction of Cecco di Ascoli, the "famous magician," evokes the fraudulent magicians in the fourth "bolgia" of *Inferno* XX, and his "frate ipocrito," or hypocritical friar, evokes Fra Catalano and his confreres in the sixth "bolgia" of *Inferno* XXIII. Describing Orcagna's *Last Judgment* in the Camposanto in Pisa, Vasari uses the very language of Dante's *Inferno.* The damned, who are dolorous, "dolorosi," are dragged down by furious demons, "da furiosi demoni strascinati." The writing here is in the language of *Inferno* XIII, which vividly pictures the "dolore" of the damned, who drag their bodies through this dismal underworld: "qui le stascineremo," here we will drag them. When Vasari adds that in this fresco Orcagna portrayed Pope Innocent, adversary of Manfredi, he alludes to the famous Manfred of *Purgatorio* III.

Painting scenes of heaven and hell, dantesque visions of Apocalypse, Orcagna is like Giotto before him, at the beginning of the rebirth of art, and like Michelangelo at the summit of its reformation. Orcagna, Vasari tells us, is not only a painter but a sculptor, architect, and poet. It cannot escape the reader that in this respect the dantesque artist is like Michelangelo.

Vasari links other works to Dante, even where he does not believe that there is a precise connection between the painting and the *Comedy.* He says that Taddeo di Bartolo, painting an *Inferno* at Monte Oliveto, followed the "invention of Dante." He further observes, however, that the painter did not follow Dante's division of sinners and punishments, either because he could not or did not want to imitate the poet.

Some artists were more exacting in their imitation of Dante. Thus we read in the life of Filippino Lippi of a certain Raggio, who carved inside a conch shell—imagine!—all the circles of hell, all the figures and details from Dante. The *Inferno* was "most ingeniously imagined" by the poet, and, as Vasari suggests, Raggio, himself a person of great "ingegno," exhibited his own wit by translating Dante in a bravura performance on such an exquisitely minute scale.

Other Florentine artists, Vasari also observes, illustrate specific subjects from Dante. Michelangelo's contemporary, Tribolo, master of Florentine fireworks, made for the famous "festa" of San Giovanni not only the burning cities of Sodom and Gommorah but also an *Inferno* with Geryon, the beast of fraud, who carries Dante and Virgil into Malebolge in *Inferno* XVII. Tribolo's protégé Pierino da Vinci also illustrated another of Dante's infernal subjects. Inspired by Luca Martini's commentary on Dante's *Comedy*, he made a relief, based on *Inferno* XXXIII, of the treacherous Ugolino of Pisa and his sons starving to death. Vasari is quick to add that Pierino exhibited no less "virtù" than Dante did in his verses, that, like Dante's work, the relief moves the viewer to pity.

It is only fitting that Vasari himself should refer to Dante in his art. Like Tribolo and Pierino, working under Michelangelo's sway, Vasari alluded to the *Comedy* when he painted in the church of Santa Maria della Scala in Rimini. Here he painted, as he tells us, all those who sang the praise of Jesus and Mary, quoting with his portrait of Dante the poet's celebration of Mary in *Paradise* XXXIII: "thou art she who didst so ennoble human nature that its Maker did not disdain to be made its making." These words are from the prayer of Saint Bernard that, as Giovan Battista Strozzi implied in his poem quoted by Vasari, inspired Michelangelo's *Pietà*. Imitating Dante, Vasari imitated Michelangelo, the new Dante.

The Language of Dante

We have already seen how Vasari uses the language of Dante to describe works of art—as if both they and their makers were dantesque. He quotes a poem of Giovan Battista Strozzi, in which the poet de-

scribes the dome that Brunelleschi built for the cathedral "di giro in giro"—circle by circle. The allusion here is appropriately to Dante's paradise, described in the *Comedy* on more than one occasion, "di giro in giro." The similitude between Brunelleschi's dome and Dante's paradise is appropriate not only because the dome is a conventional symbol of heaven but because, we recall, Brunelleschi, as Vasari says, was a scholar of Dante's poem. When Vasari also says that Brunelleschi, a "new Saint Paul," was a scholar of Dante, he also links him to Dante in another respect, since in *Inferno* II, when Dante insists that he "is no Saint Paul," he intends to identify himself with the saint, who both descended into the earth and rose up into heaven. Brunelleschi's dome rising heavenward "di giro in giro" is rooted in Dante's pauline ascent to heaven, just as it comes to foretell Michelangelo's own dantesque and pauline ascent to paradise, when he builds a similar heavenly dome for the mother church.

Vasari freely adapts Dante's language appropriate to subjects not explicitly dantesque. He pictures for us the *Massacre of the Innocents* painted in Santa Maria Novella by Michelangelo's teacher Ghirlandaio. Focusing on the bloody horror of the subject, especially the detail of the dying child with wounds in the throat, who sucks in as much blood as mother's milk, he says that the manner in which the child is painted can "kindle a spark of pity in the coldest heart"—"da tornar viva la pietà dove ella fusse ben morta." Vasari's words here approximate Virgil's to Dante in *Inferno* XX: "Here pity lives where it is quite dead"—"Qui vive la pietà quand'è ben morta." Inspiring pity, Ghirlandaio is like the dantesque Pierino da Vinci, who inspired such pity in his relief of Ugolino and, like Pierino, he resembles Dante himself.

Vasari's uses of Dante to describe paintings can be quite free. After saying that one saw the very beating of the pulses of Leonardo's *Mona Lisa*—"vedeva battere i polsi"—he observes that the manner in which Leonardo painted would cause fright and make tremble every bold artist, "far tremare e temere ogni gagliardo artefice." His reference to the Mona Lisa's pulse, to the effect of trembling, is an ingenious allusion to Dante's response to the leopard of *Inferno* I, who sets the pulses trembling: "mi fa tremare le vene e i polsi." Not only is Dante's subject terrifying, but so is his style, and Vasari associates the "terribilità" of Leonardo's art with that of Dante's by adapting the poet's language of terror.

Dante also informs Vasari's identification of pictorial subjects. Describing Raphael's *Expulsion of Heliodorus*, he says that in it Pope Julius "expels avarice from the church." Since Julius is portrayed in the guise of the ancient priest whose prayers for divine intervention are met by an avenging angel who drives out Heliodorus, despoiler of the temple, this description seems perfectly appropriate to what Vasari sees. It is possible, however, if not likely, that when Vasari speaks of the "avarizia" of Heliodorus he is thinking of *Purgatorio* XX, where Heliodorus is presented as an example of this very vice. For Vasari, as for Dante, the expulsion of Heliodorus from the temple exemplifies the purgation of vice, and Vasari's reference to avarice in his description suggests the further possibility that Raphael himself had Dante in mind when he painted the fresco.

Not unexpectedly, Dante's language informs his biography of Michelangelo, even in his description of works themselves not influenced by Dante. When he describes the Jews who proceed every Saturday to adore Michelangelo's *Moses*, he says they go "in a flock . . . like starlings": "a schiera . . . come storni." Vasari echoes *Inferno* V, where Dante compares the sinners to various birds, but specifically to starlings in a flock: "come li stornei . . . a schiera." Thus the Jews in Vasari's procession are vicious like those whom Dante beholds in hell.

At the end of his description of Michelangelo's *David*, Vasari uses Dante to very good effect, once again returning to *Purgatorio* XI. Announcing that Michelangelo has triumphed over all past sculptors, ancient and modern, he says that he has "taken the cry" from them: "ha tolto il grido." This phrase echoes Dante's statement that Giotto surpassed Cimabue, that Giotto "has the cry," "ha il grido." Vasari's use of Dante here makes Michelangelo into the Giotto of his own day. Reporting Michelangelo's giottesque triumph, Vasari himself assumes the role of Dante—appropriately, since, as we have seen, his *Lives* is a kind of "Divine Comedy" of art. The allusion to *Purgatorio* XI is especially apt, for it refers to the purgation of that very vice punished by Michelangelo's name saint, Saint Michael, who vanquished Satan for his "superbia" or pride. Michelangelo, Vasari says, was the paradigm of "modestia" or humility. Giotto's surpassing of Cimabue is a kind of purgation of pride, and Michelangelo's final triumph over all artists is such a purifying of art.

Portraits of Dante

Vasari also evokes *Purgatorio* XI in his description of a portrait of Dante. He pretends that when Taddeo Gaddi painted his lost fresco of a miracle of Saint Francis in Santa Croce he made portraits of Giotto, Dante, and Guido Cavalcanti, among others, including, some say, himself. The reference to Guido Cavalcanti in relation to Giotto and Dante is suggestive, for in *Purgatorio* XI Dante says that as the fame of Giotto obscures Cimabue, so one is born who will eclipse both Guidos (Guinicelli and Cavalcanti). Without saying so (and he cannot, for this would be pride), Dante is the very one who will surpass the two Guidos. By adding that Taddeo portrayed himself here, Vasari hinted in a dantesque manner that Dante would surpass the two Guidos, just as Giotto obscured Cimabue and Taddeo went beyond Giotto. Indeed Vasari says this, asserting that Taddeo improved upon Giotto's coloring, making it "fresher and more vivacious."

Vasari rarely misses an opportunity to keep before the reader's eyes the portraits of Dante—from Giotto's portrait of the poet through those made in his own day. Lorenzo Monaco, whose work is included in the first manner of Giotto, is said to have painted a portrait of Dante in his Ardinghelli decorations of Santa Trinita. Andrea del Castagno portrays him, Vasari tells us, among the famous men and women painted in the Casa de' Carducci, and Benedetto da Maiano, he also notes, portrays Dante on a tarsia door in the Palazzo della Signoria.

Vasari also mentions the portraits that he and his friends painted. Bronzino painted portraits of Dante, Boccaccio, and Petrarch for Bartolomeo Bettini, which were to accompany a painting of Venus and Cupid by Pontormo after a design by Michelangelo. Here Dante stands as the father of the Tuscan lyric tradition. Moreover, Vasari refers to a portrait of Dante (Fig. 14), which he painted for Luca Martini, who, we recall, wrote a commentary on Dante. In this portrait Dante is seated, surrounded by Guido Cavalcanti, Cino da Pistoia, and Guittone d'Arezzo, by Petrarch and Boccaccio. He holds a globe, as if to suggest his hegemony over the world of poetry. All of the poets, those who come before him and after, pay him court; in Dante's language, they "all honor him." If for Dante, Homer was the "sovereign poet," now for Vasari, Dante himself is the sovereign poet. Appropriately, Vasari paints Dante in the type of state portrait per-

fected by Raphael for the popes. Like Raphael's popes, Vasari's Dante is a monarch, a sovereign over the empire of poetry.

Two of the most famous portraits of Dante from the Renaissance, both mentioned by Vasari, were painted by Raphael in the Stanza della Segnatura. Dante appears among the theologians of the *Disputa* and again among the poets in the *Parnassus*. These frescoes explain the poetical and theological significance of Raphael's painting of Apollo flaying Marsyas in the ceiling of the room—an allusion to the

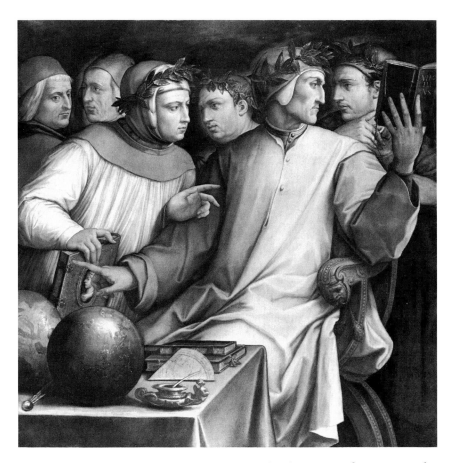

FIG. 14. Giorgio Vasari, *Portrait of Dante and Other Poets*. The Minneapolis Institute of Arts, Minneapolis

spiritual meaning of the mythic event described by Dante at the beginning of *Paradiso*. The flaying of Marsyas becomes for Raphael, as for Dante, an allegory of spiritual inspiration. Vasari's identification of Dante in both frescoes also points toward the larger dantesque meaning of the entire room. Raphael's assemblage of philosophers, poets, saints, and theologians alludes to the similar group of holy personages, poets, and philosophers in the Limbo of *Inferno* IV. Suggesting that Raphael portrayed himself in *Parnassus*, in proximity to Dante, Virgil, and Homer, Bellori later implied his own understanding of Raphael's dantesque intentions. Bellori suggested not only that Raphael was also a poet but that, by joining the great poets, he was like Dante, who "was made one" of their number.

Vasari seems to understand the dantesque implications of Raphael's *Parnassus*, which becomes the basis for a dantesque painting of his own. In a Parnassian picture painted under Vasari's supervision by Allori, on the occasion of Michelangelo's funeral, Michelangelo was shown at the center of the Elysian fields, attended by Praxiteles, Apelles, Zeuxis, Parrhasios, by Cimabue, Giotto, Masaccio, Donatello, Brunelleschi, and many other moderns. They all receive Michelangelo, Vasari says, as "all the other poets received Virgil upon his return, according to the fiction of the divine poet Dante," the moment before they made Dante one of their own. Not only is Michelangelo now the central poet, but he is described in dantesque terms. Vasari says of Michelangelo what Dante said in *Inferno* IV of Aristotle: "All admire him, all pay him honor."

Many of the artists who honor Michelangelo hold famous works that they themselves made. Among the ancients, Praxiteles is shown holding his *Satyr*, which was, Vasari says, in the villa of Pope Julius III. Michelangelo worked at this villa in the years before he dictated his life to Condivi, which included the story of his own faun or satyr. Could Praxiteles' *Satyr* have been in his mind when he invented his own faun, intending to suggest that he was a new Praxiteles? Among the moderns in the painting in honor of Michelangelo, Giotto is portrayed with his portrait of Dante. This was the first in the full gallery of such portraits of Dante catalogued by Vasari. The painting for Michelangelo's funeral is not such a portrait, although it includes Giotto's highly typical work. Rather, it is a dantesque portrait of Michelangelo, who, entering into the world of the *Comedy*, is seen as if he were the protagonist of Dante's poem.

Dante's Artistic Self-Consciousness

Although Vasari's emphasis on Dante's role in Florentine cultural life is surely part of the general celebration in Florence of Dante's accomplishment, there can be no doubt that Michelangelo's identification with Dante spurred Vasari to develop the allegory of his history of art along the lines of the *Comedy*, to develop a typology of artists who were like Dante. It is generally thought that Michelangelo wrote his two poems about Dante some time during the 1540s. This was the period shortly after his completion of the dantesque *Last Judgment*, the same time that he appeared as an authority on Dante in Giannotti's dialogues, which included one of these poems, and the very period when Vasari was composing his dantesque *Lives*.

Both of Michelangelo's poems about Dante emphasize Dante's exile from Florence: "If I could have been he! Born to such fortune, to have his bitter exile and his virtue I would forego the world's most splendid portion." Clearly Michelangelo developed his own dantesque persona by seeing himself as an exile from Florence. After his departure from Florence in 1534, he never returned. He associated with the circle of "fuorusciti" or exiles in Rome, including Giannotti, for whom Dante was an exemplary hero as heroic exile. In the 1550s, when Vasari wrote to Michelangelo on behalf of Duke Cosimo de' Medici beseeching him to return to Florence, Michelangelo refused, insisting that it would be a sin to leave his work at Saint Peter's. Despite assurances that he would be treated very well in Florence, Michelangelo maintained his image as dantesque exile by never returning. His wish that he could be Dante ("would that I were he") was part of the process of becoming Dante.

One can go even further in clarifying Michelangelo's motives. Aspiring to Dante's "bitter exile" and "virtue," Michelangelo thinks to achieve and surpass them. He concludes one of these poems about Dante: "a like or greater man was never born." From everything we know about Michelangelo's ambitions, however, we can read this line to mean that no man before Michelangelo was worthy of Dante but that Michelangelo was greater, "maggiore." This is clearly the way in which Vasari came to perceive Michelangelo—as both "simile," like, and "maggiore," greater, than Dante.

This is not an unreasonable way to read either Michelangelo or Vasari, because Dante had encouraged them to read himself in this way. Readers of the *Comedy* have always been aware of Dante's acute sense of place in literary history, of his goal to achieve primacy in this history. This ambition fired Michelangelo's own imagination and image of himself. Following the example of Virgil, his "maestro" and "autore," Dante aspired to achieve in his *Comedy* a status greater or "maggiore" than that of the *Aeneid*. When Virgil delivers Dante to Beatrice and she leads him into paradise, Dante rises above Virgil both in Christian doctrine, of course, and poetical accomplishment. Throughout the poem Dante writes about himself in relation to the ancient and modern poets he wishes to surpass. Already in *Inferno* IV, the passage referred to by Vasari in his description of the painting of Michelangelo honored by all artists, Dante is received into the circle of ancient poets. This sense of his exalted place in literary history foretells his eventual transcendence of the ancients, even as his comments in *Purgatorio* XI indicate that he will be the one who will chase the other poets from the "nest" of Florence, surpassing them.

When Michelangelo writes one of his poems about Dante, he uses the very word "nido" or nest to describe the city where, he says, he was born: "el nido ove nacqu'io." Born in fact near Arezzo, as Vasari says, linking Michelangelo to the glory of his own native city, Michelangelo now conveniently claims that he was born in Florence in order to develop his identification with Dante. Dante will surpass the two Guidos, as Giotto obscures Cimabue and Michelangelo, finally, transcends Dante himself. Dante's self-consciousness and way of describing his own poetical triumph and greatness furnish Michelangelo and his biographer with the means of imagining Michelangelo's ascendancy over Dante. In their shared historical vision, Dante comes to play Virgil to the dantesque Michelangelo, leading him to the stars.

The Bark of Saint Peter

In 1550 Michelangelo sent a poem to Vasari, thanking him for the *Lives*, a copy of which Vasari had sent him. No doubt Michelangelo was thanking his friend specifically for what he had said about himself, for Vasari had placed him at the summit of those who live eternally,

"eternamente vive," in history. Three years later Condivi published his biography of Michelangelo. Although Michelangelo corrected errors of Vasari's in dictating his life to Condivi, he also, in an act of eminent domain, exploited Vasari's rhetoric. During the next years Michelangelo wrote letters to Vasari, which remarked on his "spiritual sonnets" and his work at Saint Peter's. Both the poems and letters were dantesque, and in them Michelangelo profited from the fact that Vasari had written a "Divine Comedy" of art in which he was a dantesque pilgrim.

Vasari, in turn, exploited these letters, as we have seen, as well as a poem that Michelangelo sent him by quoting them in his revised biography. In this poem, the famous "Giunto è già 'l corso della vita mia," and in a series of related poems, Michelangelo became even more self-consciously dantesque, speaking of himself as a pilgrim—as if he were responding to the way in which Vasari had situated him in his epic, indeed dantesque, history of art. By quoting these letters and the poem, Vasari further magnified Michelangelo's dantesque identity. There were two Dantes, Dante the poet and Dante the pilgrim; so too there were two Michelangelos, Michelangelo the poet-artist and Michelangelo the pilgrim. In the revised *Lives* Vasari illuminated Michelangelo's persona as dantesque pilgrim by quoting Michelangelo's own words. The letters quoted by Vasari also recall Dante's commentaries on his poetry in the *Vita Nuova*, Michelangelo's letters being his own dantesque commentaries on his dantesque art and poetry. Vasari served as Michelangelo's "secretary," recording for Michelangelo his own "Divine Comedy" and "Vita Nuova." Indeed, as we have seen, these letters and poems of the 1550s are essentially about spiritual rebirth or "new life."

In the most famous of all the poems about the pilgrimage of his life (the one quoted by Vasari), Michelangelo begins: "Now hath my life across a stormy sea like a frail bark reached the wide port where all are bidden ere the final judgment fall, of good and evil deeds to pay the fee." Vasari shrewdly conflates the letter from Michelangelo accompanying this poem with another letter from the following year about Saint Peter's, making the latter part of the commentary of the poem. This letter is part of Michelangelo's denunciation of the church *à la* Dante's Saint Peter. Speaking of those who wish him to depart from Saint Peter's as "ghiotti," gluttonous, Michelangelo refers to the flock of Saint Peter in *Paradiso* XI, which has become gluttonous: "è fatto

ghiotto." Dante is concerned in this canto with "Peter's bark on the right course in the high sea." By analogy, Michelangelo is saying that he must stay at the helm of the bark of Saint Peter's to protect the church from those gluttons who would steer it off course. It is as if the "frail bark" with which Michelangelo completes his life's journey were the "barca" of Saint Peter's itself.

In Dante's Bark

Completing the dome of Saint Peter's—his *Paradiso*—Michelangelo brings to a close his life's journey. Although the idea of life as a sea voyage is a literary commonplace, and a tired one in the sixteenth century, the marine metaphor of Michelangelo's "Giunto è già 'l corso della vita mia" is profoundly and specifically dantesque. Strangely enough, this dantesque meaning is not illuminated in the standard exegeses of the poem, but all we need do to see this relation is to set Michelangelo's words against the imagery of Dante's poem. We should bear in mind that Michelangelo's poem is part of a series of related poems in which he speaks of himself as a "weak vessel" on the "rough cruel seas" of life.

In *Inferno* Dante observes the "dangerous waters" of this journey, the "flood" and "strong winds," the "sound of the waters." He passes across the Acheron, the River Styx, and the river of boiling blood, the Phlegethon. Pluto is likened to a vessel, his sails collapsing; Geryon, who carries Dante down into Malebolge, is a "navicella"; one of the giants at the bottom of hell is like a boat or "nave"; and Satan has the wings of a seabird. Perhaps the central marine image appears near the middle of *Inferno*, when Brunetto Latini speaks of the "corso" of Dante's voyage toward the "glorious port" of salvation. This is the very language Michelangelo adapts, speaking of "the course of my life" as he approaches "the common port" of redemption.

Dante sustains the imagery of his pilgrimage as a sea journey in *Purgatorio*. Here he boldly begins by speaking of the "little bark" or "navicella" of his wit or "ingegno," which lifts its sails as he leaves behind the cruel seas of *Inferno*. Now a pilot antithetical to Phlegyas or Charon, a "heavenly pilot," guides the souls across a river to the shores of purgatory and eventually, at the climax of *Purgatorio*, Dante

will pass beyond the waters of Lethe and Eunoë. During his journey
through purgatory Dante likens Italy to a ship in a storm without a
pilot, and Beatrice, who appears in Canto XXX, enters upon a chariot,
which is like a ship. She is the "admiral" of this vessel, which stands
for the Church. Led by her, Dante passes through the "most holy
wave" of Lethe, purified, renewed, and ready to mount to the stars.

Entering into paradise, Dante completes his journey, passing upon
his little bark or "piccioletta barca" into "the great sea of being"—"lo
gran mar dell'essere." As he says, God's will, toward which all move,
is a sea or "mare," and here Dante finally reaches the "glorious port."
The allegory of the poem is so powerful that Boccaccio adapted it to
his brief biography of Dante, comparing the little bark or "picciola
barca" of his biography to the "piccioletta barca" of Dante's life. Now
Michelangelo in his "frail bark" also imitates Dante, making Dante's
sea journey toward salvation a central element in his own allegorical
autobiography.

Dante and Michelangelo's Portrait Medal

Several years after Michelangelo wrote the poem about the spiritual
sea journey of his life, he designed his portrait medal (Fig. 6). Al-
though the aged pilgrim upon the medal descends ultimately from the
biblical idea of life as a spiritual journey, the pilgrim also stands for
Michelangelo's imitation of Dante the pilgrim. Like Dante the poet
creating Dante the pilgrim of his poem, Michelangelo the poet cre-
ates his persona as pilgrim, as dantesque pilgrim.

If the blind pilgrim of the medal evokes the pauline pilgrim who
walks not by sight but by faith, we should recall here that Dante, at
the outset of his journey, had already identified himself with Saint
Paul. Saying that he is "no Saint Paul" in *Inferno* II, he suggests his
very relation to the saint. Dante reinforces his own pauline persona,
saying to Virgil that he fears that his journey would be folly: "temo che
la venuta non sia folle." This is pauline folly in Christ, for Dante is
proceeding in his journey on the "way of salvation" through Christ.
Michelangelo, in the letter to Vasari accompanying his poem, which

Vasari quotes approximately, speaks of himself as "pazzo," thus identifying with Saint Paul. Dante imitated Paul; now Michelangelo imitates Dante imitating Paul. Vasari embellished this double imitation when he made Brunelleschi, the type of Michelangelo, both a new Saint Paul and dantesque artist.

Not only the pilgrim of the medal but also the inscription from Psalm 51 on the medal had dantesque meaning for Michelangelo. As Dante proceeds through *Purgatorio*, he is purged of the seven deadly sins, the *P* of each "peccato" or sin being cleansed from his brow, step by step. Throughout *Purgatorio* the penitent souls appropriately intone the "sweet psalmody" of David as they seek to purify themselves of vice, to purge themselves of sin. Of all the psalms quoted by Dante, Psalm 51, the psalm of Michelangelo's medal, is one of the most important, if not the most important psalm, for it is quoted twice in *Purgatorio* and again near the end of *Paradiso*.

In *Purgatorio* XXIII Dante hears *"Labia mëa, Domine"* ("O Lord open Thou my lips"), sung in tones that brought him both grief and sorrow, and at the end of *Purgatorio* in Canto XXXI, as he approaches the "blessed shore" of the River Lethe, he hears *"Asperges me"* ("Purge me with hyssop"), sweetly sung. Finally, in *Paradiso* XXXII, the penultimate canto of the entire poem, Dante witnesses Ruth, great-grandmother of the singer David, who, in grief for his sin, cried out "Miserere mei" ("Have mercy upon me"). The medal, with its quotation from Psalm 51, becomes one of Michelangelo's own last spiritual poems, like the very poem in which, filled with weighty sin or "grave peccato," he prays to God in the language of this psalm, "Miserere di me," "have mercy on me." Michelangelo's medal is not only davidic and pauline but dantesque, for the pilgrim of the medal, following the examples of Saint Paul and David, stands for the dantesque Michelangelo. The faithful and penitent pilgrim is emblematic of Michelangelo's deep identification with Dante.

Michelangelo and Beatrice

Dante's poetry is begotten of the Bible and theological literature. His *Vita Nuova* or *New Life* marks a pauline change of life, a conversion to God resulting from his vision of Beatrice. The allegorical elements of

this spiritual autobiography are richly amplified in the *Comedy*, in which Beatrice leads Dante into Paradiso. In his *Lives* Vasari develops the allegory of Dante's autobiography into a historical principle. Artistic rebirth and spiritual renewal date from circa 1300, the moment of Dante's journey. Giotto, the type of Michelangelo, is directly associated with Dante; his art, like Dante's poetry, epitomizes artistic and spiritual reform. Vasari writes from the perspective of the Catholic Reform, when such artistic and spiritual reform is completed by Michelangelo, the new Dante.

The language of Vasari's poetic, indeed dantesque, "Divine Comedy" of art is, like the poetry of Dante and his followers, charged with theological significance. The grace, splendor, and perfection of works of art convey their very spirituality and that of their creators. These works are described in the terms of "gentilezza," "grazia," "leggiadria," "spirito," "dolcezza," "leggerezza," and "miracolo," which Dante uses to describe his Madonna-like beloved, Beatrice. The supreme artist who achieves this beatricean ideal is Michelangelo.

In his poetry Michelangelo speaks of his beloved in similar terms, calling her a "specchio," mirror of virtue, and "lucerna," lamp. No wonder Vasari appropriates this very dantesque language in his description of Michelangelo and his work, speaking of him as the "most singular mirror in life," of his Sistine frescoes as a "lantern" of art. Michelangelo had aspired to be "maggiore" or greater than Dante, and Vasari makes Michelangelo into a new Beatrice. Like Beatrice, he is "divino," a figure of God; like Beatrice, he is angelic, "un angelo." A spirit sent into the world by God, he is like Beatrice who comes from heaven into the world to show forth a miracle: "venuta dal cielo in terra a miracol mostrare." Responding to Michelangelo's aspiration to achieve similitude with his beloved, with her beauty and spiritual perfection, through his art, which is born of love, Vasari asserts that Michelangelo achieves such perfection. The pilgrimage of Vasari's dantesque *Lives* thus concludes with the beatrification of Michelangelo.

Michelangelo and Homer

Becoming a new Dante, Michelangelo made himself into an epic poet. He joined the ranks not only of Dante but, with Dante, of Virgil

and Homer. At the end of his "autobiography" dictated to Condivi, Michelangelo compares himself to Homer. He says that he was courted by the popes, by the sultan of Turkey, by the king of France, by the Signoria of Venice. In this respect he was like Homer, who, of "singular virtue," was the subject of competition among many cities that wanted to appropriate him as their own.

Michelangelo's idea of himself as a new Homer was, by the time he dictated his life to Condivi, more than sixty years old. We first encounter it at the time when Michelangelo was in the Medici gardens. This notion of Michelangelo's homeric identity is implicit in the relief sculpture the *Battle of the Lapiths and Centaurs* (Fig. 15). It has been

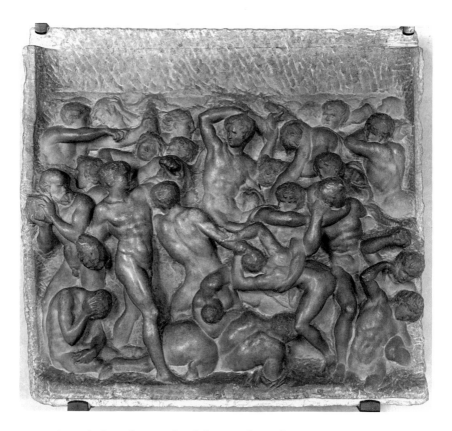

FIG. 15. Michelangelo, *Battle of the Lapiths and Centaurs.* Casa Buonarroti, Florence

called the first expression in his work of the michelangelesque. In this respect, it is Michelangelo's first essay as an epic artist.

Michelangelo made this relief, his biographers tell us, according to the advice of Angelo Poliziano, classicist and poet, the foremost scholar of Homer in Florence. His influence on Michelangelo is seen in the curious iconography of the work, as well as in its homeric connotations. According to the poets, when hostilities broke out between the Lapiths and the Centaurs, the combatants picked up the various objects at hand. In Michelangelo's relief, however, the Lapiths hold or hurl primarily huge stones. It is likely, if not probable, that this choice is purposeful—a play on words, since the Lapiths ("Lapiti") "lapidano" (lapidate or stone) their adversaries. Michelangelo makes visible a translingual play on words, from the Greek ("Lapithai") into Latin ("lapis" for stone)—the very kind of verbal wit we might expect in a "poesia" of Poliziano.

There is another curious detail in the relief overlooked by its exegetes, which, when explicated, points us toward Michelangelo's epic ambitions. Whereas virtually all of the figures in the relief are youthful, one figure standing at the left, a bald old man holding up a stone with both hands, is exceptional (Fig. 16). In the life of Pericles, Plutarch describes a battle relief on the shield of Athena in the Parthenon, in which Phidias introduced "a likeness of himself as a bald old man holding up a great stone with both hands." Surely this coincidence is not fortuitous. We can reasonably imagine that Poliziano furnished Michelangelo with the reference to Phidias. By representing Phidias's self-portrait on a similar battle relief, Michelangelo implied the phidian character of his own work, as if he were a "Phidias redivivus."

Michelangelo, inventing a faun, was like Praxiteles carving his famous satyr; he was also a new Phidias making a periclean relief. When Vasari reports that, carving the giant *David*, Michelangelo triumphed over all ancients, he echoes Michelangelo's competition with the ancients in his early classicizing works, notably the *Battle of the Lapiths and Centaurs*. By suggesting the phidian reference to his protégé, who was little more than fifteen years old when he carved the relief, Poliziano was exploiting the classic literary commonplace of the child prodigy with the skill of an old man of wisdom, the "puer senex." Phidias was both "old" and "antique." In this respect the "Phidias" of the relief was like the old faun that he told Condivi he made in his

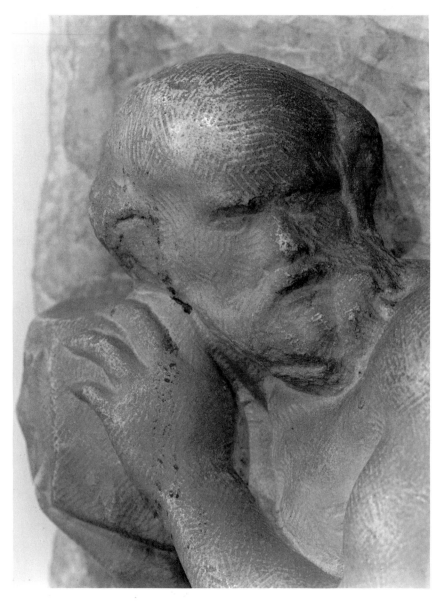

FIG. 16. Michelangelo, *Battle of the Lapiths and Centaurs* (detail of Phidias). Casa Buonarroti, Florence

youth. Perhaps he invented the faun in old age, remembering the old Phidias of his earlier days. As Michelangelo told Condivi, he had a "very tenacious memory."

The *Battle of the Lapiths and Centaurs* exhibits great fury, anticipating the similar character of his subsequent epic painting in the Sistine Chapel. Poliziano, student of Homer, must have encouraged Michelangelo to think of himself as an epic artist, capable of great boldness or audacity. Indeed, Alberti had already said in *Della Pittura* that Phidias was the artist of Homer. Suggesting to Michelangelo this phidian equation, Poliziano encouraged him, therefore, to form himself as a new Homer. Michelangelo's furious relief, like ancient Greek battle scenes, was carved in the spirit of Homer. When he told Condivi that he was like Homer, claimed by many cities, he no doubt recalled the time—in the "antiquity" of his own lifetime—when he began to think of himself as a new Homer.

The Wrath of Achilles

Poliziano not only encouraged Michelangelo to think of himself as a new Homer but to conceive of himself as a homeric hero. The "furia" of Michelangelo's figures, michelangelesque fury, was thus both expressive of Michelangelo's "furore" as poet and his rage as epic hero. As Poliziano himself had said, and Michelangelo would later repeat the assertion, "every painter paints himself." Painting and carving figures of great fury, Michelangelo was portraying his own tempestuous temper or self. It was as if, metaphorically, he was an epic warrior.

The principal source for Michelangelo's persona as homeric hero is Poliziano's *Bel Libretto*, a series of facetious utterances or stories, "facezie," as they were often called. The stories of Donatello in Poliziano's book are well known to students of Renaissance art, but their relevance to Michelangelo escapes notice, strangely enough, since Donatello came to be seen as the type of Michelangelo. In two of these stories Donatello's rage foretells Michelangelo's "terribilità" and irate behavior.

According to one anecdote, Donatello becomes angry when he fails to gain access to the patriarch Vitelleschi and goes off, remarking defiantly, "in my art, I, too, am patriarch." This tale conspicuously

forecasts the manner of Michelangelo's defiant departure from Rome when he fails to gain access to the pope. In Poliziano's other story, Donatello angrily refuses to complete the equestrian statue of the Gattamelata in Padua, smashing the head of the soldier in rage when he has to share the project with another artist and, in so comporting himself, he himself becomes a warrior. When his patrons threaten that they will cut off his head if he fails to repair the work, he replies defiantly that if they cut off his head there will be nobody to complete the task. Here too Donatello is a model for Michelangelo in his wrathful defiance of his patrons.

Poliziano's anecdotes are appropriated and ornamented by Vasari, who transfers the story of Donatello's equestrian statue to Verrocchio. In both the lives of Verrocchio and Bellano, Vasari claims, *à la* Poliziano, that Verrocchio's rage results from his being told that he must share the commission for the Colleoni project with Bellano. In the life of Donatello, Vasari's anecdotes also resemble Poliziano's. Donatello indignantly strikes his own *Zuccone* when it fails to answer him and, when a merchant fails to pay him what he thinks he deserves for a head, he drops it, smashing it to pieces. In these stories, the rage of Donatello and Verrocchio, their refusal to work or deliver their work, all prefigure the similar tendencies of Michelangelo. Both of these artists are linked to Brunelleschi, also a type of Michelangelo, who refuses to work on the dome for the cathedral of Florence if he has to share the project with Ghiberti. Throughout Vasari's biography of Brunelleschi, the artist is described as "appassionato," capable of expressing great "ardore" and "furore." Brunelleschi undertakes the building of his dome at great "risk." Indeed, he enters into a battle with the heavens, a "combattere col cielo." He is, in short, a warrior who prefigures Michelangelo, the final victor in the battles of art.

In his wrath, his refusal to work, his violence and pride, Poliziano's Donatello is like Homer's Achilles, who refuses to enter the battle against the Trojans until his concubine Briseis is returned to him by Agamemnon. Poliziano's Donatello, in his defiance of the patriarch, is like Achilles in his defiance of the "patriarch" of the Greeks. Poliziano, scholar of Homer, who encouraged Michelangelo to think of himself as a homeric artist, thus furnished Michelangelo with the achillean idea of the artist that informed his defiance of his patron, Pope Julius II. The Greeks could not win the war without Achilles and, similarly, the pope's tomb could not be completed without Michelangelo. When

Vasari used military metaphors, describing the "triumph" of Michelangelo's art, he magnified Michelangelo's own sense of himself as an epic artist in the field of art. Vasari intensified Michelangelo's idea of himself derived from the example of Poliziano's Achilles-like Donatello, and Vasari followed Michelangelo back to his source in Poliziano. In Christian terms, Michelangelo was a messiah of art, both human and divine, but, in conformity with the epic tradition, he was also like Achilles, a demigod. Vasari might well have written: "Sing goddess, the anger of Buonarroti's son Michelangelo and its devastation."

The Christian Epic

Michelangelo's idea of himself as an epic hero of great wrath brings us back yet again to Dante. What makes Dante so significant in the history of the epic tradition is the fact that he transforms the epic hero into the poet-pilgrim. He thus makes the epic into an autobiographical work, the first modern autobiography of the artist. Turning the warriors of the classical epic, Achilles, Odysseus, and Aeneas, into the poet-pilgrim, Dante invented the modern idea of the poet as hero, as the subject of his own work—an idea that Michelangelo would exploit when he became an epic artist and saw himself as an epic hero. The transformation of the epic hero into a poet or artist necessarily leads us also to Saint Augustine.

Although there is nothing specifically augustinian about Michelangelo, it is necessary to return to Saint Augustine in order to see how the epic was transformed into autobiography, a revision of the epic essential to Michelangelo's creation of himself. Rewriting the *Aeneid* in his *Confessions*, Augustine, it has been said, assumed the role of Aeneas, making the epic hero's journey to Rome the allegorical vehicle for his own spiritual pilgrimage toward God. Although Augustine claims that his reading in boyhood of the *Aeneid* was a waste of time, he acknowledges that he profited from Virgil's work, and his *Confessions* are evidence of the uses to which he put Virgil. Aeneas meets Dido in Book I of the *Aeneid*, and Augustine confronts her in the first book of his *Confessions*. In Book IV of the *Aeneid* Aeneas expresses his desire to go to a second Troy (Rome), and in the fourth book of the *Confessions* Augustine is moved by the rumor of Rome. In Book V of the *Aeneid* and

the *Confessions*, both Aeneas and Augustine set out on their respective journeys. Also in Book V of the *Confessions*, Augustine's mother takes on the role of Dido; he leaves her weeping in Carthage and acknowledges that he has lied to her. Gradually, however, Augustine reworks Virgil, using Genesis, just as Dante, following Augustine, reworks Book VI of the *Aeneid* in relation to the Bible and, as we will see, Michelangelo refashions Virgil in relation to Genesis.

By patterning himself on the itinerant Aeneas, Augustine made himself into the spiritual pilgrim in an allegorized epic autobiography. Dante would exploit this framework, making his own spiritual and confessional pilgrimage, rooted in Virgil, conform to Augustine's. We cannot fully understand Michelangelo's formation of his own persona if we do not locate its roots beyond Dante, in Augustine's revision of Virgil. Augustine established the basis for the Christian epic, in which the poet and artist, as spiritual beings, imitate the journey of Augustine, who modeled himself allegorically on Aeneas. If the distant background of the confessional character of Michelangelo is the David of the Psalms, the foreground lies in Saint Augustine, whose uses of the virgilian tradition Michelangelo inherited through Dante. Following Dante, Michelangelo meditated on Virgil's importance to Christianity, and it is to Virgil that we must turn if we are to probe even more deeply into Michelangelo's persona and its roots in the Christian epic.

Michelangelo as Virgilian Victor

In the "proemio" to the third part of the *Lives*, Vasari boldly asserts that Michelangelo is the victor or "vincitore" of art. The triumph or "trionfo" is his. Artistic victory is also a major theme in the very first life of the third part of Vasari's book, that of Leonardo. Vasari quotes Giovan Battista Strozzi's poem in which, playing on Leonardo's name, the poet says that the artist defeats Phidias and Apelles, "vince Fidia, vince Apelle." He similarly quotes from Giovanni Gaddi's epigram on Leonardo's drawing of Neptune, which surpasses the "painting" of Neptune in Homer and Virgil, "vincit eos." Even in his discourses, Vasari adds, Leonardo is triumphant, for he vanquished, "vinceva," every bold genius with his discourse.

In a description of Michelangelo's *Last Judgment*, the climax of the artist's biography and of the *Lives* in the first edition, Vasari says that Michelangelo is the victor over all artists, implicitly but pointedly referring to his victory over his earlier rival, Leonardo. Michelangelo's ambition was so great, Vasari adds, that he even wanted to triumph over himself—"volse vincere se stesso." The idea of victory is here associated with the victory of Christ's judgment, but it also evokes Michelangelo's metaphorical identity as epic hero, triumphant over his adversaries in battle. This victory also alludes to his role as epic artist, triumphant over all artists, as Leonardo had previously been victorious over all epic artists and poets, victorious over Homer and Virgil, over Phidias, the very artist of Homer.

Vasari's idea of Michelangelo's artistic or poetic victory is derived from Virgil. In Book III of the *Georgics*, Virgil dreams of his victory as poet: "I must essay a path whereby I, too, may rise from earth and fly victorious on the lips of men." Conceiving of his poem as a temple in honor of Caesar, Virgil is concerned, ultimately, with his own fame, his own triumph, speaking of himself as victor: "victor ego." There can be little doubt that Vasari, who was steeped in Virgil, had him in mind when he spoke of Michelangelo as "vincitore." "Victor ego," as Vasari suggests, might just as well have been the words of Michelangelo himself. It is only fitting that Vasari should construe Michelangelo's triumph in virgilian terms, since Michelangelo in fact illustrated virgilian subjects, aspiring to epic grandeur, or what Vasari speaks of in a different context as "gravità eroica."

Virgil and Michelangelo

Imitating Dante, Michelangelo necessarily imitated Virgil. Not surprisingly, Lattanzio says in the dialogues of Michelangelo's friend Hollanda: "Read all of Virgil and you will find nothing but the art of Michelangelo." It is therefore strange that Michelangelo's relations to Virgil are no longer discussed. We need only recall that, painting both Charon and Minos in the *Last Judgment*, for example, Michelangelo was illustrating dantesque subjects derived ultimately from Virgil's underworld. Vasari, who knew the *Aeneid* well, as he tells us, had Virgil's poem in mind while describing Michelangelo's fresco. His

quotation from Dante's *Purgatorio* XII, "the dead seemed dead, the living seemed living," follows the description of the figured pavement of the proud brought low, the last subject of which illustrates the theme of Virgil's epic: "I saw Troy in ashes and heaps."

Already in the frescoes of the Sistine ceiling Michelangelo's subject was virgilian. It has often been observed that, painting the magnificent *Ignudi* of the ceiling, Michelangelo responded obsessively to the pathos in the ancient statue of Laocoön and his sons, recently rediscovered and absorbed imperially into Pope Julius II's collection in the Vatican. The statue, as Sadoleto's poem, written at this time, makes evident, carried with it the authority of Virgil's account in Book II of the *Aeneid* of the death of the Trojan priest and his sons, which was truly "horrendous." Michelangelo's manner of depicting the *Ignudi*, inspired by the ancient sculpture, is thus like the statue, not only classicizing but distinctly virgilian. The virgilian connotations of Michelangelo's figures would surely not have been missed in Pope Julius's augustan Rome, which was saturated, if not satiate, as we will see, with Virgil's poem.

One of Michelangelo's most magnificent and prominent figures in the ceiling is even more virgilian than the *Ignudi*. Among the prophets and sibyls, at the center of the ceiling, sits the sibyl of Cumae (Fig. 17), the very sibyl to whom Virgil gave such an important place in Hades. Michelangelo's *Cumaean Sibyl* stands apart from the exquisite *Libyan Sibyl* and the noble *Delfica*, and not even the aged *Persica* is as grotesque as she. His monstrous figure is truly "horrendous," to use Virgil's very word for describing the sibyl. She is thus worthy of her ancestor in the *Aeneid*, to whom Michelangelo's figure ultimately alludes. We can properly rephrase Lattanzio's words in Hollanda's dialogue: "Look at the paintings of Michelangelo in the Sistine Chapel, both the ceiling paintings and the *Last Judgment*, and you will find the work of Virgil."

Michelangelo made clear his own virgilian ambitions when he spoke to Condivi of the "tragedy" of the tomb he made for Pope Julius II. He intended by this word the fact that he did not realize in the final tomb the original grandiose scheme, the vexations and tribulations of the project, which he endured over a period of several decades, making him a tragic figure in his suffering; however, he also used the word Dante employed in *Inferno* XX to describe Virgil's poem as a tragedy or "alta tragedia." When in *Purgatorio* XXII Statius

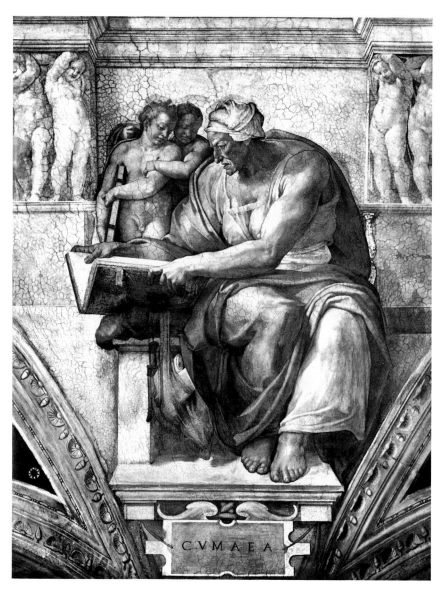

Fig. 17. Michelangelo, *Cumaean Sibyl*, Sistine Chapel. Vatican Palace, Rome

says to Virgil, "per te poeta fui,"—"through you I was a poet"—his words can be read as Dante's own, since Dante emulated Virgil's great epic. Similarly, the words, "through you I was a poet," also become Michelangelo's, for the Sistine Chapel frescoes are permeated by virgilian subjects and connotations, by the epic grandiloquence of virgilian "high tragedy."

A New Augustan Age

As the poet of the Roman empire, Virgil was especially important in the court of Pope Julius II, whose choice of names suggests his own imperial ambitions. Virgil stands prominently with Homer and Dante atop Raphael's *Parnassus* in the Stanza della Segnatura, painted for Pope Julius II in the period when Michelangelo was at work on the Sistine Chapel frescoes. The verbal tag, "numine afflatur," that accompanies the allegorical figure of *Poesia* above the fresco comes from Virgil, suggesting the fresco's theme of poetic "afflatus" or inspiration.

Michelangelo's and Raphael's common patron, Pope Julius, undertook great projects worthy of the ancient caesars: Bramante's new Saint Peter's, evocative of the Pantheon, and Michelangelo's gigantic papal tomb, imperial in its very scope. The poetry written for Pope Julius was no less imperial. Girolamo Vida wrote a virgilian epic, the *Juliad*, which no doubt aggrandized the pope as Virgil's *Aeneid* magnified his august patron. Although Vida's work is now lost, Raphael's frescoes in the Stanza d'Eliodoro, undertaken in celebration of Julius's powers, both temporal and spiritual, give us a visual sense of this epic and imperial ambition. Painted in a michelangelesque style, Raphael's frescoes reflect those of the Sistine ceiling, which are, themselves, virgilian.

The relations of Michelangelo to Virgil are also seen in Raphael's grandiloquent *Fire in the Borgo* (Fig. 18), painted for Pope Leo X in the Stanza dell'Incendio. The fresco depicts a fire during the reign of the pope's forebear, Leo III, and the scene is set forth as if it were the fall of Troy, for, as Vasari says, a muscular youth, carrying an old man from the raging fire, alludes to Aeneas bearing Anchises from the burning Troy. The grandeur of Raphael's figures conspicuously reflects that of Michelangelo's nudes in the Sistine Chapel; more gener-

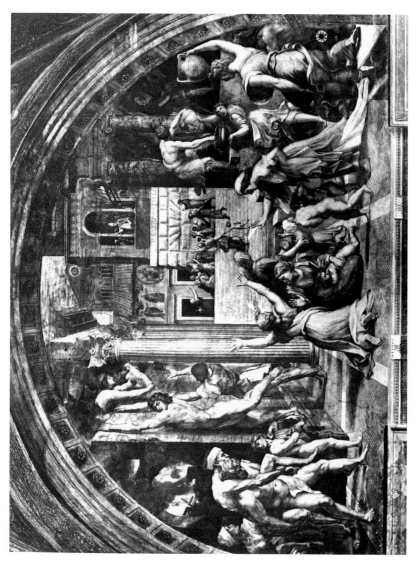

Fig. 18. Raphael, *Fire in the Borgo*, Stanza dell'Incendio. Vatican Palace, Rome

ally, as Vasari observes, the grandeur of Raphael's last style was de-rived from Michelangelo's example. Michelangelo put it even more bluntly, if less elegantly, when he wrote to Sebastiano del Piombo that the best parts of Raphael's painting depended on his own. Michelan-gelo, the new Virgil, furnished Raphael with the appropriate visual language worthy of his own virgilian subject.

It cannot have escaped Michelangelo's attention that in *Inferno* I Virgil told Dante that he was born "sub Julio"—that is, under Julius Caesar. Now, he, Michelangelo, working for a pope who took his name from Julius Caesar, made grandiose, indeed imperial, works "sub Julio." Michelangelo created a grandiloquent language of visual form worthy of the new papal emperor, a language corresponding to Virgil's epic poetry. As a new Virgil, Michelangelo, like the author of the *Juliad*, helped shape the Augustan Age of Pope Julius II.

Virgil and the Age of Gold

The colossal and horrendous *Cumaean Sibyl* of the Sistine ceiling reflects not only the *Aeneid* but also Virgil's fourth *Eclogue*. Accord-ing to a deep Christian tradition made highly significant in *Purgatorio* XXII, the sibyl of Cumae made a prophecy of the coming of Christ and of a new age. Just as the very subjects of Michelangelo's scenes from Genesis allegorically foretell the coming of Christ, so does his depiction of the virgilian Cumae, who, alluding to Virgil's eclogue, proclaims the coming of the Messiah.

In Dante's words, translated from Virgil into the Italian, "Secol si rinova," the age is renewed. "Justice returns and the first years of humanity, and a new race descends from heaven." In this allegorical reading, Virgil associates the new dispensation with the age of gold, when "the stubborn oak will distill dewy honey." Vasari understood this virgilian aspect of the ceiling, saying that the oak leaves and acorns that adorn the ceiling refer to the golden age of Julius. The oak is the emblem of the pope, whose family name, Della Rovere, means "of the oak." The arboreal forms in this christological context are said to refer to the Tree of Life, for the Cross of Jesus is the fruit of salvation. The julian oak also alludes to the age of gold, when the tree flourished and its fruits were bountiful—the very age of gold already re-created by Augustus. Pope Julius re-created the golden age, as

Augustus had done before him, now fusing this classical idea with that of spiritual regeneration. Evoking the sibyl of Cumae in Virgil's eclogue, Michelangelo's figure similarly sings of the "birth of the child" and a new age in Christ. Her prophecy of the little child, "parve puer," had come to be seen in relation to Isaiah's words: "unto us a child is born, unto us a son is given." Looking at Michelangelo's figure of Isaiah in proximity to the *Cumaean Sibyl* of the Sistine ceiling, we behold the relation between the classical and biblical prophecies.

Through the birth of Jesus and his sacrifice man can be reborn and freed of sin—a theme made explicit in Michelangelo's youthful figure of Jonah, who was resurrected or reborn from the leviathan. Painted above the altar table of the chapel, where Christ's sacrifice is celebrated, Jonah personifies rebirth, his physical beauty embodying spiritual completion or perfection. The theme of regeneration is amplified by the countless putti, angelic babies or "pueri," painted throughout the ceiling, who stand in opposition especially to the aged seers. They evoke the children who will inherit the Kingdom of Heaven, according to the words of Jesus. They are like the angels of *Paradiso* described by Dante, childlike or "puerili." They underscore the theme of spiritual rebirth through the "parve puer" of whom the Cumaean Sibyl speaks. For Michelangelo the *Cumaean Sibyl* of the Sistine ceiling thus refers not only to the *Aeneid* but to Virgil's fourth *Eclogue* as well. Her presence on the ceiling evokes her song in Virgil, prophesying spiritual renewal through the coming of Christ—the very theme of the ceiling.

The Victor's Wrath

If Michelangelo's *Cumaean Sibyl* sings the coming of Christ, his *Last Judgment* depicts Christ's return. Michelangelo's fresco proclaims Christ's victory, announcing also, Vasari suggests, Michelangelo's related victory as poet or artist. The theme of Michelangelo's virgilian triumph—"victor ego"—is bound up with the idea of "terribilità" in the fresco, for the victor, like Christ himself, is a figure of terror. For Vasari the word "terribilità" has two meanings: it stands for the terrifying skill of the artist capable of overcoming great obstacles or difficulties, as in foreshortening, and it is also expressive of the artist himself who has such skills. Michelangelo is "terribile" because his art is "terribile," and

as the victory of his art is likened to the victory of God the Judge, so his godlike "terribilità" is linked with the terror that God created—that the godlike Michelangelo re-created in his *Last Judgment*.

The notion of Michelangelo's divine powers is rooted in neoplatonic philosophy, according to which the artist as maker is like God the Creator. Vasari implies this relation of artist to God, saying that when we look upon the Adam of the Sistine Chapel we see the original creation itself (Fig. 19). The metaphorical implication of this rhetoric is that the image of Michelangelo's God, who creates Adam, is the figure for Michelangelo himself, that Michelangelo's "divine mani," or divine hands, are like the powerful hand of God, which he so majestically depicts. God not only creates and re-creates, however, he also destroys. He is the wrathful God of vengeance who condemns the sinners in the *Last Judgment*, the "Deus terribilis." The counterpart of the wrathful God, who inspires terror, Michelangelo is the irate artist who similarly inspires terror through his art. "Terribilità" is closely bound to divine "ira" or wrath.

The term "terribilità" is not part of the language of art before Michelangelo. The word is not used in the fifteenth-century writings of Ghiberti or Alberti, and, although Francesco Colonna speaks of a pyramid as "terrible," thus implying the sheer difficulty of this monument, his usage of the term is exceptional before Vasari came to employ the word to describe various works, most notably those of Michelangelo. It is worth observing that Vasari does not use the word in the life of Michelangelo as extensively as one might suppose. Its most prominent usage is found in the description of the Sistine ceiling frescoes and related *Last Judgment*. This relatively restricted usage suggests the implicit association of artistic "terribilità" with the terror of God, Creator and Destroyer, who is the very subject of these frescoes. God creates terror, which Vasari describes with many related words—"paura," "timore," and "spavento," as well as "terrore."

When Condivi, echoing Michelangelo himself, describes the *Flood* in the Sistine ceiling, he emphasizes the wrath of God like that of God the Judge in the *Last Judgment*, who has the capacity to inspire terror. Michelangelo's God, in this usage of the Bible, is the "Deus terribilis." By analogy, Michelangelo, who renders the terrifying God in his own terrifying art, is the "pictor terribilis."

Michelangelo's "terribilità" does not descend from God's wrath alone. It has much to do with the legendary ire of his patron, Pope

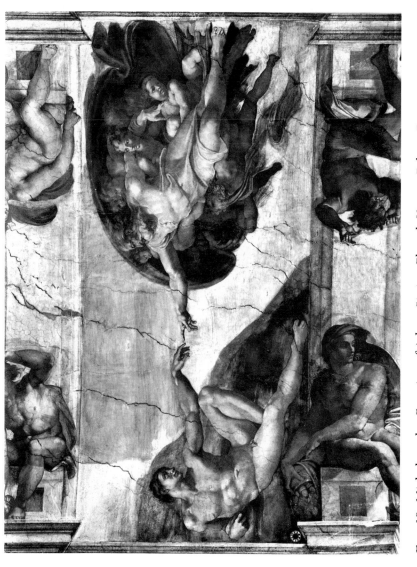

Fig. 19. Michelangelo, *Creation of Adam*, Sistine Chapel. Vatican Palace, Rome

Julius II, who imitated the wrath of God himself in his furious out-
bursts. The pope came to be known as the "papa terrible," and Michel-
angelo essentially imitated the pope when he defied him. He thus
formed his persona in part from that of the pope. This imitation of
julian wrath and "terribilità" is reflected in a story that Michelangelo
was sure to tell Condivi. When the pope was impatient for Michelan-
gelo to finish the Sistine ceiling, he became "irate" and mocked Mi-
chelangelo's words, "when I can," asking the artist: "What, do you
want me to throw you down from the scaffolding?" Michelangelo
responded to the pope's "terribilità" with his own wrath, saying: "It
will be I who throw you from the scaffolding." No matter that he
muttered these words under his breath ("da se disse"), for he memori-
alized in his "autobiography" the image of his own wrath as at least
equal to that of the pope. Julius's "terribilità" had become his own,
Michelangelo became Julius. He acted the part of the "pittore terri-
bile" who was victorious over the "papa terribile" in his wrathful
defiance of him.

It is sometimes said that the direct, intimate, symbiotic relation of
an artist's work to his personality is a modern, romantic concept, but
we see from the way in which Michelangelo formed his own persona
in relation to the image of his art and from the way in which Vasari
elaborated on Michelangelo's self-image that the romantic notion of
the artist is an exaggeration of a Renaissance concept that art is an
expression of its creator. Michelangelo created his artistic persona in
conformity with the art he created. Creating a terrifying art, he mod-
eled the corresponding "terribilità" of his own person not only on the
homeric wrath of Achilles, as we have seen, but also on the wrath of
God, whom he depicted, and on the ire of his patron, for whom he
painted the irate God. What he carved and painted therefore became
expressive both of his wrathful and triumphant patron and of his own
ire and artistic victory.

Moses and Michelangelo as Julian Princes

Nowhere is the image of Michelangelo more closely tied to that of his
patron and to that of the subject of his art than in Vasari's description

of his *Moses* (Fig. 5) as "terribilissimo principe." The description is particularly apposite, since Moses, prince of the Jews, is holding the tablets of the Law—evoking the moment when, having brought down the commandments from Mount Sinai, "his anger burned, and he cast the tables out of his hands and broke them beneath the mount." Vasari's description of the statue is no less appropriate to the patron, Julius, the "papa terribile," indeed a "terribilissimo principe." Finally, Vasari's epithet fits Michelangelo himself, for Michelangelo came to see himself as a "principe," who was "terrible."

As Dante had taught Michelangelo in his "rime," "he who paints a figure cannot succeed unless he becomes the subject." Carving the *Moses*, Michelangelo rendered himself as a "most terrible prince." He created an image of himself into which he would even more completely grow in old age. No matter that he was of medium build, that he was in fact a timid person, for he shaped himself into a terrifying colossus like the *Moses*. Not surprisingly, modern art historians have sometimes even suggested the *Moses* is a portrait of Michelangelo. They have responded to the idea of Michelangelo that he created himself, to "Michelangelo" the work of art, conceived by Michelangelo.

Anthony Burgess once remarked that when Michelangelo finally descended from the Sistine ceiling, he was like Moses coming down from Sinai. Burgess was playing on the fact that, painting the image of God, Michelangelo confronted it on high, as did Moses on Sinai. Burgess's rhetoric is like that of Vasari, which in turn is based on Michelangelo's own manner of presenting himself. Acting the "terribilissimo principe," Michelangelo encouraged his biographers to describe him as such. Thus, they spoke of him as both "principe" and "monarca."

Michelangelo, as he suggested to Condivi, acted the part of prince, for when he failed to gain access to the pope, for whom he was carving the tomb to which the *Moses* belonged, he defiantly fled from Rome. He resisted efforts to bring him back, the papal briefs, "full of menaces," which expressed the pope's rage or "collera." Michelangelo was finally persuaded to go to the pope, who was in Bologna, by Soderini, the mayor of Florence, who said to him, "You have made a challenge to the pope, 'fatto una prova,' that not even the king of France would have made." When Michelangelo was finally persuaded to go to the pope—to avoid war!—Julius said to him, "You should have come to us, and you have waited for us to come to find you," by which he meant that Bologna was closer to Florence than to Rome.

In Michelangelo's account to Condivi, he presents himself as in a sense triumphant over the pope, as more than a match for Julius, for he is himself a prince battling with the pope. Their eventual reconciliation, when Michelangelo finally kneels before Julius, evokes the meeting of a pope and emperor. Michelangelo, in short, assumed the identity of Charlemagne before Leo III. He was like the King of France, Francis I, received by Leo X, like the Holy Roman Emperor and King of Spain, Charles V, received by Clement VII in Bologna.

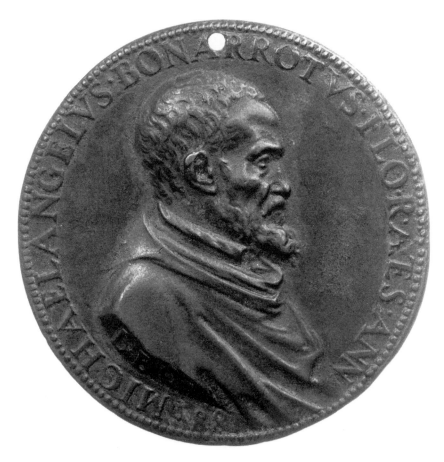

Fig. 20. Leone Leoni, Portrait medal of Michelangelo. National Gallery of Art, Washington, D.C.

No wonder Andrea Calmo would speak of Michelangelo, if facetiously, as "emperor," that Vasari likened him to the caesars. Julius II had created himself as a new emperor, and Michelangelo, emulating his patron's boldness, assumed his own imperial identity.

Michelangelo would cultivate this princely image during his last years, because through the victory of his art he had indeed become a monarch or prince. As Vasari expressly said, Michelangelo presided over the "principato" or principality of art. Duke Cosimo had Vasari write to Michelangelo in beseeching him to return to Florence, assuring the artist he would be well received. The duke was courting Michelangelo as if the artist were of a higher station. When the duke went to Rome, he went to see Michelangelo. He had him sit at his side, and he talked with the artist on most familiar terms, "con molta domesticezza ragionandogli." When the duke's son, Prince Francesco I, also went to see the aged artist in Rome, the prince, with hat in hand, stood in front of the seated artist. In a reversal of roles, the prince acted the courtier, and Michelangelo assumed the identity of the prince.

Inventing his own portrait medal in 1560 (Fig. 20), Michelangelo reaffirmed his princely self-image. The medal pointedly evoked conventional portrait bronzes struck for countless contemporary rulers, medals that descended from ancient and imperial coins depicting the caesars. At this time Michelangelo, as chief architect of Saint Peter's, saw himself as the principal defender of the Church. It is not unlikely that he came to recall the portrait medal of his former patron and rival, Pope Julius II, struck on the occasion of the commemoration of the new church of Saint Peter's, in which the *Moses* was to be placed upon the pope's tomb. Now, fifty years later, completing the colossal building begun by Julius, the princely Michelangelo usurped, we might say, the position of the imperial patron whom he once served, against whom he had battled. Modeling himself on Julius, Michelangelo finally achieved hegemony over his own domain, the "principality" of art, and from this vantage point he could survey his own empire.

The Principality of Art

Michelangelo's princely aspirations were not an isolated phenomenon during the sixteenth century. Over a period of years, Pietro Aretino

published his correspondence in a series of volumes, which presented his influence over the rulers whom he served. Although a courtier, Aretino achieved a "terribilità" of his own and came to be known as the "scourge of princes." In his correspondence with Michelangelo, he asked for a drawing of the *Last Judgment*, but when he failed to get what he wanted, he scourged Michelangelo with harsh criticism. Nevertheless, he remained a courtier to Michelangelo, failing to achieve the latter's princely status. Aretino personifies the unresolved tension within the man of letters between his role as courtier and his aspiration to princely power. Although he spoke of the domain of letters over which he presided as an empire, he was less successful than his rival Michelangelo in molding a similar image of imperial dominion over the principality of art.

Michelangelo's success as the prince presiding over the principality of art can also be measured by the remarks of Vasari about other royal artists. Vasari says that Raphael was like a "prince" and that his earlier rival, Leonardo, was "regio," regal or kingly. He elaborates upon this idea of the artist as king, making believe that Leonardo died in the arms of the king of France. In this political *Pietà*, the king serves the artist, who achieves an even greater status. Such imagery only heightens Michelangelo's ultimate victory. As prince and king, Raphael and Leonardo are pretenders to the throne that belongs to Michelangelo and Michelangelo alone. The "victor" in the hostilities among artists, he is greater than them all. When Vasari invents the painting for Michelangelo's funeral (described in the revised biography), depicting Michelangelo surrounded by all the great artists, ancient and modern, he conceives of an image of a monarch surrounded by his courtiers. This invention is an analogue of Vasari's earlier portrait of the princely Dante attended by other poets, who play the courtier to him. Dante had now become, in the very words he used to describe Homer, the "sovereign poet," and Michelangelo achieves a comparable sovereignty over all art. In fact, Vasari's portrait of Dante (Fig. 14) is informed by Michelangelo's idea of himself as a monarch. Emulating Dante's pride, Michelangelo attained a regal status, with which Vasari invests Dante, making him a sovereign antecedent to Michelangelo the prince.

Having failed in his efforts to court Michelangelo, the best that Duke Cosimo could do was to hold a huge state funeral in honor of Michelangelo in 1564. The subject matter of the paintings made under Vasari's

supervision reflects Michelangelo's success as the monarch over the "principato" of art, for in these images one beheld the princely Michelangelo courted by popes and kings. Honoring Michelangelo, the duke was aggrandizing his own city and rule by exploiting the success of her greatest son. Michelangelo had shaped himself in conformity with the princely image of his patrons; now his (would-be) patron was shaping his own image in relation to that of Michelangelo—suggesting just how powerful the metaphor of the "principato" of art had become.

Michelangelo and Machiavelli

Michelangelo's princely persona is inextricably bound up with Machiavelli's prince. In the years immediately after the death of Pope Julius II in 1513, when Michelangelo is said to have carved his *Moses*, Machiavelli composed *The Prince*, in which he held up Moses as an example of those princes who acquire principalities with their own arms. Vasari's description of Michelangelo's *Moses* as "terribilissimo principe," evocative of the pope himself, is also appropriate to Machiavelli's biblical prince, Moses. The relation of these two images of Moses is not fortuitous, since just as Michelangelo was inspired by the wrath and terribility of the pope, so indeed was Machiavelli. In *The Prince* Machiavelli presents the militant Julius as an exemplary figure in his boldness and audacity. Julian ferocity both lies behind Machiavelli's ideal prince and informs Michelangelo's idealized image of himself. Michelangelo the prince and Machiavelli's prince are two fictions fashioned from a common source—Pope Julius II.

It is possible to compare Michelangelo's creation of himself as prince with Machiavelli's prince precisely because the language of art is closely related to the rhetoric of politics. For Machiavelli princely rule is an "art," for Michelangelo art is a political activity. Machiavelli's prince established his "stato," "dominio," or "principato" through his "arte," that is, "virtù" or skill. By analogy, Michelangelo achieves hegemony over what Vasari calls the "principato" of art through "arte" or "virtù." Michelangelo's prince triumphs through "industria" and "judgment" (from "iudicare"), overcoming "difficultà." "Giudizio" and "terribilità," the capacity of art to surmount difficulties, as Vasari intends, are central to Michelangelo's accomplishment.

The relations between Machiavelli and Michelangelo can be extended further. Through his "forza," Machiavelli says, the prince triumphs (from "vincere") in his "imprese" or military engagements. He frequently needs to create fear (from "temere") with his "ferocità," "impetuosità," "audacia," his "animo grande" or great soul. All of these terms are interchangeable with those employed by Vasari to describe Michelangelo. "Terribilità," Vasari's word for Michelangelo, is closely related to Machiavelli's "ferocità" and "impetuosità," words used specifically to describe Julius II, who boldly led his own forces into battle. Machiavelli's prince, who often needs to create fear, is "terribile"; Michelangelo is ferocious and impetuous. Both draw their inspiration, as we have said, from the audacious deeds of the militant pope.

How did Michelangelo come to preside over the "principato" of art? He achieved dominion through what Vasari calls the "forza dell'arte," the force of art. The concept of artistic "forza" has roots in antiquity in the classical idea of "energeia"—energy or force. But in Michelangelo, inspired by the machiavellian Julius, this idea takes on military meaning. Thus the Sistine Chapel frescoes, which are cited for their "forza," are an artistic "impresa," as Vasari says. The word "impresa" has a decidedly military connotation, since it is often used, as by Machiavelli, to describe great deeds of arms or military feats. Eventually, as Vasari says, Michelangelo "vanquishes" the very medium, the flat wall, which resists the three-dimensional relief he achieves, as he overcomes "difficultà" through his artistic "force."

Vasari elaborates this military metaphor in a discussion of Michelangelo's Medici Chapel decorations. Here he suggests that Michelangelo is a liberator, for he broke the chains of art ("rotto . . . le catene"). Michelangelo made tombs of the dukes Giuliano and Lorenzo de' Medici, two young princes through whom the Medici had themselves hoped to "liberate" Florence. Originally, Machiavelli had thought of presenting his treatise to one, Giuliano, and he eventually dedicated it to the other, Lorenzo. Both are portrayed by Michelangelo in military attire as machiavellian figures of "forza," through the very "forza" of Michelangelo's art—that is, his capacity to overcome the obduracy of stone.

The disquieting notion of Michelangelo's militant artistic force also finds expression in the writing of the critic Lodovico Dolce, who speaks of Michelangelo's brush as a "lancia" or lance—as if, when he

painted, Michelangelo entered the lists, to joust, to do battle. Similarly, a woodcut in Sigismondo Fanti's *Triompho di Fortuna* shows Michelangelo in the guise of the pagan god Mithras slaying the sacrificial bull as he violently attacks the stone from which he carves a figure. Michelangelo here handles his tool as if it were a sword or knife. In short, such metaphors are all closely bound up with the idea of Michelangelo's militant "terribilità" and fury—with his own machiavellian persona. They comment on Michelangelo's sense of his own "forza," reflected in his youthful comparison of the tool with which he carved the colossal *David* with David's very weapon. David, we should recall here, is one of the mythic princes of the Hebrew Bible invoked by Machiavelli in *The Prince* for fighting with his own arms. Could Machiavelli have even written about David in Florence in 1513, only a decade after Michelangelo's statue was prominently erected in the Piazza della Signoria, without having in mind and expecting his Florentine readers to envision Michelangelo's colossus? In his very nudity, Michelangelo's *David* would have personified Machiavelli's idea that Florence, like David, could defend herself without the arms of others.

The image of Michelangelo is no less problematic than that of Machiavelli. There is a conflict within Machiavelli between his ideal of "virtù" in the sense of force and traditional morality, and there is a similar tension within Michelangelo—notwithstanding the artist's piety and saintly persona. The harsh, contemporary criticism leveled against Michelangelo's license in the painting of the *Last Judgment*, the condemnation of his reputed violation of religious decorum, is symptomatic of the underlying discomfort felt by contemporaries toward the "virtù" of his art, said by many to be at odds with his Christian subject matter.

The legends of artists and writers depend on the persona they themselves create. These personae depend on the very subjects of their works, as well as on the manner in which they render their themes. The legend of Michelangelo the criminal that developed in the centuries after his death stems from the criticism of his overly bold manner of painting a sacred subject. This legend, as we shall see in the final pages, is closely related to the parallel legend of Machiavelli the immoralist. Both Machiavelli and Michelangelo were like their model, Julius II, who was sharply condemned by Erasmus for wielding a "secular" sword. Like the inspirational pope, they epito-

mized the deep conflict within Renaissance culture between the classical aspiration through "virtù" to grandeur and the Christian virtue of humility or submission.

Michelangelo's Emblem

In the revised version of Michelangelo's biography, Vasari focuses at the end on the artist's funeral—the ceremony sponsored by Duke Cosimo, worthy indeed of the prince that Michelangelo had become. Among the decorations, made under his own supervision, Vasari describes Michelangelo's "impresa" or emblem. It consists of "three circles" or "crowns" interlocked in such a manner that the circumference of each passed through the center of the others. Vasari explains that for Michelangelo the three circles stand for the three arts, sculpture, painting, and architecture, which are similarly interwoven or tied to each other and which cannot be separated from each other. It is also possible, he adds, speaking of the emblem, that a man of such exalted genius had a more subtle intention, "più sottile intendimento."

The word "corona" or crown that Vasari uses to describe Michelangelo's three circles recalls Michelangelo's identity as prince, as the crown prince of art. It is also the crown of the victor and, more specifically, of the poet as victor. The three crowns were accompanied in Vasari's decorations by a motto from Horace (*Carmina* I, 1, 8): "tergeminis tollit honoribus." Horace's "triple honors" become Michelangelo's triple honors in the arts of sculpture, painting, and architecture. Horace's words, Vasari concludes, mean that, worthy of all three "professions," Michelangelo must receive the "crown" for the "highest perfection." Horace's idea of the victor's honors is closely related to the notion of his friend Virgil of the poet's victory: "victor ego." It is possible that, in accord with the proper literary advice of a friend, Michelangelo adapted Horace's words to his emblem, but it is also conceivable that Vasari had them added to the emblem for the funeral decorations. The motto from Horace, quoted by Vasari, is, in either case, closely related to Vasari's virgilian description of Michelangelo as "vincitore" or victor of all art.

We first encounter the possible origins of Michelangelo's emblem, as defined by Vasari, in his work of the 1520s on the Medici Chapel.

On some drawings of blocks of marble identified as for this project, Michelangelo drew three interlocked circles with a capital *M* within. Three interlocked rings had been the emblem of Cosimo il Vecchio de' Medici, and it is possible, if not probable, that Michelangelo, now working for the Medici, thought to appropriate the emblem as a way of specifying that the blocks were for the Medici project. Placing the *M* within the circles, he identified his own work on the blocks, thereby making the *M* stand for his identity with the Medici. If this hypothesis is correct, Michelangelo elevated himself by adapting the emblem of his Medici patrons.

When Michelangelo was buried, his connection with the Medici was made even more evident. Attached to the painting of Michelangelo courteously teaching his students were lines from Lucretius, beginning, "Tu pater, tu rerum inventor, tu patria nobis." Michelangelo, who was the "padre" or the father of academy of art, as Vasari said elsewhere, became the "pater patriae." The idea of the "father of the patria" goes back to antiquity, to Augustus, whom Duke Cosimo emulated as ruler and patron. The phrase was revived by the duke's ancestor and namesake, Cosimo il Vecchio, who was known as "pater patriae." When Vasari used the line from Lucretius, evoking the "pater patriae," he surely recalled this tradition, especially since Michelangelo's funeral in 1564 was the centenary celebration of Cosimo il Vecchio's funeral.

Whereas Michelangelo had sought to fashion himself out of his connection with the Medici, making their *M* his own, now the Medici made Michelangelo into the personification of their own glory. Like Augustus Caesar in antiquity, like Cosimo il Vecchio in the previous century, Michelangelo had become the "father of the patria." The rise and glorification of the Medici were the subject of numerous histories, from Machiavelli's *History of Florence* through Vasari's painted "storia" of Florence in the Palazzo della Signoria, the new Medici residence, which featured the ascent of the Medici to power, culminating in the glorious reign of Duke Cosimo. Now both Vasari's *Lives* and the decorations for Michelangelo's funeral, supervised by Vasari, placed Michelangelo at the summit of this history of Florence and of the Medici.

Michelangelo's own imperial ambitions are involved in those of augustan patrons, but his goals are also related to those of the poets, Horace and Virgil, who served Augustus and who rivaled their patron

in their poetry. Like Horace and Virgil, Michelangelo aspired to eternal fame. The emblem of his funeral decorations (accompanied by the words of Horace) was joined to the images of dead bodies vanquished by Eternity. This decoration reflected Michelangelo's own aspiration to eternal fame. Michelangelo had remarked earlier that it did not matter what the dukes whom he portrayed in the Medici Chapel looked like, since it would not matter in one thousand years. We miss the point of Michelangelo's remark if we see it merely as a comment on his own idealization of the dukes, since his reference to one thousand years points toward his own triumph through art over time as well as over men. His remark evokes the very rivalry of Horace and Virgil with Augustus, particularly Horace's ode (III, 30) in which the poet speaks of his own work as a monument more enduring than a royal pyramid. Receiving the ivy (crown), Horace adds he would be like the gods and rise to the stars. His triumph would be like that of Virgil's victorious poetic flight upward. The crown of the poet, later worn by Dante and Petrarch, was now worn by Michelangelo himself, who was likened by Berni to Apollo, the god of the laurel and of poetry. Apollo's own victory as musician or poet was emphasized, we recall, at the beginning of Dante's *Paradiso*. It was no less an example to Dante, who competed with the ancient poets throughout his poem, than it was to Michelangelo.

Horace's and Virgil's ambition for poetic victory irradiates Dante's flight to the stars. In fact, just as Horace's first ode concludes with a vision of his own ascendancy to the stars, so do all three parts of Dante's poem conclude with just such a vision: at the end of *Inferno*, Dante comes forth to see the stars; at the conclusion of *Purgatorio*, now purified, he is "ready to mount to the stars"; and finally, at the end of *Paradiso*, he is granted a vision of the stars. Dante's ascendancy, through the grace of God, is thus an even greater poetic victory than that of Virgil or Horace, a more signal honor. The horatian allusion to honor in Michelangelo's emblem is charged with Dante's and Michelangelo's goal of honor, "onore." Vasari uses this word repeatedly to describe Michelangelo's artistic triumph, quoting Dante in his description of the painting made for Michelangelo's funeral, in which all artists, ancient and modern, are shown honoring Michelangelo: "tutti onor gli fanno"—"all honor him." "Onore" is the very word that resounds throughout Limbo, where the great poets, philosophers, patriarchs, and warriors are depicted by Dante. Now it re-

sounds throughout Vasari's description of Michelangelo's funeral, epitomized in Michelangelo's horatian emblem.

Vasari speaks tautologically of the circles or crowns of Michelangelo's emblem as "giri tondi," round circles. This language, too, evokes the circles of Dante's *Paradiso*, which are also called "giri." More specifically, the three united "giri" of his emblem take on the implication of those three circles, the "tre giri" of the Trinity beheld in *Paradiso* XXX as a "sole appearance." The three circles of the Trinity are both three and united as one; similarly, the "tre giri" of Michelangelo's dantesque emblem are both discreet and united. Dante also calls these "giri" wheels, or "rote," speaking of the "magne rote" of paradise. In the last lines of the *Comedy* he likens his own will to a wheel, spinning with even motion, turned by the love that moves the sun and the stars. The connection of his very self to these wheels, of "rota" to "rota," brings to mind Michelangelo's very name, Buonarroti, "buone rote" being good wheels. Exploiting Michelangelo's name, Benedetto Varchi wrote a sonnet on the occasion of Michelangelo's funeral in which he spoke of his "celesti rote," celestial wheels. Dante had taught Michelangelo, as we have seen, that names are the consequences of things, and now in his emblem he was united through these "rote" to Dante, just as Dante was united to the "rote" of heaven itself.

The circles of Dante's paradise and of Michelangelo's dantesque emblem partake of the very form of God, for the circle is a metaphor of God. It is the appropriate visual metaphor for an artist who achieves "perfezzione," who is "divino." All three forms of art— sculpture, painting, and architecture—are united by the principle of "disegno," that metaphysical concept implied by the three circles of Michelangelo's emblem. As Dante's unity of three circles suggests, "disegno" is the unifying principle of Michelangelo's trinitarian circles, all united in perfect design. Like Dante's circles, Michelangelo's emblem suggests and is sustained by the Trinity. Indeed, this trinitarian meaning further evokes the three crowns of the papal tiara—an especially likely connotation given Michelangelo's symbolically papal aspirations.

Adopting the Medici rings as his own emblem, Michelangelo recognized how these rings, now circles, could be invested with the kinds of significance we have just considered: personal, social, political, aesthetic, literary, metaphysical, cosmological, and theological. Vasari

knew exactly what he was doing when he indicated that the emblem
had a more subtle meaning than that which he had himself presented.
The meanings of the emblem, or rather, its implications or associa-
tions, depend on the familiar Renaissance "paragoni" or comparisons
between art and poetry, art and politics, art and religion. Despite the
torment and deep division within Michelangelo, he aspired to achieve
a harmonious compound image of himself, like that of his medal,
through which he sought to unify his princely and saintly goals, to
unify Saint Paul and David, to achieve identity with Dante. The
emblem that he made his own is just such a compound image, a sign
of his "somma perfezzione."

The Genius of Vasari

I have suggested throughout these pages that Vasari's biography of
Michelangelo is an embellishment of his subject's unwritten "auto-
biography"—that Vasari ornamented Michelangelo's augmented im-
age of himself, sketched out in Michelangelo's own remarks and
actions. Although the "Michelangelo" of Giannotti's dialogues pro-
tests that he does not wish to be dressed in the ornaments of praise,
Michelangelo encouraged others to adorn the image of himself in
their panegyrics and biographies. This image would not be what it
is, the legend of Michelangelo would be different from what it is,
without Vasari's biography, without his *Lives*, which provides a bibli-
cal, epic, and specifically dantesque framework for Michelangelo's
legend. That Vasari served Michelangelo, that he was a satellite who
revolved around his Apollonian hero, does not diminish, however,
Vasari's own artistic genius and accomplishment. Nowhere, perhaps,
does this literary genius manifest itself more magnificently than in an
anecdote that poetically comments on Michelangelo's emblem. This
anecdote concerns Giotto's O or "tondo," wed to the "giri tondi" of
Michelangelo's emblem, as if it explained the emblem's very origins.
 Vasari's story must be read in the context of the typology, according
to which Giotto is the type of Michelangelo. Giotto is socratic, con-
nected with Dante, the painter also of the reforming Saint Francis. In
all these respects he foreshadows Michelangelo, himself socratic,
dantesque, and franciscan in his espousal of "poverty." In his wit and

judgment he also prefigures Michelangelo, especially in those anec-
dotes in which he teases the king of Naples. Painting an allegory of the
ruler's kingdom in the form of an ass, he mocks the ruler, becoming,
in a sense, superior to the monarch in a way that presages Michelan-
gelo's princely persona.

Telling his tale of Giotto's "tondo," Vasari relies on an extensive
literary tradition, in which Giotto is portrayed as a great wit and
jokester. There is not only evidence of this wit in Giotto's art, but his
name, as in his signature, "opus Iocti," suggests "iocus" or "iocatio,"
for joke or joking. The story of Giotto's "tondo," although it belongs to
the tradition of stories about Giotto as a witty or playful figure, is
nevertheless of Vasari's own invention. It is both a good story in its
own right and a superb elaboration of Michelangelo's emblem and
theory of art.

Once upon a time, according to Vasari, the pope sent an ambassa-
dor into Tuscany to find the best available artist, whom he sought for
work at Saint Peter's. After collecting examples of the work of painters
in Siena, he came to Florence. One morning he went to Giotto's
shop, explaining to the artist the purpose of his trip. When he asked
Giotto for a sample of his art to be sent to the pope, Giotto, who was
most courteous, took a piece of paper and a brush and, holding his
arm straight in order to make a compass, proceeded to make a "tondo"
equal to one made with an actual compass. So perfect was the circle
that it was a "maraviglia" to behold. "Here's your drawing," Giotto
said to the pope's ambassador. Thinking he was being duped, the
courtier said that he had to have something more than just this
"tondo." Giotto told him, however, that it was more than enough,
adding that if the courtier sent it with the other drawings, he would
see that it would be appreciated. Realizing that he could get nothing
else from Giotto, the courtier left, still convinced he had been
tricked. He sent the drawing, along with the others, to the pope,
explaining how it was made without a compass. When the pope and
the attending courtiers saw the drawing, they appreciated the excel-
lence of what Giotto had made. From this episode, Vasari claims,
arose the proverb, "Tu sei più tondo che l'O di Giotto"—"You are
rounder than the O of Giotto." The saying is beautiful, Vasari adds,
because it is ambiguous—noting that the word "tondo" in Tuscany
means both a perfect circular figure and "tardità" or slowness of wit.

Giotto's "sottigliezza," his subtlety of wit, is seen in his rendering of

the circle and is thus played off against his critic's dullness of wit or "grossezza d'ingegno." His "cognizione" or "scienza" is juxtaposed with his critic's ignorance. His grace and ease are measured against the courtier's deficiency of intellect. Vasari's story is to be understood in terms of Castiglione's *Book of the Courtier*. Defining the ideal of courtly grace, of "sprezzatura," Castiglione finds it in the manner in which the courtier uses a sword, dances, or handles a paint brush. "Often too in painting a single line, which is not labored," Castiglione observes, "a single brush stroke made with ease and in such manner that the hand seems of itself to complete the line desired by the painter, without being directed by care or skill of any kind, clearly reveals that excellence of craftsmanship, which people will then proceed to judge, each by his own lights." Clearly Giotto's single stroke, executed with ease and perfection, is the epitome of such "sprezzatura." We should note here that "sprezzatura" is derived from the verb "sprezzare," to disdain. The courtly artist is disdainful and superior, just as the epic-hero artist is disdainful or "sdegnoso." We might even say that, although the courtier serves the prince, all courtly "sprezzatura" aspires to the condition of princely superiority. The disdainful Giotto of Vasari's story is superior to the slow-witted courtier, who does not grasp the measure of the artist's accomplishment. He foretells Michelangelo, who, through his disdain, became a prince.

Giotto's "tondo," it has reasonably been suggested, is related to the "tondi" of Michelangelo's emblem. The O is also emblematic of the perfection of Giotto's "disegno" or design; indeed, it is the embodiment of the artist's michelangelesque "guidizio" or judgment. As Michelangelo himself said to Vasari, the artist must have the compass within his eye. Giotto exemplifies this attribute, drawing perfectly with the judgment that depends on the compass of his own eye. Giotto is also like Michelangelo because he speaks in a double sense, "in due sensi." What he draws is seemingly nothing—a zero or "niente," "nulla" or a nullity—whereas the circle is the symbol of divine perfection, the traditional symbol for the completeness or wholeness of God. Vasari's socratic Giotto exploits the ironic duality between appearances and inner truth. Like the ironic Michelangelo inventing his faun to create a socratic identity, Vasari ingeniously makes up a story about the socratic origins of the circle, emblematic of the perfection of Michelangelo's art.

How, we might ask, did Vasari come to invent this tale? To answer

this question is to explore the genius of Vasari's imagination, so much in sympathy with Michelangelo's own. Vasari's story is based on a line in Poliziano's *Bel Libretto:* "You are rounder than the O of Giotto." The origins of the remark remain uncertain, but it is said to be derived from a fifteenth-century Florentine poem in which the poet says: "Al tuo goffo ghiotton darò del macco, / Che più dell'O di Giotto mi par tondo."—"I will give the bowl of mush to your oafish glutton, who is rounder than the O of Giotto." The poem plays on the resounding O: "goffo . . . ghiotton . . . darò . . . macco . . . tondo." Vasari, however, turns the phrase to a different purpose.

Pretending to find the origins of the line in Poliziano, he freely retells a story in Pliny's *Natural History* XXV. Retold in the idiom of a Tuscan "novella," Pliny's tale was also clearly in Castiglione's mind when he spoke of the ease in the painter's single stroke. According to Pliny, once upon a time Apelles went to visit Protogenes and found him not at home. Apelles, instead of leaving his name, drew a line of extreme subtlety upon one of Protogenes' panels. Returning home, Protogenes recognized that this stroke could have been drawn only by Apelles, and he responded to it by drawing an even finer one over that of Apelles. When Apelles returned a second time, he drew a third line, leaving no room for further refinement. Seeing this stroke, Protogenes recognized, finally, that he had been bested. From the "subtilitas" of Apelles' stroke, what Vasari calls "sottigliezza," descends Giotto's effortless circle.

Vasari's story of course reflects his own "subtilitas"—the subtle way in which he appropriates a legend from antiquity, retells it as a Tuscan "novella," grafts it to a line of Florentine poetry, invests it with a castiglionesque ideal of grace, and, finally, makes it reflect Michelangelo's concept of artistic judgment. Although ostensibly about Giotto, Vasari's story is, as we have seen, about the legend of Michelangelo, about the origins of this legend in Giotto. Vasari's manner of crafting this tale, making it part of a history large in scope and complex, reflects, upon close scrutiny, a wit and finesse worthy of his hero—an artifice appropriate to Michelangelo's own literary imagination. We see in this story, as in all the *Lives*, a literary intelligence that is not merely subservient to Michelangelo but distinguished in its own right. The light of Michelangelo's art should not blind us to the creativity of his friend, disciple, and biographer, who played such a pivotal role in diffusing Michelangelo's self-created legend.

Retrospect: "Between Virtue and Vice"

Shaping himself, with Vasari's assistance, into a compound colossus, out of his own images of God the Creator, Moses, David, God the Judge, making all the grandeur and tumultuous conflict of his art expressive of his own self, Michelangelo was sustained by a Florentine tradition of artistic self-consciousness that I have traced back through Poliziano to Dante. Not only is Michelangelo the summit of Italian art history, as Vasari says, but he is the epitome of the Florentine cultural tradition that began with Dante.

Dante's *Comedy* is informed by the tension between his humility as Christian pilgrim and his sublime ambition and pride. This same tension, which came to inform Michelangelo's "autobiography," reflected the opposition between classical grandeur and Christian submission. Michelangelo followed Dante back to the tradition of Virgil and Homer in the sheer magnificence of his vision, but he also followed Dante back to Saint Augustine in the confessional character of his poetry and devotional works. Augustine's words—"I beseech you, God, to show myself to myself"—speak for Michelangelo in his own quest for spiritual reform and hence freedom from sin. Whereas Augustine converted Virgil's *Aeneid* into the terms of the Hebrew Bible and the New Testament, Michelangelo, following Virgil through Dante, more fully imitated the conventions of the epic. The epic heroes Achilles and Aeneas were already demigods, but neoplatonism, which now linked the artist as creator to the Creator, contributed further to Michelangelo's idea of himself as divine artist and epic hero.

In the confessional poetry of his last years, however, Michelangelo repudiated the sins, the very idolatry of his art, which he had made his ruler. He had become, he confessed, a supreme idolator. Carving sculptures, which were images of himself, in accord with Christianized neoplatonism, he made himself divine, like his subjects. If he was his own Moses, who rebuked the Jews for worshiping false idols, he was also the David whom he had carved. Now growing old, he became in his penitential poetry and in the words of Psalm 51 upon his portrait medal the ancient David of the Psalms, who said in Psalm 115, speaking of idols, that "they who make them are like unto them."

Having looked deeply within himself, Michelangelo saw that he was a maker of idols, that he had made an idol of his art and thus of himself. Forming himself, painting and carving himself as a divinity, he had made himself into an idol.

Michelangelo's conversion, his turning to God, like Dante's and through Dante's, descends from Augustine's *Confessions*. His own final "confession" and penance give closure to his life. Yet for all his penitence, he still commissioned a medal upon which he appears as prince in all his splendor (Fig. 20). Not even the words from David's penitential psalm and the dantesque and pauline pilgrim on the reverse side of the medal (Fig. 6) can fully negate the pride that stands behind his quest for glory and fame. Living his life still "between virtue and vice," he asks, in a fragment of a late poem: "What should I of myself then hope for still?"

Autobiography and Self-Creation

Michelangelo is the first fully autobiographical artist in the modern world, the first painter or sculptor to see his works as symbolically portraying the great deeds and spiritual battles of his own life. He thus encouraged his biographers, through what he said about himself, his work, and his manner of working, to exalt his works, as if the heroic grandeur or spiritual fervor of his subjects were his own, as if the majesty of his style or "maniera" were expressive of his person.

In the fifteenth century, Ghiberti had written about himself in his *Commentaries*, and the so-called biography of Alberti was probably dictated by Alberti himself to a scribe. Despite the self-importance of these artists and of other painters and sculptors, who portrayed themselves or signed their works prominently, no artist before Michelangelo made of himself what Michelangelo did. Not even Dürer, who, during Michelangelo's own lifetime, portrayed himself as like Christ, approached in degree Michelangelo's sense of his works as pictured moments in a great life. For Michelangelo the humble piety of his painting and sculpture illustrated steps in his spiritual journey toward God. The grandeur and heroism of his figures and their style also expressed and symbolized his rise to the "principato" of art.

To say either that Vasari and Condivi simply told stories about

Michelangelo's work or that they merely transformed or exaggerated what he said to them about his art is to miss the fundamental point that Michelangelo saw his own life as a colossal struggle or "agon" and that his biographers essentially reflected this central motive of his "autobiography." In this "autobiography," which can only be reconstructed by inference through the biographies in relation to Michelangelo's art and poetry, Michelangelo saw his own life as a battle. It was symbolized and realized by the tumultuous forms that he carved and painted, their subjects being expressive of the conflicts he experienced. When modern art historians have often written of the "battle," "lotta," or "Kampf" of Michelangelo, even speaking of the "conquests" of form, they have elaborated on Vasari's and Condivi's transcriptions of Michelangelo's discourses about himself. Even so romantic a book as Irving Stone's *The Agony and the Ecstasy*, whatever one might think of it as fiction or of its narrative license, is grounded in Michelangelo's "agony" or battle in the root sense of the word. The fiction of the novelist is an analogue of the writings of those scholarly historians who compare Michelangelo's *Ignudi* or *Slaves* to his poems, in which he speaks of himself as imprisoned—as if he were one of his own slaves or nudes struggling to free himself from bondage. Michelangelo's scholars, like the novelist, rewrite Condivi and Vasari, just as his first biographers paraphrased Michelangelo's own words.

At the heart of Michelangelo's "autobiography" is his struggle to create himself, to "form" himself into a perfect being, hence, to "reform" himself spiritually. Still sinful, he remains, as he says, "non finito," like the sculptures he was in the process of carving. He is in a sense one of his own sculptures, which are metaphors of the self. By comparing himself to a sculpture he is struggling to form, he invokes the hardness of stone; the very obduracy of the medium becomes a metaphor for the flesh against which he must do battle. The chisel and the drill are the weapons that he carries to this war within himself. Walter Pater once said that the "creation of life . . . is in various ways the motive of all his works." The corollary to this insight is that Michelangelo's creation of himself is the central motive of his work, since he is forming himself through the very images to which he gives form—creating an ideal image of himself. Aspiring ultimately to the "terribilità" and perfection of God, whose image he perfects in his art, he thereby seeks to perfect himself. In the *Creation of Adam* (Fig. 19), Michelangelo, as Vasari suggested, is metaphorically the Creator.

Seeing himself as "non finito," however, Michelangelo encourages us to see him also as Adam, still being formed and perfected. Michelangelo's fresco is a supreme metaphor for the duality within Michelangelo himself between creator and creature. In this central event of Michelangelo's "autobiography," we behold Michelangelo in the act of creating himself.

Benvenuto Buonarroti

When Benvenuto Cellini dictated his "vita" in the late 1550s, he modeled his own life on Michelangelo's "autobiography." Indeed, we cannot fully understand Cellini's book, which is one of the major works in the history of autobiography, without recognizing the way in which he imitated the persona Michelangelo had created of himself. Cellini not only modeled his works on Michelangelo's, but he modeled himself on Michelangelo, making himself michelangelesque.

Whereas Condivi had said that Michelangelo was in fact "timid," he nevertheless, like Vasari, presented an image of Michelangelo's "terribilità" and fury. This was a metaphorical image, since it was based on Michelangelo's bravura as an artist, but it was reinforced by Michelangelo's defiance of his patrons, especially of Pope Julius II, or at least by what Michelangelo claims to have said to the pope. Making himself into a warrior or prince in the principality of art, Michelangelo became the model for the tumultuous Cellini, the swaggering sculptor-soldier, perpetually embattled or at odds with his patrons. Wrath, ardor, passion, and fury—the attributes of the michelangelesque epic hero-artist are reincarnate in Benvenuto, who actually brandished his sword and shot cannons in battles. Michelangelo had imitated the wrath of Achilles and that of the soldier-pope Julius, creating his persona from them. Now the soldier-artist Cellini, who fought in defense of the papacy during the Sack of Rome, imitated the symbolic militant persona of an artist not himself a soldier. Michelangelo's "fiction" became the framework for Cellini's view of the "reality" of his own deeds.

Like Michelangelo, however, Cellini also transposed the idea of military prowess into the realm of art, transferring the language of epic fury to his work in sculpture. When in the dramatic climax of his life, he describes himself casting the *Perseus*—battling against illness

and the explosion of his furnace—he becomes a kind of Benvenuto Furioso. As an embattled warrior of art, he makes of himself an epigone or follower of Michelangelo, a soldier in Michelangelo's army, who exhibits michelangelesque "terribilità."

Although Cellini is an epic hero of art, like Michelangelo, he is also, like Michelangelo, a penitent saint. Michelangelo's penitential poetry of the 1540s and 1550s marks the final phase of his life, his conversion or turning to God. Cellini's imprisonment in the Castel Sant'Angelo at the end of the first part of his autobiography reveals such a conversion through penance. It was when he was thrown into prison by the pope that, as he said, "I turned my mind completely to God." In prison he also turns his attention to the very two books which Michelangelo told Condivi were so important to his own devotion, the Bible and the sermons of Savonarola. After his prayers, an angel appears to Cellini in a vision (like the angel who came to the imprisoned Saint Peter) and leads him upward upon a heavenly staircase toward God. In the divine radiance of the sun Cellini beholds Christ upon a cross, the Madonna, angels, and Saint Peter, who pleads for Cellini's salvation. Cellini finally becomes a saint, saying that there was "a brilliant splendor" above his head and that "it has been clearly seen by those few men I have wanted to show it to." Making himself into a saint, Cellini imitates both Michelangelo's conversion and own aspiration to saintliness.

The elaborate word-picture of heavenly vision that Cellini renders is apocalyptic—an approximation of the apocalyptic *Last Judgment*, which is the highly dramatic culmination of Michelangelo's career in the first edition of Vasari's *Lives*. Michelangelo's apocalyptic fresco is a dramatic moment in his life: his fresco re-creates Dante's *Comedy*, both its heavenly and infernal aspects. Similarly, Cellini's vision in prison, a central moment in the drama of his own life, powerfully reflects Dante's poem. Initially thrown into a dark chamber filled with "tarantulas and noxious worms," Cellini describes his own inferno. During his imprisonment, he sings the various psalms in penance— "De profundis clamavi," "Miserere," and "In te domine speravi"—like Dante's sinners in purgatory, expunging the *P* of his own "peccato" or sin. When he finally beholds Christ in a vision, so beautiful and gracious "that the imagination cannot reach to a thousandth part of what I saw," his experience in "alta fantasia" is like that of Michelangelo's luminous Christ surrounded by the sun in the *Last Judgment* and, ultimately, like Dante's vision of divinity in paradise.

It is as if Cellini were exploiting the place of Michelangelo's *Last Judgment* in his own life, its expression of Michelangelo's "terribilità" and devotion, its dependence on Dante, now inventing his own michelangelesque and dantesque scenario to portray his experience in prison. Michelangelo defines himself through his poetry and art as a new Dante—the *Last Judgment* being the epitome of this ambition—and Cellini sees himself as a grandiose dantesque and therefore michelangelesque figure. His michelangelesque imitation of Dante is so complete that he meets Dante's subjects in his own life.

Cellini encounters the very boatman Charon, pictured by Michelangelo in the *Last Judgment*, during a serious illness. He says that a "terrifying old man appeared at my bedside and tried to drag me by force into his enormous boat." After crying out for help several times, he falls back senseless, as Dante does so often in *Inferno*, filled with terror. His friend Matteo exclaims that "he must have been reading Dante, and now he's so ill his wits are wandering." Cellini's hallucination is a "fantasia" no less terrifying and immediate than Michelangelo's imitation of Dante's Charon. In a similar vein, Cellini enters into Dante's poem when he is in France. Appearing in court to defend himself, he beholds a judge who looks like Pluto. The judge screams, "Phe phe Satan phe phe Satan alè phe," words that evoke the language of Dante's Pluto: "Papè Satan, papè Satan aleppe." Cellini conjectures from this experience that Dante's Pluto must depend on the poet's knowledge of French. Offering this interpretation for the first time, as he brags, Cellini portrays himself as an expert in Dante, like Michelangelo, whose erudition is reflected in Giannotti's dialogues on Dante.

Imitating Dante, Cellini follows the example of Michelangelo, who sees the great works of his own life, based on Dante, in relation to the *Comedy*, which gives structure and meaning to his life as it gave form to Dante's own. At the end of his imprisonment in the Castel Sant'Angelo, Cellini writes a long "capitolo" in dantesque "terza rima," which he dedicates to the Dantista Luca Martini, who wrote a commentary on the *Comedy*. This poem in imitation of Dante is necessarily an "imitatio Michelangeli." Cellini's conversion, recapitulated in the poem, follows Michelangelo's own conversion, grounded in Dante's journey to God. Imagining his own life and work in terms of Dante's allegorical poem, Cellini, if in exaggerated fashion, impersonates Michelangelo.

No one has written more perceptively on the ways in which Michelangelo and Cellini conceived of their lives in terms of Dante's poem than Henry Wadsworth Longfellow. The translator of Dante's poem, who also made translations from some of Michelangelo's poems, wrote a drama entitled "Michael Angelo," in which Cellini and Michelangelo meet and talk, as they do in Cellini's autobiography. Benvenuto describes to Michelangelo his vision of God but goes on to speak of his earthly ambitions. After Michelangelo warns him, "do not forget the vision," Cellini departs, and Michelangelo sits down to read the *Comedy*. He wonders of Cellini, still thinking of his visitor while reading Dante, in what circle of his sacred poem would the great Florentine have placed him: "Whether in Phlegethon, the river of blood, or in the fiery belt of Purgatory, I know not, but surely not with those who walk in leaden cloaks." Whatever his sins, which include violence, Cellini, Longfellow's Michelangelo insists, is no hypocrite and is not to be placed among those in Dante's hell.

Longfellow properly reconstructs the imaginative approach to Dante of Michelangelo, Cellini, and Vasari, all of whom conceive of autobiography or biography in terms of Dante's allegorically autobiographical poem. Longfellow suggestively illuminates the ways in which Dante shaped Michelangelo's vision of an artist's life—a dantesque vision re-created by Cellini in his michelangelesque autobiography. Writing his own "vita," Cellini made a caricature of Michelangelo's "autobiography," and part of this caricature resides in his novelistic uses of Dante to describe events in his own life. We do not understand Cellini's autobiography fully if we do not see its michelangelesque structure; nor do we completely understand Michelangelo's dantesque "autobiography" and image of himself if we do not see the ways in which they gave shape to Cellini's ideas of himself and his own life.

Michelangelo and the Formation of the Romantic Self

Michelangelo is a pivotal figure in the history of Romanticism. The autobiographical character of his work, its passion, its ambition, all

stood as a paradigm to the Romantics. To the extent that his persona helped form Cellini, he shaped one of the principal heroes of Romanticism. All the pomp and bombast of Cellini in Hector Berlioz's passionate opera about the artist magnifies the fury of Cellini's autobiography, just as Cellini's life had exaggerated the passion of Michelangelo's.

Goethe, who translated this autobiography into German, saw Cellini's century in the "more real terms" of Cellini's confused apprehensions than in the clearest historical account. Cellini's "history" depended on Vasari's and Condivi's ways of describing the tumult of Michelangelo's life, which in turn were derived from Michelangelo's spoken accounts and poetry. The "agon" of Michelangelo's life, expressed in his poetry, was an expression of what the late romantic Walter Pater spoke of as his "passionate thoughts," which he connected with the "stress of sentiments" in Goethe's work. Michelangelo, Pater suggested, was an ancestor of Goethe and the "Sturm und Drang" of the German Romantics. It is not surprising, therefore, that when Fritz Knapp wrote his modern art-historical monograph on Michelangelo in the early years of our century he entitled the chapter on his youth, "Die Jahre des Sturmes und Dranges."

The historical view suggested by Pater was mapped out earlier by Jakob Burckhardt in his classic *Kultur der Renaissance in Italien*. I leave the title in the German since it has always been mistranslated as "The Civilization of the Renaissance in Italy," a translation that misses the important meaning of "Kultur." This word, in its sense of "cultivation," has a close relation to the biological sense of "Bildung," which means formation. "Bildung" is one of the important concepts of German Romanticism, for it applies to the formation of the self, as in the "Bildungsroman," the novel about the education, cultivation, or formation of the protagonist. Burckhardt's famous discussion of "The Discovery of the World and of Man" in the Renaissance deals with the emergence of biography and autobiography, which are closely linked with poetry. Burckhardt effectively traces the origins of the modern or romantic "Bildung" or cultivation of the self. This tradition, which he maps out from Dante to Cellini, is the story of the gradual development of the idea of "Bildung" or formation of the self, which culminates in Goethe and the Romantics. When Burckhardt says of Dante that "the human spirit had taken a mighty step towards the consciousness of its secret life," he speaks in the modern language of Goethe, as

well as in the idiom of the modern philosophy of consciousness from Kant to Hegel and Schopenhauer.

Although Michelangelo is not mentioned by Burckhardt, he has a central place in Burckhardt's history (as Pater implied), since he formed himself in imitation of Dante's *Vita Nuova* and *Comedy*. The self he formed, this "Bild," contributed to the formation or "Bildung" of Cellini. Burckhardt says of Cellini's "mighty nature": "By his side our modern autobiographers, though their tendency and moral character may stand much higher, appear incomplete beings." These words describe perfectly Michelangelo's portrait of himself recorded by Vasari and Condivi and rendered in the colossal forms of his own art. Carrying his measure in himself, Michelangelo contributed to Cellini's image of himself. Michelangelo's self-image, we saw, had been formed out of Dante's self-portrayal. For Burckhardt the form Dante gave to himself was the origin of modern self-consciousness—self-consciousness being the hallmark of Romanticism or modernity.

Michelangelo's Epic Art in the Romantic Imagination

Dante was a principal ancestor of the Romantics. Making himself the subject of his own poem, taking the place of the warrior in the ancient epic, he made himself, the poet, the hero of his work. He thus invented the modern idea of the artist as hero that Michelangelo would exploit. It is not surprising, therefore, that in the nineteenth century, the very age of hero-worship, Dante became a central figure. Keats, Ingres, the Rossettis, Swinburne, Arnold, Tchaikowsky, Tennyson, Browning, Liszt, and D'Annunzio are among the numerous poets, painters, and composers who transformed the cantos of Dante's poem into episodes of romantic passion and adventure. Burckhardt saw Dante as the single most important figure in his book on Renaissance history—a point now strangely overlooked by Burckhardt's closest readers. Dante was, however, the type of Burckhardt's "universal man" or "uomo universale," who preceded Alberti and Leonardo. The "great" and "august" poet was for Burckhardt the first figure in mod-

ern history to strive for "the modern form of glory." Michelangelo, Burckhardt might have added, epitomized this aspiration in his imitation of Dante.

To envision Dante and his poem artists sometimes, not surprisingly, employed the very forms of Michelangelo's art. They shared Stendhal's insight in the *Histoire de la peinture en Italie* that the fierce genius of these two men is the same. In the *Bark of Dante*, Delacroix pictured Dante and Virgil being led by Phlegyas across the River Styx, in which we behold grandiose michelangelesque figures gyrating in the tumultuous waters. Dante's image of himself as pilgrim is informed here by Michelangelo's "terribilità." In his magnificent *Gates of Hell*—an inversion of Ghiberti's baptistry door called by Michelangelo the "Gates of Paradise"—Rodin envisioned Dante's *Inferno* in forms similarly inspired by Michelangelo's dantesque *Last Judgment*. Like Stendhal, these artists accepted Vasari's vision of Michelangelo as the artist who made Dante's heroic grandeur visible— an idea derived from Michelangelo himself. Dante and Michelangelo are of course not themselves romantic artists, but they and their works came to be seen as romantic by the Romantics.

By accepting Michelangelo's identification with Dante the Romantics came to see Michelangelo as, like Dante, a supreme artist of epic form. Not surprisingly, therefore, when Washington Allston portrayed Milton's angel Uriel, he pictured his miltonic subject as a colossal michelangelesque nude, as a descendant of the Sistine ceiling *Ignudi* and *Jonah*. Allston's interpretation of Milton is linked to the modern view of those scholars who insist that Milton's *Paradise Lost* was inspired in part by his experience of the Sistine Chapel during his trip to Italy. Michelangelo's epic art was inspired by Dante's epic poetry; so too was Milton's epic poetry said to be informed by Michelangelo's epic art. The equation of Michelangelo and Milton, now something of a scholarly convention or commonplace, was put more coyly by Oscar Wilde in *Intentions:* "if a man who does not admire Michael Angelo talks of his love of Milton, he is deceiving either himself or his listeners." Three hundred and fifty years after his death, Michelangelo had succeeded in placing himself in the epic tradition that now extended from Homer and Phidias through Virgil and Dante to Michelangelo himself and, after him, to Milton. It is not claiming too much to say that part of Michelangelo's universality resides in his success in establishing a place for himself within this epic tradition.

The Religion of Art

Michelangelo also plays a central role in the history of what one can speak of as the religion of art. At the beginning of our own century, when Giovanni Papini wrote a "Prayer to Michelangelo," the title of his poem still recalled the language of Vasari, who presented Michelangelo as messiah—a "spirit" sent into the world to redeem artists who labored in error. Similarly, John Addington Symonds had concluded his Victorian biography of Michelangelo, as in a hymn, by praising God for creating the greatest artists of the Renaissance. For Symonds, as for Matthew Arnold, art or culture had come to be a form of religion in the increasingly secular modern world.

The long historical view shows that Michelangelo and his apostle Vasari had inherited an extensive tradition dating back to Dante, which defined aesthetic or artistic experience in theological terms. Inheriting Dante's language, Michelangelo had spoken of his quest for perfection in his art as the pursuit of spiritual completion and redemption. The very historical idea of artistic Renaissance, which linked Michelangelo to Dante, was powerfully informed by the idea of spiritual rebirth. The aspiration to poetic and artistic beauty was the aspiration to spiritual purity. The quest for absolutes in the modern, romantic era and after is still tied to this tradition linking art and history to religion. The Spirit or "Geist" of Hegel's philosophy, though secular, has its roots in the biblical concept of spirit and history, and Kandinsky's exploration in "The Spiritual in Art" in our own century is still rooted in theological discourse. Like Louis Sullivan before him or Louis Kahn more recently, Kandinsky cultivated the image of Prophet—a persona shaped in the tradition of the artist as holy personage epitomized by the saintly Michelangelo. The saintly Van Gogh, whose works are informed by apocalyptic imagery, is perhaps the most famous example of the artist as saint in the modern era and, although we do not ordinarily think of Van Gogh in relation to Michelangelo, he is, as artist-saint, a descendant of the divine Buonarroti.

The recent art-historical discussion of the "spiritual in modern art," echoing the diction of Kandinsky, as Kandinsky's echoes Hegel's, again calls attention to the fact that the conventions of religion are very much alive, even when sublimed in aesthetic discourse. Certainly a theological element can be found in the modern formalist aesthetic of "pure form"—as if such an art were, at some level, one of

pure disembodied spirit. Similarly, the modern estranged artist, living in conflict with bourgeois society, descends as a type from the saint and artist-saint who turns away from the materialism of quotidian life toward the spirit or spirituality of art. The very idea of the avant-garde, it has also rightly been said, is also vestigially apocalyptic. Ahead of his time, like the saint, the avant-garde artist foresees a new Jerusalem of artistic perfection. Hence the ubiquity of artist-prophets in the modern era.

Vestiges of the religious significance of art linger, I believe, in the current discussion of Michelangelo. When a scholar recently discovered what he believes to be a model for Michelangelo's *David*, the event was widely covered in the newspapers and journals of the day, on radio and television. It did not matter that at the time the work had not been exhibited and was known only through photographs. Nor did it matter that most specialists remained skeptical of the attribution to Michelangelo. The response to this "discovery" was more than that of finding an unknown work by a world-famous artist. Rather the "aura" of Michelangelo is such that it was as if the art historian had come upon a relic of the artist's very body—as if the artist were still somehow a saint, a saint in the religion of art.

In a similar vein, the controversy that has attended the cleaning of the Sistine ceiling frescoes has been charged with a significance far beyond what any problem in the mere conservation of art might warrant. It should be observed that when the splendid frescoes on the side walls of the chapel by Botticelli, Signorelli, and Perugino were cleaned—and these are works of considerable historical and aesthetic importance—there was no comparable outcry against their restoration. To be sure, there are serious technical issues to be considered in any restoration of a major work of art, but in the case of Michelangelo's work, the undefinable freight of his images is so great, so charged with implication, that any judgment of its cleaning transcends the realm of conservation. For those who put their faith in the restoration, on the basis of exact technical data, the cleaning has been a "revelation," whereas for those who have strained to find flaws in the technique of the cleaning (sometimes with the fury of religious zealots), the restoration remains a sacrilege or desecration.

It has been said that what is at stake in the revelation or damage of the Sistine ceiling frescoes is the status of what is arguably the greatest painting in the entire Western tradition of art. We cannot, how-

ever, see these frescoes merely as great art, since what we construe to be "great art" depends on our sense of its spiritual significance. Michelangelo, as Vasari correctly affirmed in response to his neoplatonism, had effectively associated himself in the Sistine Chapel with God the Creator whom he pictured. Michelangelo later came to see his art as a form of idolatry, and we can say that he made of himself an idol, an idol still worshiped in our own time. For all his objectivity or science, what the Germans call "Kunstwissenschaft," the modern art historian, who exalts Michelangelo's sacred images, serves as the high priest of his cult, and the tourists who come from the four corners of the world to "adore" them are the pilgrims, the devout "worshipers" in this modern religion of art. Even if our world is now said to be post-Christian, this modern epoch is part of what one can call the Millennium of Michelangelo, in which artistic or aesthetic experience is still tied, however tenuously, to what was once more explicitly called devotion.

The Satanic Angel

The cult of Michelangelo has from its very beginnings been highly ambiguous, reflecting the conflict within Michelangelo himself between his aspiration toward spiritual perfection and his sense of sinfulness. The principal criticism of Michelangelo stems from the charges during his own lifetime against the violations of religious decorum in the *Last Judgment*—criticism that pointed toward the pridefulness of his bold interpretation of the Bible. Such criticism was also inseparable from the sense that Michelangelo had violated the norms of classical form. Echoing such charges, Fréart de Chambray spoke in his seventeenth-century discourse, *Idée de la perfection de la peinture*, of Michelangelo's *Last Judgment* as a work of deformity, insolence, profanity, sacrilege, and impiety. Michelangelo's introduction of the pagan Charon in the fresco was, Fréart insisted, "criminal." In contrast to Raphael, the "good angel" of painting, Michelangelo was the "bad angel." When Ruskin later condemned Michelangelo for his "pride," for the vanity of his art, it was as if Michelangelo were the fallen angel, Satan himself.

Like Niccolò Machiavelli, who came to be seen as Satan or Old

Nick, Michelangelo was implicitly the Devil incarnate. So closely parallel to the legend of Machiavelli is Michelangelo's that, like the "murderous Machiavel" of the Elizabethans, Michelangelo came to be seen as a murderer. Already in the sixteenth century Lomazzo had sown the seeds of this legend, telling the story of how Raphael called Michelangelo an "executioner." In the seventeenth century Richard Carpenter told the story of Michelangelo tying a young man to a cross and murdering him in order to study and depict his agonies in death. It is not important that this story is based on a classical legend, that similar stories were told of other artists, for example, of Salieri, who was said to have murdered Mozart. What is significant is that the tale comments on the force or violence of Michelangelo's art, on the torment and suffering of his figures—that it comments on the tradition of criticism condemning Michelangelo for the lack of morality in his art.

The story of the machiavellian, murderous Michelangelo endured into the nineteenth century and was exploited by Pushkin in his "Mozart and Salieri." Having poured the poison into Mozart's cup, Salieri insists that "villainy and genius" are one. In his final lines, Salieri invokes the example of Michelangelo: "Think but of Buonarroti. . . . Or was that a tale of the dull, stupid crowd—and he who built the Vatican was not a murderer?" The legendary force and impiety of Michelangelo's art had now become part of the nineteenth-century romantic myth of the artist as criminal, immoralist, and murderer—a myth that would be carried to its greatest heights by Thomas De Quincey and Oscar Wilde. The archangel, now the fallen angel, the satanic Michelangelo now became a glorious hero of the romantic immoralists.

Michelangelo the "Übermensch"

If Ruskin condemned Michelangelo for the sin of pride, Pushkin exalted him for his villainy. Gradually, however, Michelangelo rose in Nietzsche's words, "beyond good and evil." A distinguished art historian once lamented that Michelangelo's work was obscured by nietzschean mists, but it can be said that Michelangelo stands behind Nietzsche's "Übermensch," his Superman who rises beyond good and evil. Michelangelo has been appropriately described in nietzschean

terms in the modern literature, because Michelangelo effectively influenced Nietzsche's conception of the powerful Superman.

Goethe had already spoken of the Superman, using the word "übermenschliche" to describe Michelangelo's work, a characterization that would become commonplace and would be echoed in Freud's essay on Michelangelo's *Moses*. In the intervening period between Goethe and Freud, Nietzsche wrote an apostrophe to Michelangelo as "Übermensch." Nietzsche, we should recall, had been a disciple of Jakob Burckhardt, who had exalted Benvenuto Cellini, artist and immoralist, as a figure of greatness. Cellini, we also remember, had formed himself in the image of Michelangelo's "terribilità." It has often been observed that Nietzsche's idea of the "Übermensch" is rooted in Burckhardt's idea of Renaissance man, just as Burckhardt's Renaissance man is grounded in Faust. Throughout this German romantic tradition of writing about the superhuman runs the thread of Michelangelo as hero. Inheriting this tradition from Goethe and Burckhardt, Nietzsche proclaimed in "Peoples and Countries," originally part of *The Genealogy of Morals*, that Michelangelo's conception of God as the "Tyrant of the World" was an honest one. The image of Michelangelo as prince had thus been refashioned into the image of Michelangelo the tyrant. Given the connections and affinities between Michelangelo's and Machiavelli's images and their shared roots in the machiavellian Julius II, Nietzsche's association of Michelangelo's God with tyranny was not an inappropriate response to Michelangelo. Let us listen now in detail to what Nietzsche says about Michelangelo:

> I rate Michael Angelo higher than Raphael, because, through all the Christian clouds and prejudices of his time, he saw the ideal of a culture nobler than the Christo-Raphaelian: whilst Raphael truly and modestly glorified only the values handed down to him, and did not carry within himself any inquiring, yearning instincts. Michael Angelo, on the other hand, saw and felt the problem of the law-giver of new values: the problem of the conqueror made perfect, who first had to subdue the "hero within himself," the man exalted to his highest pedestal, master even of his pity, who mercilessly shatters and annihilates everything that does not bear his own stamp, shining in Olympian divinity. Michael Angelo was naturally only at certain moments so high and so far beyond his age and Christian

Europe; for the most part he adopted a condescending attitude towards the eternal feminine in Christianity; it would seem, indeed, that in the end he broke down before her, and gave up the ideal of his most inspired hours. It was an ideal which only a man in the strongest and highest vigour of life could bear; but not a man advanced in years! Indeed, he would have had to demolish Christianity with his ideal!

Nietzsche's portrayal of Michelangelo is a hyperbolic encyclopedia of elements from the traditional image of the artist-hero: Michelangelo the lawgiver, who descends from Moses; Michelangelo the conqueror or victor, who recalls both Pope Julius II and Machiavelli's prince; Michelangelo the destroyer, linked with the God of wrath of his *Last Judgment* but ultimately more like the wrathful Olympian God, Apollo. Like Machiavelli, Michelangelo bore within himself the conflict between pagan "virtù" or force and Christianity, which Nietzsche finally draws to its extreme consequence—finding in Michelangelo the transvaluation of Christianity, a shattering and violent transcendence of its submissiveness. Nietzsche sees that what is truly "terrible" in Michelangelo is a force destructive of the religion that had identified his satanic character.

The idea of the Superman takes us back once again to Dante, who used the word "trasumanare"—the passing beyond humanity—to describe his journey beyond the world into paradise. Although his term "superhuman" is still used in a Christian context, the implicit pride of his own grandiose vision is the seed that nourished Michelangelo's own exalted, superhuman image of himself and his art. This image, despite Michelangelo's piety, especially during his last years, depends on a machiavellian sense of "virtù," a pride that destroys the Christian virtue of humility. Bernard Berenson, a close reader of Goethe, Burckhardt, and Nietzsche, characterized perfectly this force of Michelangelo, speaking of his vision of a "possible humanity, which . . . has never had its like in modern times." Michelangelo, Berenson said, created "the type of man best fitted to subdue and control the earth, and, who knows! perhaps more than the earth."

This type of nietzschean, and we might add berensonian, Michelangelo reemerges in the fiction of our century—in Rainer Maria Rilke's story "Of One Who Listened to the Stones" from the *Stories of God*. The heavens fell silent, Rilke says, the "stars trembled," and the angels

froze in fear awaiting God's angry words. When the heavens opened, Rilke continues, Raphael was "on his knees," and Angelico on a cloud above rejoiced over him. But God could recognize only one thing: "the strength of Michelangelo." When God came to Michelangelo "in dread," he asked him: "who is in the stone?" Michelangelo responded, "Thou my God, who else? But I cannot reach Thee." God sensed that "he was indeed in the stone, and he felt fearful and confined." Michelangelo's capacity to inspire terror had originally depended on that of the wrathful God or "Deus terribilis" of the Bible, but now the terrifying artist, this nietzschean Superman, seemingly had the power to subdue "more than the earth," creating terror or "Angst" in God himself. When Rilke describes Michelangelo tearing at the stone—"he tore at the stone as at a grave"—he evokes the violence of Nietzsche, who describes man shattering the very walls of necessity. Rilke creates a Michelangelo who has risen, as Nietzsche says, "beyond his age and Christian Europe," conquering God himself. Whereas Michelangelo had sought salvation from God, now it was God, imprisoned in the stone, who waited, "hoping for the hands of Michelangelo to deliver him." In his powers, similar to but now transcending God's, Rilke's nietzschean Michelangelo is, however distantly and metaphorically, the final creation of Michelangelo himself—or very nearly so.

Michelangelo's Final Work

By the time he had written his story about Michelangelo, Rilke had served as secretary of the michelangelesque Rodin, whose *Hand of God*, like Rilke's story, was a celebration of the artist's own creative hands. Rilke had also experienced the advent in Paris of the most extraordinary artist of the new century, Pablo Picasso. Although artists from Tintoretto to Caravaggio, from Rubens and Bernini to Reynolds, from Blake to Delacroix and Rodin, had all formed themselves or their works on Michelangelo's example, no artist so fully assimilated Michelangelo to himself as did Picasso.

The persona that Picasso formed through his art, words, and deeds is profoundly bound up with Nietzsche's "Übermensch." It has by now become commonplace to observe that Picasso not only encountered Nietzsche's philosophy in Barcelona during the 1890s, but that

again he found it current and widely discussed in Paris during the first years of the century. The violence and terror of Nietzsche's philosophy of destruction and transvaluation are justly recognized to stand behind Picasso's powerfully revolutionary *Demoiselles d'Avignon.* "Rage," "fury," "terror," and "horror" are words that have become fundamental to the criticism of Picasso's picture, which captures the sheer "horror and terror," the very violence of Nietzsche's philosophy and aesthetics.

In the history of twentieth-century art as it is currently written, Picasso's *Demoiselles* is said to be an assault on the conventions of painting, an "explosion," a "shattering" of the human figure that foretells the even greater violence and force of Cubism. The triumph of Picasso's art is an act of destruction. Picasso is like Nietzsche's Michelangelo, who "shatters and annihilates everything that does not bear his own stamp." Like Nietzsche's Michelangelo, Picasso is "the law-giver of new values." No artist after Michelangelo—virtually no artist, not even Caravaggio or Rodin—so fully grasped and made part of his own persona Michelangelo's "terribilità" as did Picasso. He is like Zola's nietzschean Michelangelo of *Rome* (1896): "le monstre dominant tout, écrasant tout"—"the monster who dominates and exterminates all." When Picasso spoke of painting as a "hoard of destructions," he spoke in the language of Nietzsche, of Nietzsche's Michelangelo, who both shatters and annihilates, who eradicates all.

In the legend-making biographies of Picasso in our own day, Picasso the creator and destroyer of art is associated with Michelangelo, the first artist to embody the Creator and Destroyer in himself, but Picasso's creations and destructions are more specifically like those of Nietzsche's Superman, who transcends God. Michelangelo saw himself as a prince, and Picasso, exaggerating this michelangelesque idea, wished to become the dictator of all art. In a well-known remark of 1935, he said to his Vasari, Christian Zervos: "There ought to be an absolute dictatorship . . . a dictatorship of painters . . . a dictatorship of one painter to suppress all those who have betrayed us, to suppress the cheaters, to suppress the tricks, to suppress the mannerisms, to suppress the charms, to suppress history, to suppress a heap of other things." Here Picasso aspired to become the equivalent of Michelangelo's God according to Nietzsche: "Tyrant of the World."

Picasso succeeded remarkably well, making the last century in the Millennium of Michelangelo his own, the Century of Picasso. His

fame, his enduring legend, has been formed out of Michelangelo's idea of the artist, of himself as a figure of force, a conqueror who subdues or annihilates his adversaries. Part of Picasso's biography and legend has to do with his very self-consciousness—his keeping a complete record of his work in order to establish his own place at the peak of art history. In this fundamental respect, he is a descendant of Michelangelo, who was the first modern artist to articulate his own persona in fine detail, seeing his own works as images from an autobiography. In a similar vein, Picasso spoke of his works as part of an ongoing "diary," one that he claimed he had no time to edit. But edit it he did, especially at the end of his life when he painted a series of variations on the great masterpieces of the past, making them his own, assimilating them to himself. Placing all the diary entries of his art in historical perspective, he recalled Michelangelo, self-consciously fashioning himself in old age from his autobiographical work into the final "victor" in the entire history of art. From Michelangelo, directly or indirectly, Picasso learned to think of himself as the summit of art history, as the terrifying creator, who through the destructive force of his creations made the entire history of art his own domain and conquest. Picasso's friend Apollinaire once remarked, recognizing Picasso's michelangelesque ambitions, that "Picasso is among those of whom Michelangelo said that they merited the name of eagles, because they surpass all others." Michelangelo had also once said that, although he had never married, his works were his children. Molding himself into a figure of horrifying power—a work of art in his own right—Michelangelo created the mold in which Picasso would be formed. Filling that colossal, still-dominating mold as best he could, Picasso the tyrant and destroyer, Picasso the creator and transvaluator, Picasso the demigod and giant, was Michelangelo's last son and one of his greatest creations—a reflection of Michelangelo's creation of himself.

Conclusion: Michelangelo's Masterpiece

Michelangelo was undoubtedly his own greatest masterpiece, his own greatest work of art. This is so because he made himself the sum and

more than the sum of his own *David, Moses,* and divine Sistine sub-
jects. Having compounded his image from these grandiose subjects,
embellishing his identity even further with autobiographical sugges-
tions made to his biographers and friends, Michelangelo created the
highly artistic colossal image of himself. He made himself into a mas-
terpiece in the sense of having achieved sovereignty or hegemony
over the world of culture in which he worked. Likened to God the
Creator and Zeus, to Aeschylus, Luther, and Beethoven, Michelan-
gelo has assumed a place in our cultural life that even today is difficult
to compass fully. A German art historian once remarked that "Michel-
angelo is a world," and we understand precisely what this scholar
meant, since Michelangelo both molded himself out of the entire
universe of culture to which he was heir and gave shape to a self that
has dominated our cultural life ever after.

So great and powerful is the image of himself that Michelangelo
created that it has exerted its force in ways that have been
unexpected—for example, in his influence on the modern, terrifying
idea of the "Übermensch." Like a work of art, a legend continuously
takes on new significance over time, and this is so of the legend of
Michelangelo, who is present in our cultural life even when not named.
We read the first lines of the Bible and it is impossible for us to read of
the Creation without imagining it as Michelangelo depicted it. In a
sense he has created Creation. Imagining Michelangelo's scenes of
Creation, which are so fundamental to our mental furniture and con-
sciousness, we see the images of God there as if they were projections
of Michelangelo himself, in accord with Michelangelo's will. To reflect
on Michelangelo is to recognize his capacity to captivate our imagina-
tion, to take his place, so to speak, in the Bible, to achieve similitude
with God. Thus we begin to compass the terrifying power of his self-
generating and dominating imagination.

According to one of the great fictions of our day, the author or artist
is dead—or so the claim is made as a pale echo of Nietzsche's procla-
mation of the death of God one hundred years ago. The legend of
Michelangelo and its place in our cultural life suggest, however, just
how empty this claim is, for the romantic idea of the artist as hero, to
which Michelangelo contributed so much, is very much alive. Michel-
angelo the masterpiece of self-creation, exalting yet deeply disturb-
ing, still holds up to humanity a mirror, establishing "a form of such
nobility that it has never ceased to magnify us in our own eyes"—just
as it has never ceased to fill us with awe and terror.

Bibliographical Essay

The reader who would familiarize him or herself with the vast scholarship on Michelangelo can turn to the five volumes of De Tolnay (1947–60), to Barocchi's critical edition of Vasari's biography of Michelangelo (1962), and, finally, to David Summers's book on Michelangelo (1981), the last of which affords the reader a solid review of recent scholarly trends in its extensive notes. My own selected bibliography takes into account works published through the summer of 1988, when the final draft of this book was essentially completed.

Exploring Michelangelo's image of himself, I was particularly stimulated by Seymour's book-length essay on Michelangelo's *David* (1967), whose subtitle, "A Search for Identity," is highly suggestive of Michelangelo's ambition. Summers's recent book was important to me not only for numerous, particular details but because its demonstration of Michelangelo's conscious relation to various intellectual traditions was a key to my understanding how Michelangelo exploited these traditions in forming his own persona. I also found Liebert's book on Michelangelo (1983), especially his speculations on Michelangelo's "autobiographical myth," very provocative, although I did not follow him into the deeper recesses of Michelangelo's psyche. Clements's volume on Michelangelo's poetry (1965)—a book that deserves even more attention from art historians than it has already received—includes useful observations on the autobiographical character of his work. All of Hartt's writings on Michelangelo evoke the artist's deep identification with his subjects, and Steinberg's discussion of Michelangelo's identification with Saint Paul (1975) is an important foundation for my own

treatment of the subject. Freccero's collected essays on Dante (1986), with their stress on Dante's literary self-consciousness, helped me to clarify Michelangelo's own literary self-consciousness and his emulation of Dante in this regard. The discussion here of Michelangelo's identity as a work of art is greatly indebted to Joseph Mazzeo's burckhardtian essay on Castiglione and the self as a work of art (1967).

My view of the Christian renaissance is an old one, associated with such scholars as Burdach and recently revived by Trinkhaus and O'Malley, among others. For a good review of some of this scholarship, see Goldstein's book on the Carracci (1988), which appeared shortly after my own study was completed. Goldstein offers a brief commentary on the scriptural character of Renaissance art history parallel to my own. Ladner's book on spiritual reform (1959) maps out the origins of a tradition to which Michelangelo belongs. Michelangelo's quest to perfect himself, to re-form or re-create himself, is based on the kind of Christianized platonism discussed by Ladner. Though more distant, the self-creation of modern aestheticism still lies in this tradition. Wind's book on poetic theology (1968) provides an important basis for approaching Michelangelo's manner of creating himself, and Zeiderman's essay on Saint Augustine (1988) is the basis for my discussion of the *Confessions*.

The reading of Vasari presented here descends from an approach of Italian literary scholars, still not widely diffused, that recognizes the typological character of Vasari's book; for this tradition, see Riccò's monograph on Vasari (1979). The anecdotes in Vasari are part of a rhetorical tradition of biography discussed by Kris and Kurz (1979). Chastel (1959 and 1983) remains one of Vasari's shrewdest readers, recognizing the hagiographical, myth-making, and imaginative powers of Vasari's work. Watson's important essay on anecdotes about artists (1984) persuasively demonstrates the continuity between classical tales about artists and the Tuscan tradition—to which Michelangelo belongs.

A word about iconography. I have focused on the portrait medal by Leone after Michelangelo's invention because it reveals so much about Michelangelo's way of imagining himself. The scholarship on the medal was reviewed by Barocchi in 1962. Since then, two recent discussions of the medal by Fehl (1971) and Steinberg (1975) have opened up this work to further analysis. I have related Michelangelo's medal to his emblem, the fullest discussion of which is found in

Wazbinski (1987). Throughout my study of Michelangelo's themes I have found Gilbert's translations of his poetry of particular value.

Although Michelangelo's wit and irony are legendary, there has been little sustained discussion of these aspects of his personality and art. My own view of his socratic irony and of its relations to that of Erasmus, Rabelais, and Montaigne is indebted to the work of Walter Kaiser (1963). As I have tried to suggest, Michelangelo's wit and humor belong to literary traditions of satire, burlesque, and the macaronic, still little discussed by art historians, who only pay lip service to them but which were explored in some detail by Symonds. If Michelangelo's wit were adequately understood, art historians would have understood long ago why his "lost" faun has no known provenance. Their failure to explore sufficiently the playfulness of Michelangelo and Renaissance art in general tells us more about professional art history than it does about Michelangelo and the culture of his age.

Selected Bibliography

Ackerman, James S. *The Architecture of Michelangelo.* Harmondsworth, Middlesex, 1971.

Aesop. *Aesop's Fables.* New York, 1968.

Agosti, Giovanni, and Vincenzo Farinella. *Michelangelo e l'arte classica.* Florence, 1987.

Alberti, Leon Battista. *On Painting,* trans. John R. Spencer. New Haven and London, 1976.

Alexander, Sidney. *Nicodemus: The Roman Years of Michelangelo Buonarroti.* Athens, Ohio, 1988.

Altieri Biagi, Maria Luisa. "La *Vita* del Cellini: Temi, termini, sintagmi." In *Benvenuto Cellini: Artista e scrittore.* Rome, 1972.

Aretino, Pietro. *A Paraphrase upon the Seaven Penitentiall Psalmes* (1653). In *English Recusant Literature, 1558–1640,* vol. 340, ed. D. M. Rogers. London, 1977.

Baxandall, Michael. *Giotto and the Orators: Humanist Observers of Painting in Italy and the Discovery of Pictorial Composition.* Oxford, 1971.

Bellori, Giovanni Pietro. *Descrizzione delle imagini dipinte da Rafaelle d'Urbino nelle Camere del Palazzo Apostolico Vaticano.* Farnborough, 1968.

Berenson, Bernard. *Italian Painters of the Renaissance,* 2 vols. London and New York, 1968.

Berger, John. *The Success and Failure of Picasso.* Harmondsworth, Middlesex, 1965.

Berni, Francesco. *Rime facete,* ed. Ettore Bruni. Milan, 1959.

Boccaccio, Giovanni. *The Decameron,* trans. Mark Musa and Peter Bondanella. New York, 1982.

———. *Vita di Dante e difesa della poesia,* ed. Carlo Muscetta. Rome, 1968.

Braudy, Leo. *The Frenzy of Renown: Fame and Its History.* New York and Oxford, 1986.

Burckhardt, Jakob. *The Civilization of the Renaissance in Italy,* trans. S. G. C. Middlemore. London, 1960.

Cambon, Glauco. *Michelangelo's Poetry: Fury of Form.* Princeton, 1985.

Caro, Annibale. *La Nasea.* In *Commento di ser Agresto da Ficaruolo sopra la prima ficata del Padre Siceo.* Bologna, 1967.

Castiglione, Baldassare. *The Book of the Courtier*, trans. Charles S. Singleton. Garden City, N.Y., 1959.

———. *Il libro del Cortegiano*, ed. Giulio Carnazzi. Milan, 1987.

Cellini, Benvenuto. *Autobiography*, trans. George Bull. Harmondsworth, Middlesex, 1977.

Chastel, André. *Art et Humanisme à Florence au Temps de Laurent le Magnifique.* Paris, 1959.

———. *The Sack of Rome 1527*. Princeton, 1983.

Clements, Robert J. *The Poetry of Michelangelo*. New York, 1965.

Condivi, Ascanio. *The Life of Michelangelo*, trans. Alice S. Wohl, ed. Helmut Wohl. Baton Rouge, 1976.

———. *Vita di Michelangelo Buonarroti*, ed. Emma Spina Barelli. Milan, 1964.

Curtius, Ernst R. *European Literature and the Latin Middle Ages*, trans. Willard R. Trask. New York, 1963.

Dante Alighieri. *Inferno*, trans. John D. Sinclair. New York, 1975.

———. *Paradiso*, trans. John D. Sinclair. New York, 1975.

———. *Purgatorio*, trans. John D. Sinclair. New York, 1975.

———. *Le rime*, ed. Piero Cadini. Milan, 1979.

———. *Vita Nuova*, ed. Lodovico Magugliani. Milan, 1952.

David, Alfred. "An Iconography of Noses: Directions in the History of a Physical Stereotype." In *Mapping the Cosmos*, ed. Jane Chance and R. O. Wells, Jr. Houston, 1985.

Diogenes Laertius. *Lives of Eminent Philosophers*, trans. R. D. Hicks, 2 vols. London and New York, 1925.

Erasmus, Desiderius. *Adages*, trans. Margaret Mann Phillips. Cambridge, 1964.

———. *In Praise of Folly*, trans. Betty Radice. Harmondsworth, Middlesex, 1971.

Falaschi, Enid. "Giotto: The Literary Legend." *Italian Studies* 27 (1972): 1–27.

Fanti, Sigismondo. *Triompho di Fortuna*. Venice, 1527.

Fehl, Philipp. "Michelangelo's *Crucifixion of St. Peter:* Notes on the Identification of the Locale of the Action." *Art Bulletin* 58 (1971): 327–43.

Fischel, Oskar. "Raphael und Dante." *Jahrbuch der Preussischen Kunstsammlungen* 41 (1920): 83–102.

Fréart, Roland De Chambray. *Idée de la perfection de la peinture*. Farnborough, 1968.

Freccero, John. *Dante: The Poetics of Conversion*. Cambridge, Mass., and London, 1986.

Freedberg, S. J. *Painting of the High Renaissance in Rome and Florence*, 2 vols. Cambridge, Mass., 1961.

Giannotti, Donato. *Dialoghi di Donato Giannotti de' giorni che Dante consumò nel cercare l'Inferno e'l Purgatorio*, ed. D. Redig de Campos. Florence, 1939.

Goldstein, Carl. *Visual Fact over Verbal Fiction: A Study of the Carracci and the Criticism, Theory, and Practice of Art in Renaissance and Baroque Italy.* Cambridge, 1988.

Hartt, Frederick. *Michelangelo*. New York, 1965.

———. *Michelangelo: The Complete Sculpture*. New York, 1968.

———. *Michelangelo Drawings*. New York, 1970.

Hibbard, Howard. *Michelangelo*. New York and London, 1974.

Hollanda, Francisco de. *Dialoghi romani con Michelangelo*, trans. Laura Marchiori. Milan, 1964.

———. *Four Dialogues on Painting*, trans. Aubrey F. G. Bell. London, 1928.

Horace. *The Odes and Epodes*, trans. C. E. Bennett. New York and London, 1914.

Kaiser, Walter J. *Praisers of Folly: Erasmus, Rabelais, and Shakespeare*. Cambridge, Mass., 1963.

Kris, Ernst, and Otto Kurz. *Legend, Myth, and Magic in the Image of the Artist*. New Haven and London, 1979.

Ladner, Gerhard B. *The Idea of Reform: Its Impact on Christian Thought and Action in the Age of the Fathers*. Cambridge, Mass., 1959.

Liebert, Robert S. *Michelangelo: A Psychoanalytic Study of His Life and Images*. New Haven, 1983.

Longfellow, Henry Wadsworth. *Michael Angelo: A Dramatic Poem*. Boston, 1884.

Machiavelli, Niccolò. *The Prince*, trans. Peter Bondanella. Oxford, 1984.

Mazzeo, Joseph A. "Castiglione's Courtier: The Self as Work of Art." In *Renaissance and Revolution: Backgrounds to Seventeenth-Century Literature*. New York, 1967.

Michelangelo Buonarroti. *Michelangelo: Complete Poems and Selected Letters*, trans. Creighton Gilbert and ed. Robert N. Linscott. Princeton, 1963.

———. *Rime*, ed. G. R. Ceriello. Milan, 1954.

———. *Rime*, ed. Enzo N. Girardi. Bari, 1960.

Montaigne, Michel de. *The Complete Essays*, trans. Donald M. Frame. San Francisco, 1983.

———. *Montaigne's Travel Journal*, trans. Donald M. Frame. San Francisco, 1983.

Nabokov, Vladimir. *Nikolai Gogol*. New York, 1961.

Nietzsche, Friedrich. *The Genealogy of Morals*, trans. Horace B. Samuel. New York, 1918.

Olney, James. *Metaphors of Self: The Meaning of Autobiography*. Princeton, 1972.

Panofsky, Erwin. *Renaissance and Renascences in Western Art*. New York, 1969.

———. *Studies in Iconology: Humanistic Themes in the Art of the Renaissance*. New York and Evanston, 1962.

Papini, Giovanni. *Giorni di festa*. Florence, 1920.

Partridge, Loren W., and Randolph Starn. *A Renaissance Likeness: Art and Culture in Raphael's Julius II*. Berkeley, 1980.

Pater, Walter, *The Renaissance: Studies in Art and Poetry*, ed. Donald L. Hill. Berkeley, 1980.

Penrose, Roland. *Picasso: His Life and Work*. New York, 1962.

Pico della Mirandola, Giovanni. *On the Dignity of Man and Other Works*, trans. Charles Glenn Wallis. Indianapolis, 1965.

Plato. *Selections*, ed. Raphael Demos. New York, 1955.

———. *Symposium*, trans. Benjamin Jowett. Indianapolis, 1956.

Pliny the Elder. *The Elder Pliny's Chapters on the History of Art*, ed. K. Jex-Blake and E. Sellers. Chicago, 1968.

Plutarch. *The Lives of the Noble Grecians and Romans*, trans. John Dryden. New York, 1932.

Poliziano, Angelo. *Angelo Polizianos Tagebuch (1477–1479)*, ed. Albert Welsselski. Jena, 1929.

Pushkin, Aleksandr Sergeyevich. *The Poems, Prose and Plays of Alexander Pushkin*, ed. Avrahm Yarmolinsky. New York, 1943.

Rabelais, François. *Gargantua and Pantagruel*, trans. J. M. Cohen. Harmondsworth, Middlesex, 1963.

Riccò, Laura. *Vasari Scrittore: La prima edizione del libro delle "Vite."* Rome, 1979.

Rilke, Rainer Maria. *Stories of God*, trans. M. D. Herter Norton. New York, 1963.

Ristori, Renzo. "L'Aretino e il David di Michelangelo." *Rinascimento* 26 (1986): 77–97.

Roskill, Mark W. *Dolce's "Aretino" and Venetian Art Theory of the Cinquecento.* New York, 1968.

Saint Augustine. *Concerning the City of God against the Pagans,* trans. Henry Bettenson. Harmondsworth, Middlesex, 1972.

———. *The Confessions,* trans. Edward B. Pusey. New York, 1964.

Savonarola, Girolamo. *Prediche sopra Ezechiele,* ed. Roberto Ridolfi, 2 vols. Rome, 1955.

———. *Prediche sopra i salmi,* ed. Vincenzo Romano, 2 vols. Rome, 1974.

Seymour, Charles, Jr. *Michelangelo's David: A Search for Identity.* New York, 1967.

Steinberg, Leo. *Michelangelo's Last Paintings.* London, 1975.

———. *The Sexuality of Christ in Renaissance Art and in Modern Oblivion.* New York, 1983.

Sterne, Laurence. *The Life and Opinions of Tristram Shandy, Gentleman.* New York, 1950.

Summers, David. *Michelangelo and the Language of Art.* Princeton, 1981.

Symonds, John Addington. *The Life of Michelangelo Buonarroti.* New York, 1928.

———. *Renaissance in Italy,* 2 vols. New York, 1935.

Tolnay, Charles de. *Michelangelo: The Final Period.* Princeton, 1960.

———. *Michelangelo: The Medici Chapel.* Princeton, 1948.

———. *Michelangelo: The Sistine Ceiling.* Princeton, 1949.

———. *Michelangelo: The Tomb of Julius II.* Princeton, 1954.

———. *The Youth of Michelangelo.* New York, 1947.

Valori, Niccolò. *La vita del Magnifico Lorenzo de' Medici.* Florence, 1568.

Vasari, Giorgio. *Lives of the Most Eminent Painters, Sculptors, and Architects,* trans. Gaston Du C. de Vere, 3 vols. New York, 1979.

———. *La vita di Michelangelo nelle redazioni del 1550 e del 1568,* ed. Paola Barocchi, 5 vols. Milan and Naples, 1962.

———. *Le vite de' più eccellenti architetti pittori et scultori italiani da Cimabue insino a' tempi nostri,* ed. Luciano Bellosi and Aldo Rossi. Turin, 1986.

———. *Le vite de' più eccellenti pittori scultori e architettori,* ed. Paola della Pergola, Giovanni Grassi, and Giovanni Previtali, 9 vols. Novara, 1967.

Virgil. *The Aeneid,* trans. Robert Fitzgerald. New York, 1983.

———. *Eclogues, Georgics, Aeneid 1–6,* trans. H. Rushton Fairclough, 2 vols. Cambridge, Mass., and London, 1974.

Watson, Paul. "The Cement of Fiction: Giovanni Boccaccio and the Painters of Florence." *Modern Language Notes* 99 (1984): 43–64.

Wazbinski, Zygmunt. *L'Accademia Medicea del Disegno a Firenze nel Cinquecento: Idea e Istituzione,* 2 vols. Florence, 1987.

Wilde, Oscar. *The Artist as Critic: The Critical Writings of Oscar Wilde,* ed. Richard Ellmann. New York, 1969.

Wind, Edgar. *Pagan Mysteries in the Renaissance: An Exploration of Philosophical and Mystical Sources of Iconography in Renaissance Art.* New York, 1968.

Wittkower, Rudolph, and Margot Wittkower. *The Divine Michelangelo: The Florentine Academy's Homage on His Death in 1564.* London, 1964.

Zeiderman, Howard. "Fictional Selves and Ghosts: St. Augustine's *Confessions*" (unpublished lecture). Annapolis, 1988.

Zola, Émile. *Rome.* Paris, 1896.

Index

DATE DUE